How to Make Money With Your Airbrush

About the Author

Joseph Sanchez began working in 1978 as a self-taught professional T-shirt airbrush artist, working full-time for five years in key tourist locations, including Alabama, Florida, the Virgin Islands, Texas and California. He now lives and teaches in Fremont, California.

How to Make Money With Your Airbrush

by Joseph B. Sanchez

Cincinnati, Ohio

How to Make Money With Your Airbrush. Copyright © 1992 by Joseph B. Sanchez. Illustrations copyright © 1992 by Joseph B. Sanchez, except as otherwise noted. Printed and bound in the United States of America. All rights reserved. No part of this book may be reproduced in any form or by any electronic or mechanical means including information storage and retrieval systems without permission in writing from the publisher, except by a reviewer, who may quote brief passages in a review. Published by North Light Books, an imprint of F&W Publications, Inc., 1507 Dana Avenue, Cincinnati, Ohio 45207; 1-800-289-0963. First edition.

96 95 94 93 92 5 4 3 2 1

Library of Congress Cataloging-in-Publication Data

Sanchez, Joseph B.
 How to make money with your airbrush / by Joseph B. Sanchez.
 p. cm.
 Includes index.
 ISBN 0-89134-435-7
 1. Airbrush art—United States—Marketing. I. Title.
NC915.A35S17 1992
741.6—dc20 92-22835
 CIP

Editorial direction: Diana Martin
Edited by: Mary Cropper and Dawn Korth
Designed by: Paul Neff

Page 129 constitutes an extension of this copyright page.

Dedication

To my wife Angela, without whose editorial and emotional support I could not have completed this project.

Acknowledgments

A special thanks to my good friend, and fellow writer, Kevin Texeira for all his help and support.

I would also like to express my deepest gratitude to all the artists who gave up their time for interviews and submitted art for the book. And thanks to Angela V. Sanchez, who did a wonderful job writing all the interviews.

Finally, a special thanks to the North Light Books editorial staff—Mary, Dawn, and Kate Morrow. And to Tari Sasser Jacober in the art department, thanks for always having the time for a modem transmission!

Contents

Introduction

The airbrush has been making money for artists since the late 1800s when artists used the airbrush to paint signs. Around the turn of the century, artists moved into the newspaper market as the airbrush improved and constant air pressure was produced by the electric air compressor. Throughout the 1920s and 1930s, photography was crude at best, and so the airbrush was used extensively for retouching. As photography improved, the airbrush found a new home in the commercial illustration market, which has become extremely competitive over the last sixty years.

Things didn't change much until 1950, when Big Daddy Roth of California, a popular cartoonist best known for his satirical illustrations of hot rod enthusiasts, is said to have painted the first airbrushed T-shirt. This event's significance, often overlooked, is that it was the first time an airbrush artist sold directly to the consumer. Prior to this, the airbrush artist had always been paid by a client or employer, such as a newspaper or advertiser, rather than being paid by the consumer for his product.

When Big Daddy Roth painted that first T-shirt, he started an independent business free from the artist-employer arrangement. This is one of the few times in history when the artist has been in a position to produce a low-cost, high-demand product and sell it directly to the consumer. And since the 1950s, the airbrush market has grown into a profitable industry.

Next, the airbrush was used on cars. The famous flames covering the fronts of hot rods during the mid-1950s became one of the first standard automotive designs. During the 1960s, surfers adorned their cars with beach scenes, and by the 1970s, airbrush murals had become standard on show vans and cars.

Today, airbrush artists abound in almost every coastal town of Florida, California and Texas, supplying T-shirts to tourists. Artists are teamed up with T-shirt shops in malls and shopping centers throughout the nation. They are also found at car shows, art festivals and county fairs.

There are three major factors that contributed to the fast growth of the airbrush industry. First, the airbrush is relatively easy to learn. If you can already paint or draw and understand the basics of shading, it can be even simpler.

Second, the airbrush industry is a creative industry. This means that airbrush art cannot be easily reproduced. Part of the appeal of airbrushed products is that they are handpainted. Because of this uniqueness, mass marketers have not been able to mass-produce airbrushed products and have left this industry alone. It is an artist's market exclusively.

The third element that led to the quick rise of the airbrush industry, and one that this book covers extensively, is the availability of many distribution networks for airbrush artists. To put this simply, there are many ways to get your airbrush art in front of the buying public. You can paint in T-shirt shops and art supply stores, or you can wholesale your goods and sell them on consignment. If you want, you can use several different methods of distribution concurrently.

Knowing these different methods of distribution allows you to enter the airbrush industry and make money. What good is it to know how to paint if all your paintings sit in a closet? Where is the fun of creating art when there is no one to share it with?

This book examines the hottest and fastest growing airbrush markets available today. It tells you how to find the best locations and explains, step by step, how to secure them with no money down. I will also point out the hidden pitfalls to watch for, because a major part of starting a successful business is knowing how not to get into trouble.

Chapter One

Making Money With Your Airbrush

For over forty years airbrush artists have been pleasing customers and profiting from their work, painting pictures of cars, pets, boats and such onto any surface, whether it is as small as a T-shirt or as large as a van. And that is what this book is about.

In the following chapters you will learn:

- Which airbrush markets are the most popular and profitable
- How much money you can make with your airbrush
- How to price your airbrush designs to sell
- Where to make money using your airbrush
- How to mass-produce using speed production techniques
- How to sell your airbrush products through the mail

Each chapter gives in-depth instruction on how to successfully enter the right airbrush market for you.

Answers to Basic Questions

I have taught beginning airbrushing for ten years and have seen many students begin earning money with their airbrushes even before completing my classes. Learning to airbrush with today's modern airbrush is not difficult. Airbrushing requires only a basic working knowledge and some practice to master it.

How Much Money Can You Make as an Airbrush Artist?

The high tourist traffic on the Florida coast yields the greatest earning potential for any airbrush artist (from $400 to $750 per day), but it is also the most demanding. Because the season lasts only three months, most artists work seven days a week, then take the rest of the year off. Many artists who follow the summer season to different areas all over the world easily earn well over $100,000 per year.

But you don't have to travel to make money airbrushing. During one Christmas season I airbrushed T-shirts in the display window of an art supply store in a mall. I sold over ninety portraits on canvas and close to two hundred custom T-shirts. Though the average sale was only $25, the sheer volume of work during the six-week season generated $7,250, bringing in about $175 for a six-hour day.

Working in a shopping mall can be just as rewarding as working on the coast, and the hours are a little more reasonable. Shopping malls allow you to develop a clientele that can grow to yield as much money as the Florida tourist market, with some year-round maintenance.

The income you can earn airbrushing is up to you. Many artists work part-time; others work full-time, but only during summers or Christmas seasons. Chapters two through six in this book examine different airbrush markets—T-shirts and other clothing, canvas art and portraiture, metal and sign painting, and several small specialty markets—so you can begin to explore which one is right for you. Working in these markets will also give you the skills to launch a career in other, more competitive markets such as fine art, commercial illustration, silkscreen production, fashion design or graphic design.

Is Airbrushing Difficult to Learn?

No. The airbrush is actually a very simple tool. It is a miniature spray gun designed to blend paint simply and quickly. When you understand the basics of airbrushing you can render an image with amazing realism. For artists who find drawing difficult, the secret to success is to combine an opaque projector with the airbrush. The opaque projector projects a picture that can be traced and then painted.

I tell students that airbrushing is like driving a car: It feels very awkward at first, but with time it becomes second nature. Expecting quick success with the airbrush is a mistake. Taking the time to learn it will do for your art what the car did for personal transportation. In later chapters, I'll suggest some ways you can make money faster and easier in airbrushing.

Is It Expensive to Begin?

The equipment is cheap when compared to its earning potential. All the equipment you need to make money airbrushing costs less than $300, and you can pay for it with the income from a single day's work. One of my students, who had no previous art experience, sold his first T-shirt after only two classes. By the final class session, he had paid for his airbrush equipment and the entire course.

The customer is paying for your skill, not your equipment. I once had a humorous conversation

with a customer who wanted me to paint a picture of his car on a T-shirt.

"Wow, forty-five dollars. Why is it so expensive?" he yelped.

"It takes about thirty minutes to do," I explained.

"But that means you make ninety dollars an hour."

"Well yes, less 25 percent to the shop owner."

"That's still $67.50 per hour!"

"Right," I replied, trying to be patient.

"Well, how much does the paint cost?" he went on.

"About four cents per shirt."

"How much does your equipment cost?"

"Everything you see here cost about $300."

"And how much is the shirt?"

I braced myself for an explosion. I knew he was frustrated because he placed no value on skill. To this fellow, carving a chicken was no more difficult than open-heart surgery. "The shirt isn't included in the price I quoted."

After he'd calmed down a bit, I suggested as a joke that he rent my equipment for two dollars per hour. To my surprise, he accepted.

"Sure," he said coolly. "Anybody can do that." He managed to squirt a couple of blobs of paint before putting down the airbrush.

"I, uh, guess it's not really as easy as it looks," he mumbled as he accepted my price for the shirt.

How I Got Started

When I began airbrushing more than ten years ago, the books available at the time only taught commercial airbrushing illustration methods. I had never seen a T-shirt artist use these methods or, for that matter, even sketch out designs before painting. I soon realized I was on my own.

I landed my first airbrushing job in a small shack near the beach in Gulf Shores, Alabama, a resort town noted for a miniature golf course with thirty-foot-tall concrete dinosaurs. When I saw a classified ad for a T-shirt painter, I had three designs on fabric to use as samples. Although they didn't look like any airbrushed T-shirts I'd seen before, they were close. I packed them up along with a few good pencil drawings and paintings, then drove the fifty miles to Gulf Shores.

Tom, the shop owner, took a quick look at my art and said, "You've never done T-shirts before, have you?"

"No," I confessed.

"Look, kid, I need an experienced artist. The

three summer months go by fast, and I just don't have the time to train someone," he explained. After the interview he complimented my drawing abilities and showed me some designs done by the other artists.

"Let me borrow them just for a couple of days. There aren't any books on T-shirt painting, but I'm sure I can come up with something."

Two days later, I handed him my new samples — and he gave me the job. That summer I netted $27,000, and the next summer $35,000. I lived on a twenty-seven-foot sailboat, purchased three rental homes, and went to college in the off-season. Not bad for a twenty-year-old, self-trained airbrush artist. Mine is not a one-in-a-million success story. Hundreds of artists make a good living the same way.

There were some difficult times that first summer at Tommy's T-shirts — like the first time I ruined a shirt. There must have been fifteen people watching when I misspelled the name "Bob." I was so concerned about centering the name on the shirt that my concentration slipped, and I painted "Bod." Of all the shirts I have ever ruined, and by now there have been hundreds, that one hurt the most. Imagine fifteen people laughing and jeering, "Ha, ha, that guy can't even spell 'Bob.'"

The best defense is to know it's going to happen. The moment you ruin a shirt, get rid of it. Whip it off the board, throw it in the trash and start over. Most of the time, no one will even notice. If someone does, just casually explain that you're not a machine — if you were, you'd be making a whole lot more money stamping out bumpers for foreign cars.

This book will tell you how to handle such situations, avoid pitfalls, and become a top-earning airbrush artist. It will also show you how to enter the market at your own pace, fast or slow. Customers are out there waiting for you right now.

Start Small and Grow

The beginning airbrush artist's best approach is to start small and grow. Growing too quickly can put you out of business faster than not growing at all, because each sale costs you money and time. If you sell two hundred airbrushed T-shirts wholesale for eight dollars each and commit to delivering them in one week, you will have to paint about twenty-nine T-shirts per day for seven days. Is this possible? Also two hundred T-shirts will cost $3.50 each, or $700.00 total, meaning you must have both

$700.00 and the ability to paint twenty-nine T-shirts per day.

If you can fill the order, there will be no problems. But what if the wholesaler who normally supplies the T-shirts doesn't have half the sizes you need? You can find other suppliers to supplement the missing stock or pick up the T-shirts yourself to avoid shipping time. But these alternatives cost you more time and/or money, cutting into your profits from the shirts. The horror stories I have heard throughout my career convince me that no airbrush artist is immune from making mistakes.

To begin, just paint a few samples and show them to your friends or co-workers. Once it is known you can airbrush, requests and orders will come.

Airbrush for Free

Not charging sometimes pays. A well-placed freebie can actually generate income. For example, a friend once asked me to paint a T-shirt for the president of a car club he belonged to. It was supposed to be a gag gift, so I painted a humorous caricature of the fellow sitting in his car. Though I didn't charge my friend, I received over twenty-five orders from other club members. I quickly researched other car clubs in the area and distributed flyers to their club officers; this has become a regular source of income.

Doing free work can be a form of advertising and can be considered an advertising expense. The expenses you incur are then tax deductible. The goodwill generated throughout your community is invaluable as well.

The Basics of Marketing Your Airbrushing

To make money in the airbrush markets, you'll first need to understand what a market is. The dictionary defines market as "a meeting together of people for the purpose of trade by private purchase or sale."

"A meeting together of people" means getting your product in front of potential customers. "For the purpose of trade" requires you to ask yourself if your art is really what the public wants and to answer honestly. This is a question of both quality and subject matter. Your artwork should be attractive and well executed — something people will be proud to own or wear. Select designs appropriate to your market. Car and motorcycle designs won't sell at a dog show. A design that looks good on a T-shirt may look awful on a car and vice versa. Art created "for the purpose of trade" is commercial art designed to appeal to as many people as possible.

"By private purchase or sale" means that you're selling a product that someone else will buy. You will either sell your product directly to consumers or sell quantities of your product to retailers.

All airbrush markets share some similarities. They all require that you produce an airbrush product and sell it to a consumer. Physically, the act of airbrushing on a T-shirt is much like airbrushing on a car. Yet these markets attract customers who spend different amounts of money for different end products. Because your customers will be different, you'll need to identify and locate them, then sell to them differently. The major markets for airbrushed artwork are:

- Airbrushing T-shirts and other clothing and accessories
- Painting on canvas and doing portraits
- Custom painting vehicles and metal accessories
- Sign painting
- Glass etching
- Fingernail painting
- Cake decorating

You'll find everything you need to know about each in a chapter devoted to that market or related

markets, including: where to find customers, how to set up and earn in the most cost-effective way, and how to buy the materials you will need. Much of conducting business successfully is knowing how not to waste money, and this too is covered.

On a larger scale, knowing industry trends can also affect your chances for success. Your endeavor may be affected by such factors as competition or changes in styles or trends. For example, in the auto-painting industry, airbrush art comes into and goes out of popularity about every five years. If you lack such information, and if you can't assess current trends, you may be taken by surprise and find yourself unemployed.

Although this discussion is broken down into individual markets, you don't need to limit yourself to working in just one. In fact, it may be smarter to have more than one specialty, in case your primary market—auto painting, for example—suddenly fails to provide you with a good income.

Bob Orsolini, an airbrush artist in Belmont, California, not only paints T-shirts at his home but also plans to open an airbrush shop that offers fabric, metal and canvas painting. By covering several different markets, Bob will not be hurt if any one of the markets flattens.

To help you choose the right airbrush market, the next section examines the pros and cons and inherent variables of each airbrush market.

How to Choose Your Airbrush Market

Only you can choose the market that's right for you. People have different job-related needs and requirements. It would be difficult for me to say what is right for you because I would be basing the decision on my own needs and desires.

Young people who want to travel may choose to airbrush in the tourist markets. Other artists may have families and homes that would make traveling difficult and impractical. Then again, older retired couples may want to travel the world, too, airbrushing in different countries.

In the following section I have listed the pros and cons relating to the employment side of all the markets covered in this book. For example, is the market easy to enter? Is there potential for growth? How secure is the market?

I open each section with a brief paragraph that generally explains the economic status of each market. I recommend that you review this section before deciding which market is right for you.

Airbrushing T-Shirts and Other Clothing and Accessories

This is by far the market with the highest earnings potential. It is simple to learn, and you don't even need to know how to draw. You can work out of your house part-time, set up in a local mall, or travel the world to work in exotic tourist resorts. Start-up costs are low and mistakes are not expensive. There are many different ways to market airbrush garments, and the potential for growth is great. I recommend this market for beginners looking for a place to start or for seasoned pros looking for something new.

Pros:
- Simplest market to set up and make money
- Yields the most money of all nonprofessional airbrush markets
- Chance to travel (you can find work virtually anywhere)
- Start-up costs are low
- Good training for expansion into other commercial markets
- Can market work retail, wholesale or both

Cons:
- Difficult to establish job security (unless you own your own shop)
- Much of the high-income work is seasonal
- Long working hours during seasonal periods

Paintings on Canvas and Portraits

The key to success in this market is to paint what people want at a price they can afford and to market the paintings in a cost-effective way. All the marketing pieces have to be in place to make money. I do not recommend this market to people who have no art experience at all, because you have to paint fast to keep the prices down. If you become proficient at painting T-shirts and understand the T-shirt marketing techniques, you will be able to make a transition into this market more easily.

Pros:
- Very little competition
- Lots of distribution outlets available
- Good job security once your reputation is established
- Start-up costs are low
- Good opportunities for growth into fine art and gallery markets
- Hours are flexible

Cons:
- Advertising costs can be high
- May take some time to establish a reputation

Custom Painting Vehicles and Metal Accessories
Painting on metal requires a steady hand, but aside from that it's not much different from painting on T-shirts. You can charge top dollar for designs on metal; however, this can also make for some expensive mistakes. A working knowledge of metal paints, bodywork and surface preparation is essential. I recommend taking a general course at a local community college. Get to know your materials and get it right the first time!
Pros:
- Can be financially rewarding
- Easy to establish a reputation
- Lots of distribution outlets available
- Low advertising costs
- Good opportunities for growth in the business markets
- Good job security once your reputation is established

Cons:
- Requires knowledge of auto-painting techniques as well as airbrushing
- Can be affected by industry trends
- Mistakes can be expensive
- Paint fumes are toxic

Sign Painting
Sign painting requires you to sell your services to businesses rather than individuals. Many people don't like selling, and the other markets covered in this book require very little. You will also have to operate in a more businesslike manner; you will have to make bids, establish credit accounts, and use contracts that the other airbrushing activities don't require. This market would be good for a person seeking independence from a current job or a retired business person who knows all the aspects of selling business to business. There is a lot of work in this industry, and the pros far outweigh the cons, even for the beginner.
Pros:
- Can be quite lucrative
- Easy to establish a reputation
- Lots of distribution outlets available
- Low advertising costs
- Good opportunities for growth in the business markets
- Good job security once your reputation is established

Cons:
- Competition can affect pricing
- Requires knowledge of sign-painting techniques as well as airbrushing
- Requires working capital because many accounts are commercial
- Paint fumes are toxic

Glass Etching
This market is so new that I had difficulty finding people working in the field. In fact, the only people I did find were etching car windows in conjunction with custom metal painting. The opportunities for residential and commercial applications should eventually be great. Etching is easy to learn.
Pros:
- New market with very little competition
- Excellent add-on to an existing sign-painting or vehicle-painting business
- Low advertising costs

Cons:
- New market, so promotion may be difficult
- May take some time to establish your reputation
- Does not at this time pay enough to be your main source of income
- Cutting compound used may cause severe health problems if protective gear is not used

Fingernail Painting
This is one of the newest and fastest-growing airbrush markets. It is a perfect beginner's market. If you have a good sense of design and color usage, this is the market for you. As in the T-shirt market, start-up costs are low, and there are lots of places to set up. You can start making money in this market in just a few days.
Pros:
- Low advertising costs
- Lots of places you can work
- Very little competition
- Good job security once your reputation is established
- Good profit potential
- Low start-up costs

Cons:
- In many states you must have a manicurist's license to legally paint fingernails
- Involves setting up at multiple locations
- In some places work will be very seasonal and income uneven

Cake Decorating
Cake decorating is a simple, fun way to make money. You probably won't get rich, but you are

sure to have fun. I would almost call this a hobby rather than a market, except that I found so many people making good money doing it, I had to include it as a bona fide market. All the cake decorators I spoke with agreed on one thing: Don't expect to make a lot of money. This is a part-time, have-fun, work-when-ya-got-a-job kind of market.

Pros:
- Low advertising costs
- Very little competition
- Good job security once your reputation is established
- Low start-up costs

Cons:
- Limited demand
- Requires a flexible schedule to deliver freshest possible cake to customer
- Specific compressor filters required to meet health department regulations

Chapter Two

T-Shirts and Other Garments That Sell

*T*he airbrushed clothing market is the largest and by far the most profitable of all airbrush markets. Images can be rendered on fabric with an airbrush in a matter of minutes, so airbrushed clothing is quick and easy to produce, making the price competitive to that of "machine manufactured" clothing.

No manufacturing operation can equal the airbrush in custom designing and lettering. When a multicolored design is required, the airbrush's closest rivals, silkscreen and iron-on transfers, drop out of the competition. Adding a second, third or fourth color with the airbrush involves only changing the color jar, but adding colors to silkscreen and iron-on transfers requires involved mechanical artwork, an extra screen or printing plate, another press run and much more expense.

What You Can Paint On

Almost everything made of fabric has been painted with the airbrush at one time or another. Some items, such as T-shirts and sweatshirts, are more popular with the buying public. The most popular airbrushed clothing and other personal products are, in order of popularity:

- T-shirts
- Sweatshirts
- Hats and visors
- T-shirt dresses
- Jeans and jean jackets
- Leather jackets
- Tank tops
- Shimmels (half-length athletic shirts)
- Baseball shirts
- Tennis shoes
- Tote bags
- Key chains

T-shirts outsell all other items of clothing, ten to one, though sweatshirts can run a close second in cold weather. This is important to know when purchasing an inventory of garments. It would be expensive to stock all of the products listed above in the different colors and sizes available.

How to Buy Clothing Wholesale

You're considered a "retailer" the moment you begin selling T-shirts to the public. Retailers can buy

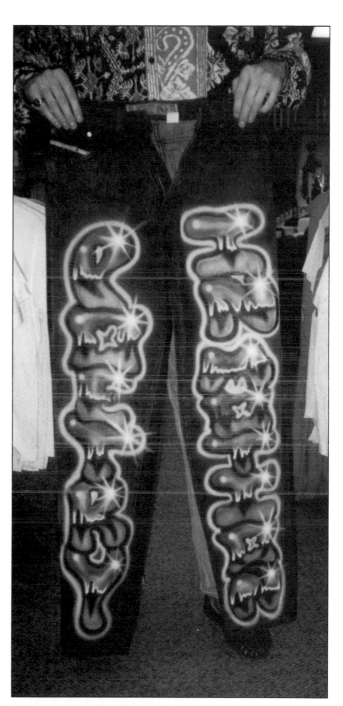

Sample of airbrushed jeans.

"blank" clothing at a discount from wholesalers, generally listed in the Yellow Pages under "T-shirts, Wholesale"; "Sportswear, Wholesale"; or "Garments, Wholesale." Most cities have local wholesalers. If you live in a small town, your local library has phone directories for larger towns listing wholesalers that sell by mail order.

Impressions magazine, the sportswear industry's trade magazine, carries an annual listing of clothing wholesalers and manufacturers. This lists every garment you could possibly want, from T-shirts to high-fashion sportswear. It also includes listings for valuable services such as silkscreen and sublimation transfers, which are discussed on page 26. I've included the names and addresses of some national wholesalers in the "Resources" section of this book to get you started.

With few exceptions, wholesalers require COD (cash on delivery), and some require payment before sending shipments. Once you've developed a good relationship with a wholesaler, your personal check might be accepted, but credit is almost unheard of in the industry. You must invest the initial capital for your start-up inventory, but you'll probably add to your inventory from later profits.

For sales tax purposes, wholesalers will need proof—a tax identification number—that you are a business. If you are a business, you are required to pay quarterly sales taxes, but you won't pay them to the wholesaler. If you don't have a tax identification number, the wholesaler will charge you sales tax. (For more on sales tax and other taxes, see pages 102-103.) One way to avoid the problem entirely is to set up with a T-shirt shop that will supply blank garments. In this way, your initial stock is provided, saving you the cost of a start-up inventory.

Purchasing Inventory

If you don't set up in a T-shirt shop that carries blank stock, there is no way to avoid the purchase of an initial inventory. The absolute minimum inventory is one dozen white extra-large T-shirts (XL) and one dozen white large T-shirts (L). Sixty-five percent of the T-shirts sold are in these two adult sizes. For two dozen white T-shirts (depending on quality), the costs break out to between $3.50 and $4.50 per T-shirt, for a total of $84 to $108.

An initial inventory to cover 95 percent of the adult buying public for the least amount of money would be eight dozen white T-shirts. That's two dozen each of extra-large (XL), large (L), and triple extra-large (XXXL) and one dozen each medium(M) and small (S) T-shirts. The XXXL sizes not only service larger people but can also be sold as T-shirt dresses or beach cover-ups. These eight dozen garments would cost between $3.50 and $4.50 per T-shirt, for a total of between $336 and $432.

This may sound like a lot of money, but if you sold all ninety-six T-shirts for only $10 each, your gross would be $960. After subtracting the cost of your T-shirts, you would have at least $528 ($960 minus $432 for the T-shirts).

Children's clothes can be a major investment, with as many as eight different sizes running from infant to youth sizes of 14-16. They're only slightly less expensive than the adult sizes. Children's clothes don't sell as well as the adult sizes because parents are cost conscious. To make money on children's clothing, keep the designs simple so you can keep the price of the art low. To lower inventory costs, carry a dozen white T-shirts in every other size, since most parents will buy the next size up.

The Kind of Shirts to Buy

You can buy adult and children's T-shirts in three basic blends:

- 50% cotton-50% polyester
- 100% cotton heavyweight
- 100% cotton regular weight

I recommend 50-50 polyester blend T-shirts because they are the least expensive, and the textile dyes used to paint them adhere better to the polyester blend. The 100 percent cotton heavyweight T-shirts are the nicest but the most expensive. The polyester T-shirts won't shrink, but they're not as comfortable as the 100 percent cotton T-shirts. The 100 percent cotton shirts breathe and won't make you sweat, but cotton shrinks. The blend and the all-cotton T-shirts sell equally well in the airbrush markets.

Artwork looks best on white fabric. Because the textile paints are transparent, they will blend with the color of the fabric. A blue paint sprayed over a yellow fabric will turn green, and a green sky can look a little silly. Colored garments will not increase your sales significantly. In fact, colored garments are only necessary if your competition offers them.

If you do stock colors, be sure to carry them in all sizes, as customers can become upset when you don't have a color in their size. Finally, avoid dark-colored garments altogether; most paints used on them will not show up. Some airbrush artists paint dark shirts using enamel paints, but this is difficult to do and often not worth the effort. Enamel paint fumes are toxic in confined areas and often turn away customers. Some textile paint manufacturers offer nontoxic opaque paints, but using them will cost you time because you will have to apply multiple coats.

Hats and visors are good sellers when offered

with custom lettering, such as free monogramming. Plastic mesh hats are known as baseball hats, while those made of fabric are called golf hats. These are very inexpensive—about $1.30 each—and can be sold for up to twelve dollars depending on the design and your location. Women prefer terry cloth visors, and these sell as well as the men's hats.

If customers request styles you don't stock, don't turn them away. Suggest a different one. Or ask the customer to purchase the item elsewhere and bring it back to be painted; this strategy has saved me many sales. If the sale is profitable enough, you can buy the clothing yourself at another retail store. This is especially easy to do at mall locations where blank garments are easily found.

The Pitfalls of Wholesale Buying

Although having enough stock on hand is extremely important, you will rarely be a high-volume buyer. Remember, your profits are in the service you provide, not in the clothing itself. Even though high-volume silkscreen printers buy T-shirts in hundred-dozen lots per size, color and style and distribute to hundreds of retail outlets, their profit can be as low as fifty cents per item of clothing. On the other hand, I painted a total of ninety T-shirts on the busiest day of my airbrush career and profited twelve hundred dollars. The silkscreener has to sell twenty-four hundred T-shirts to make the same money.

You must develop good relationships with wholesalers. Because you aren't a volume buyer, and volume buyers are the wholesaler's best friend, they will fill orders for volume buyers before yours. Many times, your friendly attitude can make the difference between a full shipment and a back order.

Here are some other tips to help you deal successfully with wholesalers.

Shop locally whenever possible. Buy from a wholesaler in your area. You may see a better price advertised by an out-of-town wholesaler, but when you add shipping costs, the savings may disappear or, if the savings are slight, the risks involved may not be worth the small amount saved. You can also save yourself some headaches by dealing with a wholesaler nearby. If you experience any problems, you can quickly correct them. Check your order on the premises so that you can exchange any damaged garments on the spot. If an order is shipped from out of town and you find it contains damaged merchandise, you will have to return the goods and wait for the replacements. You'll also have to pay for return shipping if there are any mistakes made by the wholesaler.

If you must shop out-of-town, be careful. Call the wholesaler before you order to make sure the garments you need are in stock. If possible, order with a credit card so you can secure the garments immediately. If you mail in a check and the garments are sold to someone else before your check arrives, the wholesaler will ship what he has and back order what he doesn't. This will tie up the cash you sent, forcing you to either wait for the back-ordered garments or spend more money on garments from yet another wholesaler and cancel your order with the original wholesaler to get your money back. If you don't cancel, the original wholesaler will ship you the garments he had back ordered, and you will be stuck with a double shipment. Watch out when returning garments that were back ordered; many wholesalers have a 10 percent restocking fee.

Understand wholesalers' return and exchange policies. Most wholesalers have established policies for returns, exchanges and refunds. Before doing business with one, write them for a catalogue, price list and copy of their policies. It's your responsibility to read and know what those policies are. If you don't understand something, have the wholesaler explain it to you until you do. Not reading a wholesaler's policies can cost you money. For example, many wholesalers set a thirty-day limit on returns. Miss it, and you're stuck with the merchandise. You can write letters and make angry phone calls, but when you hear the words "It's printed right in our policies," the game is up. Any dispute will have to be settled in court, and out-of-town legal action is usually not worth the aggravation and costs involved.

Have several regular sources for garments. Because more garments are sold in the summer than at any other time, virtually all wholesalers are low on stock in July and August. If you don't have a garment in a customer's size because you couldn't get it from your wholesaler, it will cost you a sale. When customers are in town for short periods, they can't wait for an order. (Year-round markets are a little more forgiving, since the customer is usually local and can wait to pick up an order.) Your only defense is to have several regular sources for garments, because finding an alternative source can take two weeks or longer, including delivery. Airbrushed clothing carries high markups—at least four to five times the cost of the shirt, plus part of the costs of paints and equipment (your overhead), and any percentage paid to a shop owner. So pay-

ing an extra dollar or two in shipping costs to an alternative supplier is better than losing a sale. Remember to cancel any back orders if you use an alternative supplier to fill out an order.

Retail Locations for Airbrushing

Painting clothing in a retail store is by far the most profitable setup for both you and the store owner. The store provides a high-traffic location for you, and you draw customers into the store. An airbrush artist is not restricted to just T-shirt shops. You can set up in almost any retail store that has foot traffic. Art supply and craft stores and small clothing boutiques work well, too. If you're visible to the passing foot traffic, you'll make money. Airbrush painting is part showmanship and always sells better when you are standing at the easel painting. People are amazed as the artwork comes alive before their eyes. Because the art sells itself, very little selling on your part is necessary. Conversations with the customers are typically short.

But if the retail store happens to be a T-shirt shop, all the better. The recent trend in T-shirt shops has been to carry only preprinted garments, yet most still carry iron-on transfers and provide iron-on lettering to customers. To do this, they have to stock blank garments, which means that you will not need to purchase any. Most towns, no matter how small, have at least one T-shirt shop, and larger towns have many.

Finding the Best Stores

Finding the right place to paint is the key to making money with the airbrush. More foot traffic in a store translates into higher dollar earnings for you. Look first at shopping areas such as malls, shopping plazas, or simply streets with lots of shops and boardwalk type areas. When the city of Gulf Shores, Alabama, did a marketing survey of its foot and street traffic, it found that over fifteen thousand people per *day* passed by the shop I worked in, either on foot or in cars. In that location, my daily income averaged over five hundred dollars. In Hanford, California, I painted in a mall where only two thousand people passed by the shop per *week* (or fewer than three hundred per day), so I earned only three hundred dollars per week.

Watch the foot traffic in and out of shops that you think would be good to set up in. Notice the foot traffic at different times—weekdays, evenings and weekends—to determine the changes in numbers of shoppers as well as the total. Generally:

- Weekdays during business hours (9:00 a.m. -
5:00 p.m.) are the slowest
- Evenings, especially early evening, are when business picks up
- Saturday and Sunday will be the store's busiest times

You can also contact wholesalers and, after explaining what you want to do, ask them which retailers buy the most T-shirts and to recommend owners who might be interested in having an airbrush artist in their stores.

Approaching an Owner

Once you've chosen the store you want to work in, your next step is to persuade the owner to let you. This is not difficult; my own experience has shown that fewer than one in ten will turn you away. Retailers are always looking for ways to make their stores unique and special, to set their stores apart from the competition. Smart owners will immediately recognize you as an asset. The key to successful selling is to know the answers to the owners' questions before they ask them. If you remove all the reasons to say no, the owner's only option is to say yes.

Go into the store where you want to work and introduce yourself to the owner. Mention right away that you are an airbrush artist, and ask these questions to determine his attitude toward having you work in his shop.

Q: Have you ever heard of an airbrush artist?

Q: Have you ever had an airbrush artist working in your shop?

Q: How did it work out for you?

The owner who has had positive experiences with airbrush artists may say, "Yes, I've had an artist working here before, and we made a lot of money, but he left. Are you looking for a place to set up?" If this is the case, he is aware of the airbrush's earning potential, and you've got the job. He may want to see some samples of your work. If the work passes inspection, you're in business.

Owners who have worked with artists before can help you immensely. They know what designs sell, how much to charge, how to display your art, and what kind of hours to keep. This information lets you get set up faster and starts the money rolling in much quicker.

If the owner has any reservations, you'll find out right away. I've had difficulty convincing owners only when they've had an airbrush artist in their shops before, and that artist left them with bad feelings. I found this a lot in Fisherman's Wharf in San Francisco. I was told, "Yes, I let an artist set

up once, and he dripped paint all over the place. It was a mess." Or "We both made a lot of money when he showed up, but he never kept regular hours." These shop owners wanted nothing more to do with airbrush. I finally found a new T-shirt shop that had never had an artist, and we did very well.

Tell the owners immediately that what you propose will not cost them any money. Store owners are constantly harassed by sales reps and will often tell you they don't have time to listen. Assure them that you are not a sales rep and that you plan to make them money. This usually gets their attention. If they still insist that they are too busy, schedule a time when you could come back. If they continually put you off, it may be a sign that their shop is not the right one.

Once you have the owner's attention, point out the advantages of having an airbrush artist in his shop:

No investment is required. You have all your own equipment, display material, and inventory. You're not looking for an investor, you're looking for a location.

Airbrushing makes the shop owner money immediately. You intend to pay for your space in the shop (in the form of a percentage of your net sales). You can be set up and making money in one day.

You will increase the store's sales. When you paint in the front window or any place visible to the foot traffic, you'll draw people into the store. Once inside, even if they don't buy your T-shirts, they may buy the shop's products. Either way, the shop owner makes money.

It costs nothing to try. Repeating your first point in this statement usually closes the deal, but if the shop owner still has reservations, suggest a trial period of thirty days.

After you have pointed out all the advantages of having an airbrush artist in the shop, the owner may still have questions. If you can answer these questions satisfactorily, you will probably have found your first location for airbrushing. Here are the questions you will most likely hear and some good answers to them.

Q: How much will this cost?

A: It won't cost you anything. Even after being told that it will cost nothing, every shop owner I've ever approached has asked this question. I don't think they really believe someone would walk into their shop and offer to make them money.

Q: You want space in the front window? The front window is the main draw for a retail shop, so

changing or modifying it will be of concern to the shop owner.

A: Everybody's fascinated by airbrushing. People will stop to watch me work and then come into the store. If the store owner still has reservations, offer to take only part of the window or ask the owner to suggest an alternative. As long as you are in view of the foot traffic, you will succeed. (If no compromise can be reached on this point, consider a different shop, because you must have exposure to heavy foot traffic to succeed.)

Q: Will it be messy? Retailers take pride in their shops. They don't want paint dripped on the floor or other merchandise damaged by carelessness.

A: No, the way I set up the display will minimize any mess. Explain what steps you can take to minimize mess and other problems. With a little forethought and organization, airbrush can be presented in an attractive manner. (See pages 17-20 for more on set-ups and displays.)

Q: What about the paint fumes?

A: Fabric paints are water-based, nontoxic and odorless.

Q: Will I be responsible for your equipment? What the shop owner is really asking is, "Who will be liable for your equipment or inventory?"

A: No, I'll be responsible for my equipment, samples and inventory. Your equipment can be packed up at the end of each work day. Your inventory represents a large investment. It would be wise to keep it locked up if the shop owner can provide space or take it with you when you leave.

Q: How much will my electric bill go up?

A: If I painted forty hours per week all month, your electric bill would increase by about seven dollars. I called my local power company and asked them how much a 1/10th horsepower air compressor would cost to run for 160 hours per month (a standard forty-hour work week). The power company based their seven dollar estimate on the number of amps the motor drew. Call your local power company and do the same. This will show the shop owner that you have done your homework and are very serious. You might mention at the same time that if you paint forty hours per week all month, the shop owner's earnings will be considerably higher than that amount.

Q: Who will provide stock?

A: I can, but if you'd like to make the markup on the garments, you can provide the stock. If the shop you're approaching already sells blank garments, you can make arrangements with the owner to sell only your art services. She will sell the garments to the customer and be responsible for main-

taining an inventory of garments. If she provides the garment, she will make the profit on the garment and a percentage of the money paid for your art services. You will lose the profit on the garment, but you won't need to maintain any inventory.

If the shop does not sell blank garments, you will most likely be responsible for providing them.

Q: How do I make money?

A: I will paint whatever customers request onto garments, charging them based on the difficulty of the design. I will pay you a percentage of that money. If you supply the garments as well as the designs, the store owner will receive a percent of this, too. Because you can mark up the T-shirts by as much as 150 percent—depending on the market—to cover the owner's percentage and make a good profit, you will make more money if you provide garments.

Q: What is my percentage?

A: I usually give owners 25 percent. Does that sound fair to you? The industry standard is 25 percent, and from my experience that seems fair. At 25 percent I feel I can make a good income and still do a good job for the customer. The owners are happy with the 25 percent and with the draw I provide for their shops.

You may want to start with a lower offer of 15 to 20 percent, leaving room to negotiate. If the shop owner thinks that's too low, remind her that this service is not costing her anything. Also, mention that the shop will earn money from the draw you create.

If the owner makes a counteroffer, increase your offer to 25 percent, but ask to be included in any store promotions. Many stores send out mailers regularly or distribute flyers, and it would cost very little to include you. If an owner wants more than 25 percent, beware. There are a lot of greedy people in business who believe that a good deal happens only when they can take advantage of someone else. Never be afraid to walk away from an offer.

After you have answered all the questions, the shop owner will become quiet. This is the moment to take charge. Assume the owner wants to do it—and ask when he'd like you to start. Nine times out of ten, he will set a date and you'll have your first location.

Working With the Owner

It's important to remember that you'll be setting up in the retailer's environment and disrupting the store's normal routine. Let the owner set the pace,

listen to her advice, and try to follow her rules. Displays will have to be moved to make space for you and your equipment. Take the time to get to know the employees and explain what you'll be doing. You don't need to go into the technical details. They only need to know that you paint designs that customers order onto a garment. Explain what role they will play in a sale and what to do when you're not in the store. Store employees can increase your income.

Be sure to have all the materials you need to set up your displays, such as hammers, nails, staple guns and tape. Try not to borrow things—you did say it wouldn't cost anything, and the shop owner will be the first to point that out.

Because a customer will occasionally ask for a refund or a redo on an order, you should work out refund and redo policies with the store owner before setting up. I will explain the policies I have developed over the years below. They seem to work well for the customer, for the shop owner and for me.

Refunds. My policy has always been that I don't give refunds. The only valid reason a customer would want a refund is if they don't like the art, so in this case I offer a redo. I would rather lose the cost of the garment than the entire sale. Most of the time, the customer will accept the original garment once he understands that I don't provide cash refunds.

Remember, customers will want refunds for many reasons other than dissatisfaction with your product. In tourist towns, people often run out of money and try to get a refund just to get some cash. I have had customers ask for a refund in malls just because they found something else they wanted to buy. Don't be afraid to take a hard line with customers; you've done your part and you should be paid.

To completely contradict myself now, I will say that I have given some refunds. These policies are not written in stone. Sometimes, when you are extremely busy, the interruption of a redo may result in delays for other customers waiting for their orders, so you would in fact be saving more money if you gave a refund on one order.

Refund policies are really insurance policies that leave you with the option of returning the money or not.

Redos. I will redo any order at my own expense if I made a mistake, but I will charge full price to redo a painting if the customer made a mistake when ordering.

Determining the Best Hours for Business

Every location is going to have busy and slow hours. It is silly for you to sit in a deserted shop. After conducting a foot traffic survey, you should have some idea of the high traffic hours. Or the owner may know the best hours for you to be there.

Once you commit to certain hours, stick to them for at least a month before making any necessary adjustments. It will take that long for word about you to spread. Nothing upsets a customer more than not finding you there during your regularly scheduled hours. This is the leading reason why airbrush artists are asked to leave a store.

Recruiting Help From the Store's Employees

The employees working in the shop can double your income if you teach them how to deliver garments and take orders for you. Once the customer selects a design from your display or brings in a photograph or drawing for a custom design, the employee writes up the order. The employee should record: the number of a stock design; whether the design goes on the front or the back of the garment; what kind of garment the customer wants, and what size. If the customer brings in a drawing or photo for a custom design, it should be placed in a bag with the garment. The employees should be sure they write down the customer's phone number so you can call the customer later to clarify any information.

Supply employees with a written price list for standard designs and a printed order form that is easy to understand. After you've worked with them for a month or two, they will develop a better understanding of what you do and may even begin pricing custom work, too. A good way to protect yourself when an employee is pricing custom work is to have her tell the customer that the price she's quoted is just an estimate and that the artist will have to approve it. This way you can telephone the customer later and negotiate a different price if the employee's quote is too low. (For more on keeping track of sales and getting paid, see pages 21-22.)

Keep in mind that if you get angry with employees for making a mistake, they will stop taking orders for you. They are not making money on the sale and would rather avoid trouble than generate income for you. Mistakes in the other direction happen, too. At times, employees have charged prices much higher than I would ever charge.

If the employees like and respect you, they will do anything they can to help you. I have tried offering a commission, but it has never increased sales; on the contrary, it created problems. Employees may fight over who saw which customer first, or customers may inquire about airbrushing with one employee and return later to place an order with a different employee. A policy that works well for me is to offer artwork at half price to every employee all the time. By charging them something, you won't be inundated with their work, and at the same time they'll appreciate the good discount.

Displaying Your Work

Displaying your artwork is the only way to show the public what you can paint. A well-designed display reflects your abilities as an artist and attracts customers. A display must also be neat and attractive, because customers may not even stop to ask about your art if your display is sloppy and unkempt.

The standard display and airbrush work area will include:

Designs. Designs are samples of your work. You can display standard designs that you will duplicate for customers or create custom work that they request. Stock designs are usually painted on pieces of fabric and stretched over a square foot of cardboard. Custom work is displayed on the actual garment to give the full effect of the finished product.

Designs are usually displayed on a wall behind you as you work at the easel. On occasion you may find yourself setting up in the center of a store where you have no wall to hang your designs on. In these cases you can build a freestanding sandwich board, hang a board from the ceiling, or use inexpensive display easels to display your work.

Signs. No matter how obviously your display seems to say what you do, add a sign that reads: ANYTHING YOU WANT PAINTED ON A T-SHIRT, SWEATSHIRT OR CANVAS (if applicable). I believe there are some people that have very literal minds; unless you put it in writing, they won't understand what you do. For these people I would also include a sign that lists the most popular designs that are asked for: CARS, MOTORCYCLES, PETS, PORTRAITS, etc.

You should also have a sign that says who you are and what you do: for example, CUSTOM AIRBRUSH, BY JOSEPH B. SANCHEZ. Post small signs on each of your designs with a price and a number so the employees can take orders for you.

The Best-Paying Subjects to Paint

The following list of the top ten best-selling images is based on interviews with airbrush artists from all over the country. They are listed in order of popularity, with the highest-earning first. I don't know what makes them so popular: There are as many theories about what makes a design sell as there are artists.

Top-Selling Images
1. Vehicles: Cars, motorcycles and boats.
2. Pets: Dogs, cats and horses.
3. Portraits: Boy/girlfriends, wives, babies.
4. Custom: Company or club logos, local subjects.
5. Music: Album covers, band logos.
6. Fads: These change constantly and depend on where you are. For example, as of this writing, the hot trend here in California is to paint names and cartoons on jeans and overalls.
7. Cartoons: Popular cartoon characters you have permission to use and your own custom creations.
8. Local Interest: Beach scenes, windsurfers, snow skiers.
9. Lettering: Names, lettering mixed with designs.
10. Biker Designs: Skulls, grim reapers, and other popular grisly designs.

This list may help you choose the designs for your display. Cars, pets and portraits are sure to generate sales in any general market. If you are planning to enter specialized markets, such as pet shows or car shows, you need to paint only variations of one category. Remember, if you want to use a design or image to which someone else holds the copyright (such as a cartoon character or an album cover), you must get permission.

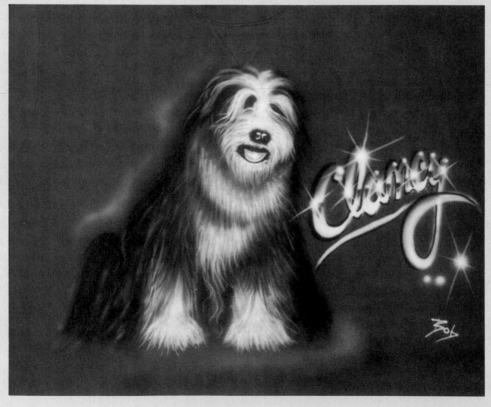

Typical design for a pet owner.

Photographs. Most artists also provide a photo album that the customers can look at and see samples of other custom work the artist has done. I highly recommend this to everyone. It is a great sales tool and will earn you a lot of money.

Hardware. The standard airbrush display will also include an easel, a chair, a storage box that can be locked, something to cover the floor, a table for paints, and the photo album.

The storage box usually houses spare parts, extra

paint, and the air compressor. This is often useful as a table, too. The storage box can be eliminated if the shop owner will give you a little space in the back storage area of the store. An air hose can also be routed from the back of the store to eliminate the noise created by the compressor.

Designing the Display

Always consider your surroundings when designing your display. Make sure it goes with the store's decor. For example, to match a shop that has a Hawaiian decor with lots of plants, floral designs and unfinished wood, use greens and browns around the borders of your designs and in the lettering of your signage. If you need to buy an easel anyway, a wooden easel complements a Hawaiian decor better than high-tech chrome.

Because each situation is different, it is difficult to explain in detail exactly how to design your display. Be prepared for any contingency. Here is a list of materials you'll find handy. Besides a general toolbox with screwdriver, hammer, pliers and the like, you should have:

- Extra fabric (for reworking designs in your spare time)
- Tacks
- Tape
- Scissors
- Fishing line (to display shirts so they look as though they're floating)
- Small finishing nails
- Tabletop easel(s)
- Poster board (for signage)

Most of the time you will have a wall and floor to work with. Let's consider the wall first.

If the wall is smooth, you can easily attach your designs directly to it using double-stick tape to avoid damaging the store wall. When the wall is textured or unevenly paneled, you'll need to cover it with a smooth surface that's easy to hang art on. Styrofoam is good because it's cheap and easy to install with the spongy kind of double-stick tape. You can paint it, cut it with a hot knife, and arrange your displays on it with straight pins. Styrofoam can be bought in sheets from commercial building

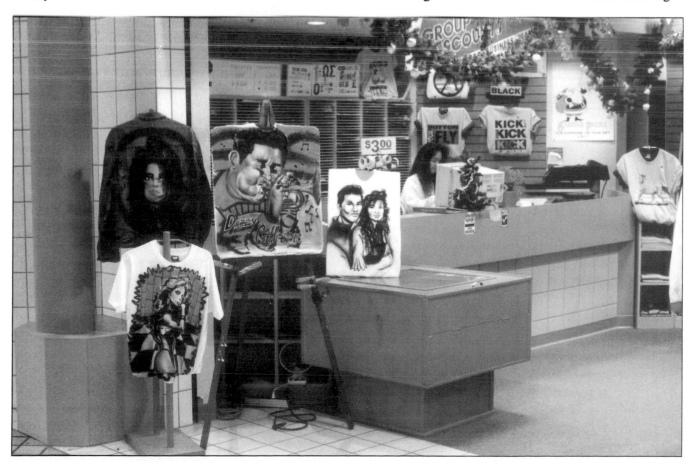

Airbrush artist's display in a T-shirt shop.

contractors' supply stores. Check the listing under "insulation" in the Yellow Pages for other sources.

If you see carpet on the floor, *cover it*. The quickest way to upset a shop owner is to spill paint on expensive carpet. In fact, it's a good idea to cover any flooring to protect against spills. Any carpet or linoleum remnant will do, but keep the store's decor in mind when you pick out a floor covering. Try to maintain the integrity of your surroundings.

Once the floor and wall are ready, paint your designs. For display designs, most airbrush artists use a 1-foot square piece of bright, white fabric, available at any fabric store. Any thick cotton will work. Remember to assign each design a unique number to identify it on orders and put a small sign showing that number on a corner of the design. When creating the artwork for a display, don't get carried away and end up with a design that cannot be produced in a reasonable amount of time for a reasonable price. When airbrushing, you will have to compromise quality when you are not being paid for quality. I know this sounds harsh, but it is a fact: You cannot allot the same amount of time to a ten-dollar design that you would a fifty-dollar design. Only you can control this, and you will have to know when to stop working on a design. If you don't, you will be losing time that you could spend making money on other designs.

On the other hand, the customer will be dissatisfied if your display designs look better than the actual artwork you produce for them. Ideally, the customers' artwork should always look better than the samples on the wall. To insure this, make your displays a little simpler than the actual finished paintings.

Remember that the designs in the center of the display, at the customer's eye level, are seen first and sell best. Try not to place the designs more than three feet above or two feet below eye level. Also, displaying more designs is not necessarily better. More can sometimes lead to confusion by simply overwhelming the customer. The customer will want to look at every design to make sure he chooses the right one; if there are too many designs to examine at a glance, he may give up and walk away. I have displayed as many as thirty or forty designs on one wall, but my sales did not increase significantly over those from previous displays of only ten to twenty designs.

Organize your design display. The most financially and aesthetically successful arrangement is to stack your painted designs in vertical and horizontal rows. You can also group different styles into such categories as lettering, stock designs, music and custom artwork.

Change your designs frequently. Most retailers recommend replacing the design that moves the slowest—some designs will not be as popular as others. Always dedicate a corner of your display to fads and new ideas to keep your display looking fresh and generate new customers who were not interested in the previous display.

If you intend to offer custom work, you'll need a photo album. Seeing an actual photograph of other customers' orders puts the fear of poor quality to rest and makes it easier to close sales. I use a 35mm camera with a 50mm lens, but a good quality Polaroid is also adequate. With a Polaroid camera, however, you won't have negatives for reprints. If a picture is lost or damaged, it cannot be replaced.

If you want to be fancy you can display your photo album on a podium. Use a heavyweight music stand or build something yourself. Displaying your photo album, no matter what the cost, will more than return your investment.

Pricing Your Art

In the late 1970s, when I first started airbrushing, I priced my art at $60 per hour. In the tourist towns a $10 beach scene would take ten minutes to paint. Over the years I have not increased my dollar-per-minute figure because my speed has increased. What used to take ten minutes now takes five, and I am effectively earning $120 per hour.

The thing to keep in mind when pricing your designs is how much the customer is willing to pay. You will sell more three-dollar designs than fifty-dollar designs, so you will want to offer designs that cover a range of prices, all based on a dollar per minute.

If you are just starting, you may want to start your pricing at fifty cents per minute, or even twenty-five cents—just to get some sales rolling in. As your speed increases, so will your income. The industry standard is a dollar a minute. As you become experienced you may even increase this.

Keep in mind that the first time you create a design it may take thirty minutes to do, but after you've painted it ten or fifteen times, it may only take five or ten minutes to paint. Your pricing should reflect the faster time; otherwise you are asking the customer to pay for your learning curve. You will become adept at pricing as you gain experience.

Keeping Track of Sales and Getting Paid

You are the only person who will keep track of your sales. Most businesses have systems that track a product from the moment it comes in the door until it is delivered and payment is collected. Develop a similar system and put it in place to keep disputes about money to a minimum.

Store owners will expect you to know how to keep track of airbrush sales. Because you've offered a percentage of your sales, a store owner will want an accurate system to keep track of how much you earn. You, in turn, will want a system you can use to check the store owner's totals. Customers will also want receipts, since they must prepay any airbrush orders.

I have developed a tracking system that relies on a three-part carbonless receipt book. The receipt pad produces three duplicate, numbered copies and usually contains fifty sets of receipts. You can purchase this receipt pad at most office supply stores. Let's start at the beginning and take it one step at a time.

Step One: Taking the Order

The customer agrees to buy one of your designs. After negotiating a price, write the order down on the three-part receipt form. Get the customer's name, address and phone number, in case you have forgotten anything. Always check the spelling of names.

Write down the garment type, size and color, if applicable. If you are supplying the garment, help your customer make her choices at this point in the sale. If the store's employees will be selling the T-shirt, have someone help the customer now. List what goes on the front and the back of the shirt, identifying a stock design by the number you have given it. Customers often request a name on the back and a picture on the front. Trusting your memory can be very risky, especially when you have many orders. (One or two redos will cure any artist of carelessness.) To avoid any spelling discrepancies, have the customer write out any lettering included with the artwork. If she has any questions once the artwork has been painted, you can show her her own handwritten request. For safekeeping, put any picture, garment, or other item the customer brings in for you to use in creating a custom design into a bag with the shirt and a copy of the order.

Once the order is written, the customer must initial the order to establish that a formal agree-

Invoice.

ment has been made. Keep the top copy of the order (receipt) form and give the two duplicates to the customer. Direct him or her to the counter clerk, who will ring up the order.

Step Two: Ringing the Sale at the Cash Register

The customer now goes to the cash register with his two copies of the receipt. Once in a great while, a customer disappears between you and the cash register; however, this occurs infrequently. If a customer places an order, he usually follows through.

The store owner or an employee calculates the sales tax, rings up the sale, and places one of the customer's receipts in the cash register. Since airbrush artwork is a service rather than a product, it may not be taxed in many states. Then tax will only be charged on the shirt itself. (See pages 102-103 for more on taxes.) In either case, the owner may assign a specific cash register key for your product or find some other way to keep your sales separate.

T-shirt painted from a reference photo.

The customer's remaining order receipt copy is stapled to the cash register receipt. The customer should be told that this receipt is necessary to redeem the finished garment. Now the shop owner has a copy of the order, the customer has a copy, and so do you. Congratulations! Now, both you and the shop owner have a way to check the airbrush totals. This leads to the final step.

Step Three: Totaling Tickets
Once a week, sit down with the shop owner to total the tickets. There will be no problems as long as the tickets match, and speaking from experience, tickets do get lost. Since the only tickets you'll be paid for are those that have made it into the cash register, be prepared to prove that you did the work your tickets say you did with the customer's copy of the receipt. When the customer returns to pick up the order, collect his order copy and the sales receipt. If the customer needs a receipt, write one from your own pad.

Once the tickets have been totaled, the owner deducts her percentage from your sales and pays the balance owed you. Always check the totals and the percentage deducted. It is not a question of trust; rather, you are acknowledging that it is human nature to make mistakes.

This system has worked well for me. You may want to adopt it yourself, modify it, or develop your own. Whatever you do, make sure it works smoothly. Anything that doesn't go smoothly may prompt the owner to change her mind about letting you set up in her shop.

Tools and Materials

You need the right tools and materials to make money airbrushing. The following is a brief listing of the items you'll need to airbrush T-shirts and other garments and of what they're used for. I mention brand names only when there is no other brand on the market or when no other available brands serve the purpose as well.

Airbrushes
The standard airbrush used throughout the hand-painted fashion industry has always been the Paasche, specifically the Paasche VL series. The VL accommodates three different tips and needles that produce three different spray widths. The VL-1 sprays the finest, the VL-3 produces a medium spray, and the VL-5 sprays the heaviest. Though all the Paasche airbrushes are solid performers, the Paasche VL is very durable and consistent. The less downtime, the more money you will make.

I have taught airbrushing for several years and have noticed that students who choose a brand of airbrush other than the Paasche VL always have more difficulty learning. In fact, the few times I have seen an airbrush artist use some other airbrush, they have spent twice as much time cleaning and adjusting their airbrushes.

I am not discounting other airbrushes, but most are designed for detailed illustration work. These finer airbrushes clog more easily, require more adjustment, and are less durable. Many artists, including me, have different brands of airbrushes specifically for detailing fabric or illustrations. I currently use an Aztek airbrush for all my illustration and fine detail work. Paasche, Thayer-Chandler and Iwata also make fine detail airbrushes. The airbrush industry is constantly introducing new products, so always be ready to try new equipment. *Airbrush Action* magazine is an excellent source for finding out about new airbrushes, accessories and paints.

Textile Paints
Though some artists may disagree with me, I have found very little difference between textile paint brands. I find them all about the same in quality, durability and ease of use.

The greatest variable lies with the artists who use the paints. Some paints come from the factory labeled "ready to use," meaning they are pre-thinned. I find this difficult to believe because the factory doesn't know what kind of airbrush you are using or how much air pressure you're working with. Both factors have a bearing on paint flow. My preference is to buy the thickest paint I can so I can thin it and get the best value for my dollar.

All that aside, there is one sure way to get the maximum performance out of any paint: Mix your paints as thin as possible. Thin paints don't appear any lighter on the fabric than thick. Thin paints also allow a finer line to be sprayed through finer tips with minimal air pressure, and the paint won't dry on your tip as often.

The best way to thin your paints is to overthin them until the water in the paint is drawn out into the fabric, much like catsup on a napkin, then add the thick paint until the water absorption stops. This will leave your paints at their thinnest.

The only paint you can't thin to the maximum is white. White is used last on a painting to add highlights and must be run as thick as possible in order to cover. If you develop a painting technique where you paint around highlights and let the white of the garment fabric show through as a highlight, you can avoid using white altogether. This will save time and money.

Besides white you should have black, a transparent stop-sign red, canary yellow and sea blue. These colors will combine to mix most of the other colors in the spectrum. Use your black for line work and for toning the colors and the white of the fabric for highlighting.

Proper color usage can save you a lot of time and money. If you take a moment to analyze the painting you are about to work on, you can get by with using only these three colors.

For example, when I painted the sky blue in a beach scene, I also painted the leaves of the palm tree blue. Later, when I painted the sun with yellow, I passed over the leaves again with the yellow, which turned them green. This meant I didn't have to change to a green color jar, which would have taken longer, nor did I even have a green color jar. This is especially helpful when mixing a brown, which requires all three primary colors. Developing this technique also lets you mix custom colors for each painting. You will have to experiment to develop a feel for color blending, and in the meantime you can use premixed colors.

Accessories

You may want some of these accessories to make your airbrush business run more smoothly:

Fishing tackle box. Great for carrying all your airbrush equipment.

10-foot hose. Makes moving around a lot easier.

In-line water trap. Catches any moisture that forms in your airbrush hose. Water that condenses and gathers in the hose can spray onto the garment and cause the paint to spread uncontrollably, ruining the garment.

Mounting stand. Attaches to an easel or table and holds your airbrush. A dropped airbrush is the leading cause of bent needles or torn tips. It doesn't happen often, but dropping an airbrush can bend the joint where the head assembly joins the body, and the airbrush will never spray correctly again.

Portable easel. Lightweight and easy to set up. This is especially important when doing location painting. These easels are handy when working away from the studio—for example, during the Christmas season, a one- or two-day demo at an art store, or when teaching a class. I have found that two easels are essential when doing seasonal work. Orders taken during the day can be drawn in the studio at night, where the opaque projectors can be used. Without two easels, you would need to transport your only easel every day between the location and the home studio.

Polaroid camera. Handy to have around, especially on location. If someone orders a portrait, you can photograph them right away. Quite often, a customer wants a picture of a custom car painted on a garment, and it is no problem to take a quick picture that you can later use with the opaque projector. Of course, remember to charge for this exclusive service.

Spares. Always have the right backup equipment. If you paint on location with only one airbrush and something breaks on that airbrush, you are out of business until the part is replaced. This can cost you a lot of money or, worse, you may be replaced by another artist. The following parts break or wear out often; you should have spares on hand:

- Tips and needles
- Bushings
- Trigger lever
- Color jars
- Compressor

Studio Accessories

If you plan to set up a home studio, some of these accessories may help you become more efficient. The following sections list equipment you will find in studios of artists who make a living from hand-painted garments. If you plan to be competitive in the marketplace, you may want to invest in this equipment, too.

Opaque projector. This machine allows you to project any picture, photograph, or printed material directly onto any surface. This means you can copy a company's logo onto shirts for employees or combine elements from a couple of sources onto a garment. You can also draw your design on paper to get it perfect and then project it onto the garment. By moving the projector closer to or farther from the surface, you can adjust the image size. Once you've sketched the outline you're ready to paint.

The opaque projector is not a slide projector and doesn't require a camera or film processing. You can use any reflective art that will fit on the copy board. The price of the opaque projector depends on the size of the copy board. I purchased one of the least expensive models for about $150, and it came with a 5 × 7-inch copy board. The units with 8½ × 11-inch copy boards start at about $350. But you can get by with a less expensive model if you have access to a reducing copy machine. Then, no matter what the size of the original, you can photocopy it to a size that the opaque projector will accommodate.

Many airbrush artists use an opaque projector to speed up the painting. The more paintings they can produce, the more money they can make. But other artists say that, by using the projector, you are cheating because you are copying rather than creating.

35mm camera. You'll want to photograph your artwork as soon as you finish it, so you'll have good photographs of your custom work to show prospective customers and slides for submissions to shows and fairs. Once the customer has picked up a garment, it is difficult to arrange a photo session. I recommend a 35mm camera because the negatives can be reprinted and sized to your specific requirements. To save money, I only develop the film into negatives before choosing which negatives to print.

A camera can also assist you in creating designs. You can project your pictures onto a garment with the opaque projector and then paint them creatively. The artist who wants to create high-end garments may find this useful. This technique would not be cost effective for doing location work because each garment would take too long to produce. You would have to charge more than the typical customer would pay.

Studio easel. An easel is an essential piece of equipment if you plan to do high-quality custom artwork. A high-quality heavyweight easel holds your garments still while you paint details or trace an image from the opaque projector. A good easel lets you easily adjust the vertical and horizontal position of your painting so you can work comfortably. Many artists underestimate the importance of this and strain to reach the hard-to-get places of a painting. This strain is obvious and affects the painting.

Foamcore board. This board is really a sheet of Styrofoam with a low-acid paperboard laminated on both sides. It can be used for a variety of purposes, but was designed as a backing for artwork when framing. I use foamcore as a board to stretch garments over for painting. It is lightweight and inexpensive, about three dollars for a half-inch-thick sheet. I use several board sizes for different sized shirts, and I find that the lightweight board is less cumbersome than wood or pressboard. I have seen a lot of damage caused when an easel with a heavy wooden board is knocked over.

Clamps. Clamps grab the edges of a garment and hold it in a taut, smooth position while you paint. Once a garment is stretched over a piece of foam core, the sides can be clamped close to the bottom of the board, thus smoothing out the garment. If the garment is not smooth against the backing board, the wrinkles will catch the paint overspray.

Spray adhesive. A light coat on your backing board holds a garment snugly and allows you to draw easily with soft lead pencils. One shot of the adhesive lasts for several T-shirts, so don't overuse it. Spray mount is also good for holding temporary stencils in position. Repeated use on a stencil is not recommended because dust and debris will also stick to the stencil.

Because there are many brands of spray adhesives that can really damage your art or garments, I recommend 3M's Spray Mount Artist's Adhesive, product number 6065. Some other brands are so strong that they have permanently glued stencils to T-shirts or T-shirts to backing boards. Remember: Test before you invest. Never use new products on artwork in progress. Try anything new on a rag before using it on your artwork.

Spray adhesives are extremely flammable and the vapors are very toxic. *Don't* use spray adhesives indoors. If used indoors, everything in your work area will soon feel as if it were upholstered with fly

paper. *Don't* use it while standing downwind. It is important not to breathe this stuff even when outside, so I wear a breathing filter whenever I use spray adhesive. Once it is sprayed onto a surface, it is safe.

Drawing table. A good table provides a comfortable place where you can develop your designs. Comfort is often overlooked and sacrificed by new designers. When an artist is uncomfortable, it is invariably reflected in the artwork.

Soft lead drawing pencils. These, especially the #3B, #4B and #5B, work well on fabric. The soft lead transfers easily and doesn't pull the fabric. A hard lead pencil, such as a standard #2, may catch on the fabric, pull threads, and in some cases, the material may tear. Small, obvious holes in the T-shirts result in unsalable products.

Low-tack tape. This tape is handy to have around for a quick, straight stencil or when you need to hang a sign. I recommend low-tack over high-tack tape because the high-tack sometimes pulls the fabric of a garment and changes the texture underneath the tape. Though this disappears after the garment is washed, it looks funny to the customer when the garment is picked up.

Double-stick tape. Double-stick is used to hold stencils that are in a negative space. If you want to block out the color in one area of a T-shirt—to create a bright white sun in a beach scene, for example—a paper circle backed with a piece of double-stick can be taped to the garment.

Rulers. These are handy when you need a straight edge or when using linear perspective drawing techniques.

X-Acto knife and blades. The X-Acto knife is the machete of the art world jungle. You can use it as a cleaning tool for your airbrush or for cutting stencils. It slices through plastic garment tags or broken fingernails that keep snagging T-shirts. You can chase off irate customers with it or play darts during slow times. It's a handy-dandy tool. I recommend the #11 blades.

Speed Production Techniques for Clothing

This section describes some techniques used by top-earning airbrush artists to speed up their work and thereby increase their income. Some of these techniques are simple and some are difficult, but you will find them very profitable if you take the time to learn and implement them.

Blend color directly on the clothes. All the colors of the rainbow are made from the three primary colors: red, yellow, and blue. The three primary colors, when applied in the right densities, produce greens, oranges, purples and browns directly on the garment. This saves time because you don't have to clean out your airbrush or attach another color jar to apply these colors. The only faster way is to have an airbrush reserved for each color.

Use an airbrush for every color. Using an airbrush for each color requires more of an investment, but you save an immense amount of time by not having to wash out colors between uses. The cost of each additional airbrush is about sixty-five dollars. The hose and water trap add about twenty dollars. When I painted many T-shirts per day, I used five airbrushes. One airbrush was for black and three more were used for the primary mixing colors: red, yellow, and blue. The fifth airbrush was reserved either for replacing a clogged airbrush or for holding some specialty color such as purple, violet, or one of an assortment of Day-Glo colors. In high-volume tourist locations, I have used as many as twelve airbrushes.

Create designs you can paint quickly. Designs don't have to be difficult to be good. One way to increase your productivity is to keep designs simple and easy to paint. If the design takes a long time to develop, it will probably take a long time to paint. Designs with cars and animals that require intense drawing effort always take longer to reproduce than landscapes and beach scenes, which are more of a freestyle type of art. Beach scenes are one of the easiest and fastest designs to paint and are largely responsible for the large incomes to be earned in the tourist towns.

Paint freehand and avoid stencils. Avoid using stencils whenever you can to save time painting. Stencils are time-consuming to make and difficult to keep clean. Most artists who insist on using stencils seem to spend more time looking for the right stencil than painting. If you have ten designs with an average of three stencils per design, there are thirty different stencils to keep track of. In a fast-paced environment, this leads to disaster.

That doesn't mean you can't use a straightedge to make a water line in a beach scene or the bottom of a paint jar to make the circle for a sun. It is just the overuse of stencils that leads to problems.

Put one garment over another. This simple technique is especially useful when you have an order for several T-shirts with the same design. (This technique only works with garments that have a thin weave; it will not work with sweatshirts.) Pull one T-shirt over your backing board and smooth it out. Then pull a second T-shirt over the one you

just put on the board. When you paint the design on the top shirt, some of the paint will pass through to the T-shirt underneath. This leaves a ghost image of the design on the second T-shirt that can be used as a template. This eliminates the need to draw the design on the second T-shirt.

By placing a fresh blank T-shirt under the one with the ghost image each time you paint, you can repeat this process. I once produced fifteen T-shirts for a squadron of Navy pilots this way. Be careful not to drift away from your original design. It's easy to lose details with this technique, so check all the shirts against the original before you remove them from the board. Don't move either T-shirt once you start painting.

Combine airbrush with sublimation transfers and silkscreen. This technique is most useful for artists who produce large volumes for wholesale or consignment sales. If you are going to stock a certain design for months or even years, you can have transfers made. The transfers save drawing time. There are two ways to do this: using sublimation transfers or silkscreen methods.

Sublimation transfers are inexpensive T-shirt transfers. The transfer ink turns into a gas when heated and becomes hard when it cools. These transfers don't really have the opacity of silkscreen; this is their primary asset for the airbrush artist. Because the transfer leaves very little ink on the garment, it is unnoticeable when covered with airbrush paint. You can iron an image onto a garment, trace over it, then add colors with the airbrush. The finished product is indistinguishable from any other airbrush art.

When you use silkscreen with this technique, however, it will be obvious to customers that you have mixed the two different mediums. Silkscreen ink is applied heavily and has a different texture from airbrush ink. This technique can be used to keep the price of your garments very low.

The artist either has silkscreen transfers made and irons them onto the garments himself, or he has the garments screened directly. I recommend that anyone interested in this technique silkscreen the garments directly; the designs will hold up better. Besides, silkscreen transfers are hard to store.

Once the garments have been silkscreened, the artist applies the color and shading detail with the airbrush. The airbrush creates gray values with ease, and when a different airbrush is used for colors, the application of color is quick, too. When the airbrush is used to complete and accentuate a silkscreened image on a garment, the finished product can be quite dramatic.

Artist Spotlight: Greg Terrell

Greg Terrell is an airbrush artist who owns and operates a successful T-shirt shop in Daytona Beach, Florida, part of the "Gold Coast" region. Greg earns the bulk of his annual income—in the mid-forties range—during the peak summer tourist months of June, July and August, the season that has earned the region its name.

According to Greg, a good airbrush artist who paints fast can earn as much as a couple hundred dollars a day during the peak season. Greg keeps up with the high volume of demand at his shop, Art Reflections, filling all the airbrush orders himself. He does hire a counter clerk to take orders, stock the shelves with garments, and ring up sales.

Educating the customer on the uniqueness of airbrush garments is critical to sales. Greg says it's necessary to sell potential customers on the special, one-of-a-kind nature of airbrushed items. He can't hope to compete with the low cost and wide availability of silkscreened products, but his garments are original and personalized works of art. He finds it invaluable to show potential customers a photo album that shows the scope and quality of his work.

Greg relies on word-of-mouth to expand his business. He says, "Never underestimate the value of a happy customer to generate multiple sales. And remember that one unhappy customer can cost you more than that one sale." Location is also important. His shop in Daytona Beach puts his work in front of a steady flow of tourist traffic. And he doesn't have too many competitors. Greg

feels that "airbrush artists too often fail because they've opened [their shops] in areas that are already oversaturated with airbrush shops."

Despite his warnings about the dangers of competition, Greg believes that shop ownership is the ticket to large profits. "The drawback to working for someone else," he says, "is splitting profit." Also splitting hours in the peak season with other artists or working in shifts provides less profit for the individual airbrush artist.

Greg knows what he's talking about. He first saw the income potential of the airbrush at a summer job in a gift shop. When he graduated from the Wrigley School of Art, he accepted a position as a graphic designer in a silkscreen studio and began working as an airbrush artist at a mall in Fort Myers, Florida, to earn extra money. Greg says, "Right away I earned more money working at the mall as an airbrush artist than I ever would have as a traditional graphic designer." The answer was clear: Airbrushing would be the path to Greg's future success. He began saving money to open his own shop. After two-and-a-half years at the mall, Greg moved to Daytona Beach where he opened the airbrush business he owns today.

To maintain a steady, year-round flow of income, Greg keeps a loyal following of local customers supplied with airbrush garments. He participates in such events as the "Daytona Bike Week," during which motorcycle enthusiasts from as far away as Canada take part in parades. During this event, Greg offers airbrushed garments that reflect the biking enthusiasts' pride in their unique motorcycles.

Greg also teaches airbrush classes at a nearby college. He believes that airbrushing is easy to learn,

given the right artistic aptitude. For students with a basic understanding of drawing and shading, it's just a matter of practicing to learn the airbrush. Because there were no airbrush classes offered when Greg began airbrushing, he read several books on the subject and learned as much as he could from other airbrush artists. Now he's passing his knowledge on to others.

Chapter Three

Increasing Your Sales of T-Shirts

Although most T-shirt painters start out painting in a T-shirt shop or other retail store, there are other outlets for your work. Instead of working in a retail store, some T-shirt artists choose to work art fairs and shows, traveling across the country annually. Selling by direct mail—taking out an ad in a publication and soliciting orders through the mail—has been very successful for many T-shirt painters. It's a good way to sell your T-shirts or simply to expand your customer base, especially if you have mostly seasonal work.

In addition to selling your garments directly to a consumer, you can sell them to retail stores. The stores will then sell those garments to their customers. Or you can place your garments in stores on a consignment basis, getting paid only after the T-shirts have been sold. You can also hire sales representatives to expand your retail customer base.

If you don't find any of these alternatives to painting in a retail store attractive but still want to increase your income, you can travel. Many T-shirt painters work the summer tourist season in one area and then move to a ski resort or set up in a mall during the winter.

Let's look in detail at each of these outlets for selling your garments.

Fairs and Art Shows

I find that fairs and art shows are one of the most enjoyable ways to promote airbrush. These events are frequently held in parks or areas with beautiful surroundings, and the festive atmosphere is upbeat. Many artists travel the art fair and show circuit year-round. Some are retired people supplementing their income. Other artists aggressively market their art and make a living from the shows. Some just attend local shows to promote their reputations in that area. Whether you work them full- or part-time, art shows can be fun if you want to show your art and also earn some money.

Finding good shows and fairs in your area is simple—just ask someone who has been selling art at the shows. At local shows ask several different artists whose artwork is similar to yours which shows they recommend. Their art doesn't have to be exactly like yours, but it would be helpful if they paint similar images. Their market should definitely be the same, however—you won't sell many T-shirts targeted to a low-end market at an upscale show or fair, or vice versa.

Many art magazines publish a list of shows in the classified section. These listings provide addresses where you can write for applications and entrance requirements. They also inform you if the show is juried or not. Juried shows require that you send in slides of your art to the show's review committee, which decides if you will be accepted to the show. Most art fairs and shows are family affairs, and inappropriate or pornographic art is not allowed. If your art is generally good—you demonstrate a basic understanding of your medium and your designs are pleasing to the eye—your chances of being accepted are good.

Show promoters earn their money by renting space to artists, so every artist rejected means less money. A show with a reputation for making artists money and selling out space well in advance will, however, be very competitive. In this case, send a few slides of your best art rather than a volume of samples. The promoters are looking for quality rather than quantity.

Sometimes show promoters also ask to see the actual rack display system you plan to use to hang your art at the show. At well-established shows, the promoters want the presentation of the art to look as nice as the art itself. These hanging systems can be purchased or you can build them yourself. The prefabricated displays are designed to store easily in a minimal amount of space and set up with minimum effort. Prefabricated displays often come with a choice of accessories, such as matching lighting assemblies and signage. If you plan to build your own, it would be wise to look at the different models offered so you can find out all the available features. Lighting is important because many shows are held at night, and commercial electrical codes are enforced.

For the best-priced hanger systems designed specifically for displaying art at shows, check the mail-order section of national art magazines. They can also be ordered through most art stores, but because they are not a fast-moving item, don't expect them to be in stock.

Entrance Fees, Travel Expenses and Inventory
Once you have been accepted for a show, you will be expected to pay the entrance fee. The entrance fee is usually requested at the time you send in your slides and is refunded if your slides are rejected. Entrance fees vary from about $25 to $1000, depending on how successful the shows have been

for the artists in terms of earning power. A high fee does not guarantee that you will make money, only that many artists have. But as a general rule, shows that are expensive to enter usually do draw spending crowds.

The entrance fee doesn't entitle you to a choice location in the show. Many artists have paid large entrance fees, only to find they've been placed at the end of an aisle where few show patrons ever walk. The promoters try to arrange the artists' spaces in such a way that every artist — in theory — will have good exposure, but in practice, this is close to impossible. Usually, when you are accepted into a show, the promoters send you an acceptance letter and a map of the show's layout and your place in it.

It's difficult to tell, just from the layout map, whether you will have good or bad exposure. The general rule for promoters is to place the artists who have been attending the show the longest in the best spots. If you are new to the circuit this may seem unfair, but in truth, there is no other way. If you enter the show market, it is wise to understand this. It doesn't mean you won't earn anything at the shows; rather, you will have to attend the same show for several years to maximize the return on your investment. The show and fair market is a long-term investment. It takes several years to get to know which shows pay and to establish your seniority within the system.

Your travel expenses are often more than the amount you'll pay the promoter for display space. When you travel out of town, you must consider hotel, vehicle, and gas expenses. Book your hotel room before you leave so you can set up your display immediately after you check in. Many show promoters have established strict set-up and break-down times. By arranging lodging early, your schedule will be more flexible. Good planning makes for a smooth and profitable trip.

People who regularly work the fair and show circuit may travel in a van or motorhome. This lowers travel expenses and offers more flexibility. The added space of a van or motor home makes it easier to set up and break down. With a mobile set-up, you can also work many smaller shows and local events that otherwise would have not been cost effective.

Plan your inventory before you leave for the show. Finding T-shirt wholesalers out of town is risky, at best. When planning how many T-shirts to buy, keep in mind the cost of your trip. You need to have at least enough inventory on hand so that your show sales will cover the cost of the trip.

For example, you can be reasonably sure to make a net profit of $15 on each T-shirt after subtracting the cost of the blank shirts and paint. Stock designs may yield as low as a $3 profit, while custom work can bring in a $75 profit, so a $15 per-shirt profit is a safe figure to estimate.

With this $15 figure, you can now estimate the cost of your trip and determine how many T-shirts you need to sell in order to break even or even produce some profit. The cost breakdown for an average three-day trip is similar to this:

Entrance Fees	$100
Hotel	$150 (based on two nights lodging at $75 per night)
Gas	$ 70
Food	$ 60
Total	$380

By dividing $15 (profit per shirt) into $380 (total cost of trip), you realize that at least twenty-six T-shirts must be sold to break even. It may seem that you need only twenty-six T-shirts in your inventory. However, not all the T-shirts sold will be in the same size. Of the twenty-six T-shirts, some may be small, medium, large, or extra-large.

So, the question is: What sizes do you need to sell twenty-six T-shirts? While experience is the best teacher, the section, "Purchasing Inventory" on page 12 will help you plan an initial inventory.

Selling by Mail Order

Mail-order sales can be very lucrative for the airbrush artist. The income potential is great. It is impossible to explain all there is to know about the mail-order industry in one chapter, but I hope to give a general outline of the opportunities for selling airbrush specifically through the mail. This may help you avoid some of the problems I've encountered. When I first sold airbrush T-shirts by mail order, I read several books on the subject. You should, too.

With mail order, your advertisements are your showroom and sales staff. The magazine in which you place your ad determines the potential customer pool for your garments, so place your ad in a publication that appeals directly to readers most likely to buy them. You'll also want your ad to be seen by as many people as possible for your advertising dollars, so keep the publication's circulation in mind before placing the ad. For example, if you

Concerts and Music Designs

Music designs can be a highly profitable market for the right artist. Requests for music-related designs are common, but because the music industry changes so quickly, you must be extremely sensitive to the latest trends to be able to keep up with this fast-paced industry.

Although you will get many requests for music designs in any shop, there are other, more specialized outlets available to the airbrush artist who chooses the music avenue. There are thousands of record and tape stores across the nation that can be used for set-up or display locations and are potential outlets for either wholesale or consignment sales, too. Arrangements can also be made with promoters to set up at concerts, but this market is harder to break into. In fact, as of this writing, the record/music store and concert market has yet to be exploited to the fullest.

Which record store you set up in will have a bearing on your income. Artists who set up in high-traffic stores in malls will of course do better than artists painting in small used-record stores. Record stores also cater to different clienteles, and this will impact your income. Heavy metal enthusiasts, for example, tend to buy less airbrush than the top-40s customers. You may have to do some in-store demos or keep your prices low when first establishing yourself.

Approaching a music store owner is no different from approaching a T-shirt shop owner, so you can follow the guidelines I gave in the previous chapter. (See "Approaching an Owner," pages 14-16.) For selling T-shirts either wholesale or on consignment to music or record stores, follow the guidelines in the sections, "Selling Clothing and Other Wearing Apparel Wholesale" and "Consignment Sales" on pages 33-38 and 38-39.

Contacting the concert promoter may be difficult and involve some letter writing, but your efforts will be well rewarded. If you either live near a major performance center or are willing to travel the night of the concert, the best way to contact promoters is by contacting the theaters and coliseums.

Theater owners normally book performances years in advance and will send you a listing of upcoming events. Once you have a list of performers, you can contact their managers and make arrangements to set up an airbrush concession. The concession at a concert is similar to the set-up at a high-end, competitive art show or fair. (See pages 54-56 for more on this.) If you can't get permission to work at a concert, don't set up outside or down the street to sell your work. When you get caught (and it will be *when*, not *if*), the promoters may take legal action against you because you aren't legally licensed to sell performance-related items.

want to paint T-shirts for people interested in custom cars, you may want to consider placing ads in automotive magazines. If you plan to offer general fashion designs, you can place ads in more general publications with high circulations.

You can find lists of magazines organized by type, such as automotive, in *SRDS* (*Standard Rate and Data Service*) at your local library. This book gives you information about a magazine's readers and rates for advertising. Once you've identified those magazines that look like the best places for your airbrush artwork, write the magazine at the address given in *SRDS* for a media kit, which will tell you the publication's circulation, customer profiles, and other valuable marketing information and the most up-to-date information on advertising rates. Magazines are always anxious to find new advertisers and will gladly send you a kit when you write expressing an interest in buying ad space.

Your major overhead expense in the mail-order business is the cost of ads. Ad space in national magazines with a circulation of around a million can cost several hundred dollars. Most ads are sold by the column inch. A column inch is the space on a page that is one-column wide and one-inch tall. If the page is broken into five columns and the columns are approximately one-and-a-half inches wide, an ad that measures one column inch will be 1½ × 1-inches.

Creating and Producing Your Ad

Once you know where you want to place your ad, you will have to design and produce the ad. You must plan your ad before you set out to write copy for and design it. Decide what you want to do in each ad: introduce your airbrushed garments to potential customers; convince them of the benefits of owning your garments rather than something else; work for immediate return (cash orders) or for long-term results (a catalog that will let customers order later); or some combination of these objectives.

All mail-order ads share basic elements, although there are many variations on design and arrangement. The basic elements are:

- Headline
- Body copy
- Ordering information
- Visual material

Let's look at each of them in turn:

The headline should attract a reader to your ad and then lure him into reading the copy. Headlines usually offer a major benefit such as "Exciting New Designs" or "Have a Beautiful Beach Scene on Your T-Shirt."

The body copy describes in more detail the benefit(s) of buying your garment and then leads into the ordering information. Tell the reader what high-quality garments you use, how exciting and original your designs are, and anything else that will reinforce the benefit in your headline. If you're also offering a catalog, tell how to get one here. Always keep your copy short and simple.

Ordering information tells customers how and where to order your garments. This includes information on how to order designs and sizes and your address. Plan your ordering information carefully. It must be easy to understand and yet yield the specific information you need to paint the garment correctly. It's frustrating to receive orders you can't fill because you don't know whether the design goes on the front or the back of the garment. The best option, if you can afford the space, is a coupon that people return with their orders. Otherwise, give very clear and simple instructions for ordering sizes and specifying whether designs are to go on the front or the back of the garment. Ask customers to include their name, address and phone number on the order even if it's printed on their checks. (Once you've cashed that check, the information is gone.)

Decide whether to offer custom or stock designs—specific designs from which the customer must choose. If you are selling stock designs, you can identify each design (if you're offering more than one) by a number that the customer writes down. If you offer custom airbrush through the mail, tell customers how to describe what they want so you can create it. Ask them to include an illustration with the order. And in either case, instruct customers to clearly indicate what goes on the front and the back of the garment.

Include in your ad the postage and handling fees. It is quite common to do this. You can ship T-shirts in 9″ × 12″ manila envelopes, and sweat-

Producing an Inexpensive Catalog

For the best return on your mail-order investment, offer a catalog in your ad. People will often request a catalog, even if they don't buy anything the first time around. If they are interested enough to request a catalog, they will probably buy something. Often, they will save the catalog and order Christmas or birthday gifts from it.

Big Daddy Rat's, an airbrush T-shirt shop in Daytona Beach, Florida, places a catalog in every bag and enjoys year-round business through the mail as well as the regular retail trade. The catalog they use is a black-and-white, 8½″ × 14″ sheet of paper that contains a sampling of products and ordering instructions. This type of catalog is inexpensive, about sixty dollars per thousand to produce.

Catalogs don't need to be expensive. If you take your own photographs and group your designs so they only require one halftone, you could produce your own catalog easily for less than one hundred dollars. If printing is outside your budget, the halftones can be reproduced, as needed, on a high-quality photocopy machine. Color copies are available now at reasonable prices. The photographs can be nicely arranged with the same ad copy.

shirts fit in 10″ × 14″ envelopes. These can be purchased at most office supply stores. Have an envelope with a T-shirt or sweatshirt folded in it weighed at the post office to get a better idea of your costs. Your handling fee should cover the cost of the envelope and mailing label (cheaper if you buy in bulk) and something for your time.

Visual material. A photo of an airbrushed T-shirt is your strongest selling tool in an ad. People want to see what they're buying and will remember a photo better than words. You should always include a picture of your garments for the best sales results.

Plan your ad carefully, especially if you can afford only a small one, so all your copy and your visual(s) fit into it. Look at other ads the same size as yours to see how many words you can have and how big the copy and your visual can be. You may need to write and rewrite your copy to get it short but keep it clear. And it goes without saying that you should avoid spelling or grammatical mistakes.

Because you want to include a visual of your gar-

ment whenever there's any space for it, you'll have to supply the paper or magazine that's printing your ad with camera-ready art—copy suitable for print reproduction. And after the text is written, the ad copy (headline, body copy, and ordering information) should be typeset so it will be extremely sharp and clear for photographing and printing.

Typesetters are listed in the Yellow Pages under typesetting, but they can be expensive. Today, many copy shops rent time on computers with page layout programs that let you do your own typesetting. The new computer systems are easy to learn (user-friendly) and cost much less than a professional typesetter. If you do your own typesetting, keep your type size relatively small to fit in more words and use a typeface that is readable at that size.

Once your ad copy has been typeset, your visuals need to be prepared. All photographs must be halftones in order to be printed. Halftones are the result of a process that converts a continuous tone photograph into a dot pattern. When printed, these dots look just like a photograph to the naked eye. A photograph can also be sized to fit in the ad. Most printers can produce a halftone at an average cost of about fifteen dollars. The printer who does your halftone may also arrange for relatively inexpensive typesetting for you and may paste up your ad as well. Ask what services are available before you spend a lot of time learning how to typeset.

Full-color ads are up to three times more expensive than black-and-white. They require color separations and professional layout and paste-up skills. Getting involved in this process will take time away from airbrushing and selling your airbrush. If you feel a four-color ad will greatly improve your sales, then invest the money to hire a professional graphic designer (you can find them through referrals from other artists or in the Yellow Pages). Plan to use the ad enough to recover what you've spent.

Selling Clothing and Other Wearing Apparel Wholesale

The term "selling wholesale" can be defined as "selling goods or services to another business that are then resold to the consumer." If you sell your garments to a retailer, you are in the same business as the person from whom you buy your blank garments.

When you sell wholesale your customer, a business, has different needs and requirements from those of the consumer. Retailers purchase goods in quantity. Those goods are then marked up and sold, one at a time, to the consumer. So the most important element of success is understanding the retailer's needs.

There is an old business saying, probably coined by a wholesaler, "Quality, service and a good price: Pick any two." What this means is that it's very difficult to offer a retailer all three. For example, if you spend all day soliciting, taking orders from, and shipping orders to retail customers, you may have to hire another artist to help you paint. This maintains good service and quality, but the extra artist raises your prices.

If you don't hire the extra artist and continue to service the retailers during the day, quality suffers because you must work at night to complete the orders taken during the day. There is no right or wrong way to successfully juggle all this, but understanding the three different aspects of quality, service and price will set you in the right direction.

Quality

Retail products available today cover the full spectrum from high-quality, expensive products on one end to low-quality, inexpensive products on the other. And these two categories of products are sold differently.

In the stores at Fisherman's Wharf you'll find airbrushed T-shirts, ranging in price from $7 to $35, depending on where you shop. The cost of manufacturing and materials may account for only $7 of the $28 price difference. So, what explains the other $21? Could it be the way the products are sold?

T-shirts that sell for $7 are offered at discount stores where the T-shirts are thrown into large piles for customers to pick through. The T-shirts have one-color, simple, or even unattractive designs. Many of the garments are seconds or cheap imports. It is hard to believe, but this low-end market came about by demand. There is an army of bargain hunters who love to spend hours sifting through these mountains of T-shirts just to find the right one.

The $35 T-shirts are well designed and professionally displayed. Many of them are associated with high-profile products, such as surfing equipment, sports equipment, or popular music groups. The stores where they are sold are also beautifully designed. Sales personnel are well trained and eager to please. Would this add $28 to the cost of a T-shirt? No; the decor and extra service do add to the cost, but not much.

People often pay a high price for image, and that

Case History: Finding the Best Market

In my early experiences with mail order, I placed an ad both in a publication that specifically targeted people interested in the product offered and in a publication that simply had a high circulation. I wanted to see which would offer the best return.

I offered a beach scene that was a best-seller in the tourist towns on a woman's French capsleeved knit T-shirt. The blank T-shirt cost $2.75; my asking price for the painted shirt was $12.95, and I asked for $2 to cover postage and handling. I should have charged more, since it actually cost me about $2.75, on average, to ship the garments.

Because my garment was designed for women, specifically young women, I felt that the best publications in which to advertise would be women's magazines such as *Glamour*, *Cosmopolitan*, and *Mademoiselle*, so I requested their media kits. When I read the specifics about the magazines' readers, I found that *Glamour* was targeted for the high-end market, not the one I wanted. *Cosmopolitan* was designed for an older group than I wanted to reach. I knew from experience that young people bought most of the type of airbrush garments that I painted at the time.

Mademoiselle fit all my requirements. It had a young audience with a circulation of about 750,000. Although its circulation was lower than that of the other two publications, I still felt I would reach more people interested in my product.

Though I chose *Mademoiselle* for its clientele, I couldn't help thinking that a publication that reached a massive number of people would work well, too. I had worded my ad to offer not only specific garments but also a free catalog, and I hoped to receive requests from many people interested in general airbrushed fashions.

I placed the same ad in the *New York Times*, even though I had read that newspapers are only good for one day: They are read quickly and then thrown out, so your ad life is not very long. Magazines are usually saved for a while, and therefore the ad life is longer. However, the *New York Times*'s circulation was so high—close to two million—that I decided there was a good chance my ad would generate sales.

It cost me $300 for a tiny ad in the shoppers' section of the *New York Times*. The ad was so small I could barely see the picture in it. The ad in *Mademoiselle* was a little bigger and cost about $325. You can see here how circulation can affect pricing.

The results were surprising. Within three weeks of the ads' appearance I received a total of 275 replies, including thirty paid orders. The other 245 replies were for the free catalog I offered. I had immediately recouped about $300 of the $625 that I had spent for both ads. Of all the replies I received, about sixty were from *Mademoiselle* and the rest were from the *New York Times*. From this and other experiences, I think that circulation is the key factor in the mail-order business. The more people you reach, the more sales you'll make. I was surprised to find that a one-day run in an obscure section of a rather staid newspaper would generate more interest than a magazine targeted at a specific audience.

The catalog I mailed was printed on a copy machine. I took the photographs myself and used a typewriter to type the text. I included six stock beach scene designs and an offer for custom lettering and custom art that I could paint on a T-shirt from any picture the customer requested.

From the 245 catalogs I mailed out, I received over 120 orders. This is why I stress preparing a catalog to mail to people who request it. The catalog orders came in over a three-month period. My total gross income for the project was over thirty-three hundred dollars. My costs never exceeded one thousand dollars.

accounts for most of the $28 price difference. Pricing has more to do with how much people want something than the product's actual worth. For example, many designer clothes sell for up to 50 percent more, just because a certain label is sewn into the collar.

Clearly, retailers cater to different clienteles. Some seek customers with middle to high incomes, while others try to attract the middle- to low-income customer. This is important to know, especially if you decide to sell your airbrush garments wholesale. It is a waste of your time to sell a high-end product to a low-end retailer and vice versa. The low-end retailer is interested only in the bottom-line cost and the quantities that must be bought in order to make prices affordable.

The retailer who sells T-shirts for $7 buys low-quality, blank garments in quantities of hundred dozens. The printing may be done by automatic silkscreen machines or by employees paid the abso-

lute minimum. The designs are often knockoffs or close copies of popular, successful designs. No matter how quickly you work, it will be hard to compete with cheap, mass-produced, silkscreened T-shirts.

Airbrushing for the mass market, whether Macy's or K-Mart, is difficult because these retailers buy in volume. Theoretically, an artist could paint large quantities of T-shirts, if given enough time, but it's highly unlikely. When taking orders for up to two hundred T-shirts, I found out the hard way that maintaining consistency is almost impossible. Many stores have policies that restrict them from buying anything handmade, because maintaining consistent quality in handmade goods is difficult and requires constant monitoring.

To sell airbrush successfully, produce a high-end, handpainted garment. It will sell well to retailers catering to a select clientele who appreciate high quality and unique products. Because your earnings from each garment will be higher, you can take your time and do a superior job. In some exclusive shops in San Francisco, airbrushed jean jackets can sell for over $800.

Sales and Service

The thought of having to sell scares many people to the point that they won't even try. Artists seem to have been dealt a double dose of this trait, because the product they are selling is personal. So buyers can often take advantage of an artist's insecurity. They are in business to make money and will not show their admiration for a product for fear you will inflate the price. This is a shame, but unfortunately it is true.

Airbrush fashions sell themselves. When approaching potential customers, your goal should be to develop a friendship. They know you want to sell them your garments, and they also know it is a difficult undertaking. Try to be yourself. Simply tell them you would like to show them your garments. If they are too busy, set a time when you can come back. If they say they just don't have the money, ask them when they will. Again, make an appointment.

It is important to set these appointments and keep them. Owners are more likely to buy from people they like, and regular visits are a great way to develop a relationship. Also, regular visits give the appearance that you are doing well enough to keep returning. When retailers think that the competition is making a profit from your garments, they become motivated to buy.

An owner who likes you will often try to help you, either by telling you ways to improve your garments or suggesting other stores that may be interested. Develop a relationship that will make them smile when they see you walk in the door. Tell them a joke, ask how business has been, or how the family is. When I started selling, I went to the library and checked out several joke books, memorizing a couple new ones each time I went out to sell.

Store owners have to make a living like anyone else. Their biggest fear is that they will spend their funds on a product that won't sell. If a product sits on the shelf, it will not return the invested money. This means the owner won't be able to restock the products that do sell. With rent and other overhead expenses, it takes only a few purchasing blunders to lose everything.

If your work is good and they feel it will sell for them, store owners will buy it. If they reorder, you know you're doing well. Reorders mean that your garments are being purchased by their clientele, and they want more of your product to sell. This is, of course, the position you want to be in, but you may find that it takes some work to get there.

When you visit retailers at their shops, bring samples of your work, a price list, and your data sheet. The designs you present should reflect the style of the retail shops you are approaching. For example, elegant, abstract designs are most appropriate for high-end specialty fashion stores; mid-range stores might respond to Americana and humorous designs. If you approach a specialty market, such as a pet store, cute pictures of dogs, cats and iguanas will work best.

Your samples should be accurate examples of what you plan to deliver when the retailer places an order. If you make the samples look better than what you deliver, you are in for trouble.

When creating samples, keep in mind that every minute you spend painting a garment drives up the cost, but samples will not take as long to paint the tenth time as the first time. Therefore, your prices should be based on how long it will take you to produce the design once it's been completely worked out—not on how long it took you to develop it. Estimate the time it will take to paint the design once you've produced it several times. I have always been able to reduce the painting time of any design by at least fifty percent. I think you would be safe in using this figure to establish your pricing.

Since the difficulty of the design largely determines the final price, it is important to develop designs that fit your market. If you spend a week on one garment, you have to sell it for several hun-

dred dollars in order to recoup your costs. Or, for the same profit, you could paint garments that take less time to paint and sell a larger quantity at a lower price per garment. Both approaches work, but choose which market you plan to target before painting designs.

There are several points to consider when choosing a market. Are you looking at retailers who cater to fewer customers with a lot of money or to a lot of customers with less money? Stores that target low- or middle-income consumers have a market that likes T-shirts but doesn't have a lot of money to spend. If you plan to paint designs that are easy and inexpensive, this may be the market for you. However, the store owners are used to buying silkscreened garments and may not want to pay as much as you need to charge.

If you want to develop garments that make more of a fashion statement, set your sights on the fashion boutiques and specialty retailers. These stores have a clientele that is looking for unique products and has more money. This is the strongest market for airbrush garments because the owners are open to new ideas and are comfortable paying higher prices for products they feel will appeal to their customers.

The amount of money you can earn depends on how many outlets carry your garments. For example, you find that a store can consistently sell two of your garments per month, but you want to sell thirty. To sell thirty, you will have to find fifteen more outlets to carry your garments. Your income is limited only by the number of available outlets for your garments.

A receipt book records your sale. You will need a receipt book that makes two copies, one for you and one for the shop owner. It is important to keep accurate records of each sale, not only for tax purposes, but to answer any questions that may arise between you and the shop owner. In most cases, you will make the sale on one day and deliver the finished product a few days later, so a photocopy of the sales receipt can also be used as a delivery receipt.

Pricing
Most people assume that, by lowering the price of a product, they will sell more. This common misconception has been the downfall of many businesses. The truth is that prices are generated by demand. The more people want something, the higher the price. When manufacturers sell more, the cost of production goes down. If the demand remains high and the cost of manufacturing goes

How to Advertise Your Garments

When you show your garments to a store owner, you are advertising them. If the owner decides to stock your garments, your advertising has been successful. There is really no need to purchase advertising in newspapers or magazines that reach thousands of people who don't own stores.

Part of the reason you can keep your prices down is low overhead. You don't need fancy retail space. The cost of paint per garment is almost negligible, and airbrush equipment is inexpensive to maintain. However, if you start spending money on advertising you don't need, you will have to charge prices that may be unacceptable.

The only advertising tools you will need are:
- Business cards
- Price lists
- Data sheets

These don't need to be expensive. Most quick printers offer attractive, simple business cards for about fifteen dollars per thousand. You can produce a typewritten or handwritten price list and photocopy it. No store owner has ever told me that my garments looked great, but he wasn't interested because my business card was ugly. A data sheet consists of brief descriptions and pictures of your garments that can be left with the store owner. It doesn't need to be expensive, either. You can use photos or drawings, and text can be added with a typewriter or by hand. Then make copies (or even color copies) on a photocopier. It's best not to invest money in the data sheet because you will probably be constantly adding and dropping the designs that appear on it. You should also include your policies on refunding, returning and exchanging your garments after a retailer has bought them.

Some store owners may ask you to take part in co-op (cooperative) advertising, where wholesalers or manufacturers contribute to the advertising budget of a retailer when the retailer places an ad in local newspapers and magazines. I would not recommend these programs, because you won't get a good return on the cost. Co-op advertising is done by large companies that are seeking ways to promote brand loyalty. Brand loyalty requires a company to keep the name of its brand in consumers' minds. This type of advertising is expensive, and useful *only* after your brand name is known by a large percent of the consuming public.

down, the company will make more money. It is only when demand drops that prices drop.

Retailers will often ask you to lower your prices, but you won't sell more garments if you do. You can handle this situation in one of two ways. You can build a discount into your price or you can offer a discount for buying in quantity.

You build a discount into your prices by asking for a little more than you actually need. If a retailer asks you to "give them a special price," you can. However, this will alert retailers to the fact that you are willing to negotiate your prices. Once you offer retailers a discount, it is human nature for them to want more of the same. The next time you call on them, they may ask for even lower prices. Since you already gave up your built-in discount, any more of a discount cuts into your profits. If you refuse, you run the risk of losing the sale.

I recommend developing quantity discounts. The more a retailer buys, the better price he will get. This way, when retailers ask for a discount, you can say, "It depends on how many you buy." Quantity discounting is standard business practice in the wholesale industry.

It is difficult to say exactly what to charge for the fashions you create. You can be sure that the retailer will need to double the price he pays you. The question to ask yourself is whether or not the consumer will be willing to pay double the amount the retailer paid.

If you can paint a $5 design on a $4 T-shirt, you will be selling that garment to the retailer for $9. The retailer will in turn sell that garment for $18 — not an unreasonable price for the consumer. A $15 design on a $4 T-shirt will cost the retail customer $38, and that might be getting a little high.

The final selling price will also be affected by the retail shop you approach. For some shops, $38 may not be high at all; for others it may be out of sight. This is where the retail shop owners' opinion will come in handy; they know their customers, and most will not mind helping you fit into their niche. Be careful, though. Don't let the store owners take advantage of you. Take everything a shop owner says with a grain of salt. It is a bit like asking the car salesman how much you should pay for a car.

When setting quantity discount prices, set an absolute minimum price for which you are willing to sell your products and then add to that. Be sure to include gas, mileage, and the wear and tear on your car. For example, if you are willing to sell a garment for $9, then increase that price to $12 for a dozen, $11 for six dozen, $10 for twelve dozen, and finally, $9 for any orders over twelve dozen. If you set a

minimum purchase of one dozen, the stores will have to buy four dozen to get all the adult sizes (small, medium, large and extra-large).

You should also set a minimum purchase of one dozen per size and design, because that is how the wholesaler sells the blank garments to you. If you "break dozens," you will find yourself with an excess stock of different sizes. Also, retailers will want to restock in extremely small quantities and you find yourself running to the post office or packing UPS orders of two and three garments at a time. It can become a real nightmare. Most companies sell in dozens. Don't let the retailers tell you any different.

Exchange, Return and Refund Policies

Exchange, return and refund policies are important when establishing a relationship with a retailer. Many retailers try to exchange, return or receive refunds for garments that have not sold. It is up to you to decide whether or not you want to offer them those options.

Agree only to exchange garments that are not selling for garments that are, *if* you are sure you can sell the unsold garments somewhere else. Once you've done this, of course, the retailer will expect you to do it again.

The same is true for returns. Give refunds only if you are certain that another retailer can and will buy any stock that you accept back. Even then, give refunds only as a credit for future purchases and not in cash. Make this clear to the retailer before garments are delivered and money changes hands. These policies should be printed on the back of your data sheets, along with a time stipulation. This protects you if any questions come up in the future.

Most garment wholesalers offer a thirty-day period when a retailer can exchange garments or return damaged items; after that, the retailer cannot return anything. You should do the same. If you don't set a date beyond which you will no longer offer refunds or exchanges, the retailer could ask for an exchange a year or two later. This can be a record-keeping nightmare and also result in a large loss of income. Retailers will try to get you to take back goods that aren't selling and can be quite intimidating to someone new to the industry. Don't be afraid to lose a customer. Be proud of your work and stand by it — very often, it is not your fault the garments aren't selling.

A retailer once called me to say that my products weren't selling and wanted a refund on everything left in stock. I informed him I only offered a credit on refunds and reminded him that he had agreed

to this when he purchased the garments. He continued to insist, so I agreed to meet him the next day. I checked his order in my records and noted that he had purchased a dozen T-shirts about two months previously.

When I arrived at his shop the next day, I discovered that he had sold half of the shirts. I asked him where the others were, and he took me to a table where there must have been at least a thousand T-shirts lumped in a huge pile. After digging through the pile for a while, he found five of the six remaining T-shirts that I had sold him.

I asked him why he displayed his T-shirts in one big pile and not on hangers like all of the other shops in the area. He said that he could not afford hangers. Then I looked around the shop and noticed that the rest of the inventory looked thin. I asked him how business was going, and he said everything was fine. When I mentioned that the shop's inventory looked thin, he became upset. I told him that if business was a little slow right now, I would be glad to help him out. In the end, he confessed that business was off and that he needed money for overhead.

I gave him a cash refund for the five shirts, not only to help him out but also because I did not want my shirts displayed in a pile. Besides, I knew another retailer who would purchase the garments immediately. Had I not had an alternate buyer, however, I would not have given this retailer a refund.

Consignment Sales

A consignment sales agreement means that a retailer agrees to offer your garments for sale and pay you after each item sells. The retailer keeps a percentage of the sales as payment for acting as your salesperson. There are pros and cons to selling on consignment. It is much easier to sell to retailers than a straight wholesale agreement. For one thing, you are not asking them to pay out any cash in advance since you will be financing the inventory they carry. This arrangement can help you increase your potential retail sales but will only benefit you if you can afford to purchase, paint and deliver the garments to the retailers, and then wait for the garments to sell before you are paid.

If you set up consignment arrangements with retailers, check in with them often. Don't let much time go by between the time a sale is made and the time you are paid. Quick payment for your goods should be arranged with the shop owner prior to stocking your goods in her shop. Stop by a store

when you know the owner is in and ask to be paid for any sales up to that point. You lose time and money if you have to come back several times to get your money. Replace any store owner who puts you off repeatedly with one who is more conscientious.

Protecting Yourself

Be sure to count all garments and list them on a two-part form before leaving them with the retailer. Assign an asking price to each and list the total number of garments. This informs the shop owner of the garments' cost and how much responsibility, in dollar value, she will be assuming. Have the shop owner sign your receipt book and remind her that either the garments or the cash value of the garments must be returned. Establishing all the rules in the beginning of a relationship shows that you know how to conduct business and that you expect the same from the retailer.

Each time you visit a shop, count the garments and subtract this figure from the number of garments you left on your original trip to the shop. The difference is the number of garments that have been sold. If the shop owner disagrees with the total and you have no documentation to prove how many you left initially, you may lose not only the value of the lost garments but also the money and time spent in developing the relationship.

Store owners may claim they didn't sell a garment because they don't have a record of the sale, and that it was, therefore, probably stolen. Since they didn't make any money out of the deal, they shouldn't have to pay you. At this point, the decision is up to you. You really shouldn't have to lose money because the shop owner "lost" an item. But on the other hand, if the shop owner has earned money for you in the past and items aren't "lost" frequently, you may choose to disregard one missing item.

Also, have each retailer inspect the garments for any damage or stains before they accept the garments. Inform the retailers they are liable for any damage to the garments after they are brought into their shop. Retailers may ask you to put a time limit on this because they do not want to enter an open-ended agreement. They will also want to know when you plan to show up again. Settle on a time and stick to it.

If your garments are damaged when you return to pick them up, your recourse is limited. It would be silly and expensive to sue a retailer over one damaged garment. If the retailer has sold several dozen garments for you in the past, would tension

over one damaged garment be worth ending a profitable relationship? Common sense is a helpful asset in the consignment sales field.

Success in business comes as much from knowing what to look out for as what to do. Beware of shop owners who constantly lose garments or argue about how many garments you left on your last visit. It is up to you to demand payment that is due you, and if a retailer does not honor her commitment, end the relationship.

Increasing Your Business With Sales Representatives

Sales representatives can increase your business considerably by expanding your distribution outlets. These salespeople represent you in selling your garments to store owners. Some representatives travel far selling their goods. I once painted sand dollars for a woman who used them to produce small souvenir items. By developing strong relationships with sales representatives, she sold these sand dollars in hundreds of cities all along the Mississippi, Alabama, and Florida coasts.

Sales representatives can be found occasionally in the T-shirt trade magazine, *Impressions*. There is also a national listing (see the "Resources" section, pages 117-128). Reps can also be found through retailers. If you sell your garments to local retailers, ask them if they know any sales representatives who are calling on them and might be interested in carrying your product. If they provide you with a phone number, contact the sales representative directly.

You can also do this if you are not selling wholesale. Find retail shops in your area that carry products similar to those you produce. Then call the shop owner and explain that you are trying to find sales representatives for your garments. Most people will offer some assistance. They may also ask to see your garments, and you may end up with a sale.

Sales representatives are always looking for products that sell. They make their living by finding unique and special products that can be offered to their retail customers. Once you locate a sales representative, call him. Ask if he is interested in looking at new products. You don't want to send expensive photographs to uninterested parties. If the representative is not interested in your garments, the sales information ends up in the trash.

Approach an agreement with a rep cautiously. You are asking him to enter into an ongoing business relationship. You are wondering how well he will represent your product. On the other hand, the rep wonders if you are going to deliver products on time and maintain quality standards. There is no way you can really know if a sales representative performs until you have worked together. Reevaluate your decision to work with a rep at regular intervals based on his performance.

Once you confirm the representative's interest in your garments on the telephone, send photographs of the products and pricing information. Include any quantity discount information that you would normally offer to a retailer.

The representative may want to see some actual samples. If samples are requested, you can interpret this as genuine interest in your product, so send them. If you do not hear from the rep within three to four weeks, call back. He may tell you that the garments are not right for him or that he services an entirely different clientele. Don't take this personally. It is not a direct reflection on your art. Salespeople develop very specific customers, and they know what is right and wrong for them. Often, by saying no the sales representative is saving you needless time and worry.

Beware of any representative who asks for payment to sell your product. A rep's payment is based on a percentage of any sales that he produces.

Here's how your relationship with a sales representative generally works. First, you supply the rep with sales tools (see pages 35-36) and any other information he or she requests. The rep then shows your product to any of her customers (retail shop owners) she believes would be interested. If a customer decides to buy your product, the sales representative writes up the order and sends it to you. You then ship the order to the customer COD. (When you ship via UPS, you can specify whether you want cash or a check from the retailer.) The retailer will pay the shipper, who will in turn send you a check, usually within a week to ten days. Once you are paid, promptly pay the percentage owed to the sales representative.

Sometimes, representatives prefer that you ship the garments directly to them, so they can deliver the goods directly to the retail customer. This is the only way they can protect their accounts. Once you ship to a retailer, you will have the address and contact name of the retail outlet and, in theory, could contact the retailer directly, work out a deal, and exclude the representative altogether. However, such behavior is unscrupulous and is sure to deter any reps from opening any new accounts for you. If the rep wants you to ship the garments to

him, you should bill him the same way you would the retailer: COD.

I recommend conducting business on a cash basis, especially if large distances are involved. If a problem with a bad check arises, you will have to initiate and conduct legal action in the county of the retailer who wrote the check. Long-distance legal actions will cost you time and money, and the outcome is questionable. If the retailer claims to have no money, you will have to wait for payment. I have known several businesses that have operated at a loss for years, only to go out of business in the end.

How and What to Pay Sales Representatives

Sales reps are paid a commission based on a percentage of their sales. To pay the rep, you must decide whether to mark up your garments or dedicate a percentage of your profits. If you mark up the garments, you run the risk of pricing yourself out of the market. In other words, you may raise the price so high that no one is willing to buy. If you've developed a high-end fashion product, an increase in the price will not adversely affect sales. However, if you are trying to keep the price competitive with comparable fashions, raising the price might result in a drop in sales.

You can assign the money that would have been spent on auto and telephone expenses to pay the sales representative. Also, if the sales representative increases the volume of garments you are selling, there will be more money available for a commission. No matter how you decide to do this, the sales representative expects to earn a commission based on a percentage of generated sales.

Commissions start at about 2 percent and can go up to 50 percent. The high-end products tend to command higher commissions because they are usually sold in less volume. The expenses incurred by the sales representative per each sale are fixed. If he sells a large volume, the profit per sale is higher, and he makes more money on fewer sales. Thus, he may not need to charge as high a commission. High-end products, on the other hand, rarely sell in volume, so the sales representative must ask for a higher commission to earn the same profit per sale.

Whatever commission you negotiate, be sure that you can afford it. Don't sacrifice today's profits based on future sales. If the representative says she can sell huge amounts of your garments if you lower your prices, ask her to produce a sales order first. Then estimate your cost and make a decision.

Before you spend any money or incur any costs, be sure the representative sells your product.

This includes paying commissions, too. Never pay a sales commission until the garments have been shipped, accepted by the customer, and paid for in full. If you have established any return policies, such as a thirty-day period when the customer can return any damaged or defective items, do not pay any commissions until after this period.

Taking Your Business on the Road

For the artist who would like to travel, airbrush offers a wide range of opportunities. You can generate income at virtually any location where people gather in large numbers. Throughout my airbrush career, I have painted all along the coasts of Texas, Mississippi, Alabama and Florida, on Forty-second Street in New York City, and in California at Fisherman's Wharf and Pier 39. I spent a season on St. Thomas Island in the Caribbean and have begun looking into working in Europe. I feel traveling has been one of the most enjoyable aspects of my airbrush career and has broadened my personal horizons as well as having a positive impact on my art.

Traveling as an airbrush artist may seem to be a rather risky and insecure way of life, but keep in mind that it can be very profitable. Experienced airbrush artists earn twenty to forty thousand dollars in the three-month summer season. If they work at ski resorts during the winter season, they can double their income. While I traveled as an airbrush artist, everything I owned fit into the trunk of a car. However, I always had enough money saved so that I could live for a year without working.

Most traveling airbrush artists keep a lot of cash on hand to offset the risk of being unemployed. Anything can happen while you are traveling. For example, a dispute may arise between you and the shop owner that leaves you with no place to work. If this happens early in the summer season, finding another location could take a long time. Most of the summer locations are filled months in advance. Having enough money in savings will come in handy when you find that you've moved to a town that, for one reason or another, can't support an airbrush artist. With enough money in savings, you can simply start over. The life of a traveling airbrush artist may not be for everyone, but it is one of the most exciting ways to see America—or the world.

There are some shortcuts to traveling that can help you minimize travel costs and maximize future

profits. Remember, you won't be earning any money while traveling and getting settled at your location. So it is important to have a job waiting and a place to stay before you leave.

Finding Work Before You Go

Before you decide to move, consider the obvious: the location. If there are airbrush artists working in the location you've selected, some telephone calls to local T-shirt shops could land you a job right away. If the location has never had any airbrush artists in the area, chances are that the local T-shirt shop owners won't know much, if anything, about airbrushing.

Finding work in a shop that is accustomed to having artists on the premises is no different from landing a local job. At one time, I worked in New York City during the summer months and didn't want to stay there through the harsh winter. So I called a T-shirt shop chain in Daytona Beach, Florida, that enjoyed a good winter business and interviewed for an airbrush position over the telephone. I knew that many of the airbrush artists employed there would be leaving after the summer season and that an opening would be likely.

The manager of the Daytona Beach shop asked me how fast I could paint different images, including cars, beach scenes, and different lettering styles. T-shirt shop owners want artists who can paint many T-shirts fast. Then he asked me if I would be willing to relocate and what commission I required. The shop owner also questioned me about the basic images and typestyles that are standard throughout the airbrush industry.

The manager asked me to send samples of my work, a standard practice. I sent pictures of work I'd done in Florida and called him back after I knew he'd received them. He said they looked fine, and we set a date when I would arrive at his shop in Florida.

At this point, I asked him if he could recommend any places where I could stay when I arrived. He happened to know of a vacant apartment that was priced reasonably. Shop owners understand that many artists travel with the seasons. Often they can help arrange lodging or at least recommend an inexpensive place to stay while you are looking for more permanent housing.

To find work in an out-of-town location where airbrushing has not been established, you'll need to find the T-shirt shops first. Then you can ask the shop owners or managers if you can set up in their shops. Call the chamber of commerce in the town you've selected. Explain that you are an airbrush artist looking for work and that you're trying to find the local T-shirt shops. Ask for a photocopy of the local Yellow Pages listing the local T-shirts shops, T-shirt wholesalers, and souvenir shops. Also, ask them to include any general information that they have about the town, as well as a copy of the local newspaper and a map. Usually a local chamber of commerce can provide you with all the information requested.

The local newspaper will give you a general sense of the town's personality. Sometimes you'll find ads placed by local T-shirt shops, adding to your source of potential job sites. A local newspaper can help you find a place to stay. Most resort towns have high rents if you stay in the tourist areas, so find a place where the rents are reasonable. Most of the time, you will live away from the tourist areas. Newspapers can also help you find roommates in the town you are planning to move to.

The town map usually indicates high-density areas, and you can be sure that the dense area is where the money will be. Ask T-shirt shop owners where the shops are located in the town, then you can use your map to check whether or not the shops are located in the prime traffic areas. Most resort and tourist towns have a small, three- to ten-block area that pulls in 90 percent of the town's business. If you are not in this area, you may regret it, or you may decide to opt for another shop with a better location. Although you can't know for sure how good a location really is until you get there, the more thorough your research is, the better your chances are of setting up and earning money quickly.

The Yellow Page photocopies containing the T-shirt wholesalers and retailer listings will contain the most important and useful information. The first call you should make is to the T-shirt wholesaler(s) in or near the town to which you're relocating. The wholesaler will know all the local retail shop owners and, in most cases, won't mind recommending a few shops that might be interested.

Talk directly with someone in sales and explain that you are an airbrush artist looking for a shop in which to set up. Salespeople will be the most helpful because they are in contact with the shop owners you are trying to reach. If there are no wholesalers in the listings sent by the chamber of commerce, your only other option is to call the T-shirt shops individually.

Expect the shop owners to be a little surprised by your call. After all, you are a stranger calling from out of town and asking for a place in which to work. The owners are going to be apprehensive.

Marketable Images

There are certain designs and lettering styles that artists will be expected to know if they plan to work in the airbrush industry.

The most basic typeface you will need to know is script. Script is used for names and short phrases. You will also need a block lettering style that is used for names (usually when the script style would be too feminine) and for longer blocks of text. Block letters are used for long text blocks because they are the easiest to keep straight and level.

Beyond these two typefaces, script and block, you could increase your design capabilities if you would learn several more, but this is optional. You can find typeface samples at your local library listed under typesetting, lettering and calligraphy. You will see entire typeface alphabets rendered in these books, and it is only a matter of copying what you see. As you practice, you will become familiar with each letter's differences.

Proficient lettering will come with practice; there is no reason to force it. Use a soft lead pencil (I recommend a #6B, which can be found at any art store) to sketch out your letters when you first begin painting letters. You will be amazed that, after practicing only a few times, you will be familiar with the entire alphabet.

In the coastal tourist towns, you will be expected to know how to paint beach scenes. The beach scene is basically an arrangement of many different elements: palm trees, waves, sand and plants, water skier or surfer, sky, clouds, birds and water. The same applies to ski resort towns, where you have mountains, trees, different birds and plants and, of course, the skier to work with. You will have to know how to arrange all the different elements into interesting and creative compositions and also incorporate lettering.

In any location, you will be expected to paint cars, motorcycles, boats and pets; these are the basic custom orders. To paint them, you will need basic drawing skills, an opaque projector, or a creative style that frees you from the constraint of drawing.

Different artists have different levels of ability to draw and render, and they compensate for this in a variety of ways. Some artists who don't draw well or don't want to take a lot of time drawing develop a style that replaces drawing skill with high energy and creativity, such as a cartoon style.

Shop owners won't expect anything specific, but they will expect you to have a certain style and skill level already developed for their market.

The best approach is to be very upbeat and excited about what you do. The shop owner will be reassured if you project a positive attitude.

The shop owner's biggest fear is that you want a long-term commitment from them for a place to work when you arrive. They are afraid of reprisals should they make this promise and then renege if things don't work out, after you have gone to all the trouble of moving. This has never happened to me, nor have I ever heard of problems like this happening to other artists, but I can understand the shop owner's fears. Reassure the owner that you understand these are tentative arrangements and that he is not responsible if things don't work out.

When I call out-of-town shop owners, I usually tell them that I've just finished the season at my current location and would like to try a new location. I tell them that their town has all the elements needed to make us both a lot of money. If things don't work out, I'll consider it a nice vacation. This always dissipates tension and lets the conversation move on to other details.

If the shop owner refuses to listen to your proposal, I can assure you that a working relationship was probably impossible, too. There are a lot of narrow minds in the T-shirt industry, so don't be discouraged if you hear a few "nos." When I relocated to St. Thomas in the U.S. Virgin Islands, I was told no fourteen times before I found a place where I could set up. (For more on this trip, see pages 46-47.)

While talking to the shop owner, convey the same information as in "Approaching an Owner" (see pages 14-16). The only difference is that you must set a date to show up and begin painting.

Don't plan to be set up and working the first day you arrive in town. If you set up within three to five days, you'll be doing well. The shop owners usually want to talk through the operation and arrange a space where you can paint, as well as gather any stock you may need. Also, find a place where you can stay and get settled in. The first few days will seem very confusing, but try to stay calm. It won't take long for the money to start rolling in.

Sometimes things don't work out. Perhaps the shop is too far from the main strip or you just don't hit it off with the shop owner. Don't despair. If you can set up and paint in the shop as planned, you should. This will keep some money rolling in, even if it's only a temporary arrangement. In your off-time, tuck your portfolio under your arm and visit some of the other shops in the town. Then arrange for a better location with another shop.

It is ideal if you can visit a town before moving there. I do this when the towns are close enough, perhaps within the same state. If the location is far away, however, such as the time I moved from California to the Virgin Islands, it probably won't be cost effective to visit first. (In my case, I had planned for the worst, and knew it might be necessary to return to a location where I knew I could find work, such as the Florida coast.)

Finding the Hot Markets
Airbrushed T-shirts are the best-selling gift items in tourist areas. Most tourists want to bring back a gift for friends or relatives. T-shirts are lightweight and don't take up much room in suitcases. When you add the fact that airbrushed T-shirts are one-of-a-kind items and can be personalized with monograms, their popularity increases.

If the tourist market sounds right for you and you are willing to travel, the first step is to choose a town that has few airbrush artists or none at all. Having a few artists working in the same area actually increases business and sends a message to potential customers that airbrushing must be popular in order to support all these artists. On the other hand, don't worry if you are the only artist within a hundred miles. The sheer novelty of airbrushing will usually generate plenty of business. If it turns out that the reason there were no airbrush artists was because there was too little business to support any, move on. Besides having enough savings to carry you for a while, you should choose a backup location and research it before you leave home so you can move easily if you need to.

The worst situation is a town saturated with too many airbrush artists. The areas most saturated with artists are towns along the Florida coast, especially Panama City and Fort Walton Beach. I have seen airbrush artists set up in gas stations and other oddball places throughout these towns during the summer season. And yet, only thirty miles down the coast in Pensacola, there were fewer artists who were charging more and producing better artwork overall.

When an area like Panama City or Fort Walton Beach becomes saturated with airbrushing, the artists cut prices in order to compete. They have to paint more shirts faster in order to earn the same amount of money. Painting faster lowers the quality of the art and leads to dissatisfied customers. I have seen the quality of painting drop in some tourist towns to the point where customers completely stopped buying airbrushed T-shirts.

Also, shop owners in saturated areas demand

that artists pay higher percentages. Competition accounts for this: They can easily find other artists who will work for less. This results in a proliferation of unqualified artists who paint poorly, and, again, customers stop buying. Businesspeople are usually not artists and most can't tell a good artist from a bad one, so they hire any artist willing to work for low commissions.

Know when to start looking if you plan to work during the busy seasons. The southern coastal area is busy in early June, when high schools close for the summer. The season continues until September, when the kids return to school. Most of the hot summer airbrush locations are secured by late May, so the best time to start calling is early April.

The season at winter resorts starts with the first snowfall and becomes continuously busier as the season progresses. Just before the first snowfall, contact the resorts to find work. There is usually a calm period before the snow comes. This is a good time to make arrangements and set up displays. When the snow is on the ground, the reservations pick up. As the rental facilities fill up, your business increases.

Summer tourist locations. Locations that generate the highest airbrush incomes are summer vacation spots located along the beaches of the United States. The East Coast's choice airbrush spots start at Virginia Beach and continue south to Florida and along the Gulf of Mexico to South Padre Island at the southern tip of Texas. This area is known as the "Gold Coast" to airbrush artists.

On the West Coast, the hot areas start at San Diego and follow along the coast north to Santa Cruz. During the summer, tourists flock to these areas to enjoy the beaches and other attractions of California. The California coast does not offer the same income opportunities as the East Coast, but it does enjoy a strong and slightly longer season.

Ski resorts. These resorts offer the same excellent income opportunities as the summer tourist towns and for the same reasons. Tourists want to buy gifts that are relatively inexpensive, personal, lightweight, and easy to store. Airbrushed T-shirts offer all these elements and this, in turn, spells success for the airbrush artist.

The ski resort season starts with the first snow and continues until the snow melts (in some areas, as late as May). These resorts are located throughout the northwestern and northeastern mountain ranges. Contact any travel agent to find out the specific names and addresses of resorts. Most resorts also have general information telephone numbers that can provide you with the names and addresses of local T-shirt shops that may be located there.

Amusement parks and other resort areas. Some towns have certain geographical or man-made attractions that attract customers year round. These locations can be extremely lucrative for the artists that discover them and find a good location to set up within them. Because these towns draw customers all year, you will be able to fill your available work hours twelve months a year, and because you don't have to move with the seasons, your income is not interrupted, eliminating that expense. These hot spots can yield some of the highest incomes in the airbrush industry.

The reason I don't list these sites as the best income-producing locations is because they are hard to find. Most artists just happen onto them—and never leave. I know of two locations in the United States with that sort of year-round potential. I will describe both in hopes that if you happen upon one of these locations, you will recognize it and take full advantage of it.

Gatlinburg, Tennessee, is the first. The main attraction of Gatlinburg is snow skiing in the winter and water skiing and boating in the summer. Having a mountain and mountain lake together has attracted year-round tourist business for this town. You can see how the geographical influences have worked together to create one of the best locations for year-round airbrush.

I contacted the chamber of commerce in Gatlinburg and requested the information I outlined in the previous section. I also contacted some of the local T-shirt wholesalers and with their help tracked down a couple of airbrush artists working there. Both confirmed that the location did in fact yield a year-round income with only minor slowdowns around the edges of the winter and summer seasons.

The second year-round location is Branson, Missouri. I first heard about Branson, Missouri, on the television show "60 Minutes." It seems that many top country and western singers are building their own theaters here to perform in. At last count there were twelve and several more under construction.

While the thrust of "60 Minutes'" report was to explain this boom, my ears perked up when I heard an amazing statistic: the town of Branson had a permanent population of only 4000 people but played host to over 4,000,000 tourists per year. To illustrate how good this location could be, let's compare it to the island of St. Thomas, which has about 3,200,000 tourists per year and a local popu-

lation of about 25,000. A high local population usually indicates a lot of competition and depressed prices. The lower the local population, the more opportunity you will have.

I called the Branson Chamber of Commerce and instigated my standard investigative techniques. I could only verify that there were three artists working in the town, but they were all doing extremely well. I'm sure there is room for many more.

Winter work in malls. During the winter, many artists seek opportunities to set up in shopping malls. If you prefer a mall environment, the whole country is open to you. All you need do to make a living is find a shopping mall with heavy foot traffic. You may not earn as much money as you would in the summer resort areas, but the average mall income is between three hundred to eight hundred dollars per week. This range is wide because shopping mall traffic varies greatly. If you find that you are not earning enough money in a specific mall, try to move to another location. Expect to make a lot of money during the Christmas season, but you can also receive requests for birthday presents and other custom work.

Foreign locations. There are many rules and regulations that must be observed in order to work in a foreign country, so looking for work outside the United States is a major decision. You will need a passport in most cases (Mexico and Canada do not require passports). A passport application can be obtained at your local post office; in my case, the post office mailed an application to my home.

Each country has different requirements for foreign workers, such as visas and work permits. To find out about these regulations, contact their nearest embassy and request an information packet, which should include all the applications and information you need. Many First World and Second World countries have embassies in most large cities, and any country that has an embassy will also have one in Washington, D.C.

To contact an embassy, call for telephone information either in a large city near you or in Washington, D.C., and ask for the number of the embassy of the country in which you want to work. Call the embassy and ask for its mailing address. Then send a letter asking, first, if aliens are allowed to work in their country and, second, if they could forward you information about how to do so. I suggest writing a letter because your request will be routed to the right department and you will receive written instructions on how to arrange to work in a foreign country. The person on the telephone at the embassy is not the one to ask for advice. I can't stress strongly enough the importance of following through on every step required when arranging foreign employment. Many countries don't like foreigners stealing jobs from the locals, so you need to be particularly sensitive to protocol.

When I was looking for a spot in the Caribbean to paint, I chose the Virgin Islands because they are U.S. territories and I wouldn't have the hassles of setting up in foreign territory. Just before writing this book, I traveled to Europe just to locate potential airbrush locations. Since tourists are the main consumers of airbrushed T-shirts, it seemed logical that what works in the United States would also work well in the tourist areas abroad.

In London, England, and Paris, France, I found literally hundreds of small T-shirt and tourist shops located near most major monuments. The majority of the shops were independently owned, which meant the owner was easy to find. I talked to many of the shop owners and found them to be very open to the idea of having an airbrush artist work in their shop. This was welcome news.

There are also a number of outdoor shopping areas that will accommodate an artist and are inexpensive. It is only a matter of contacting the property owners and renting a spot. Usually, this information can be learned from other vendors. Don't confuse these outdoor locations with the American flea market or garage sale. European outdoor bazaars are stocked with new, high-quality merchandise, the atmosphere is festive, and most importantly, they draw large crowds.

The only negative factor I encountered was the language barrier in Paris. Many of the tourists were French and spoke only the native language. I knew that to access the entire market, I would need to hire a bilingual helper or find a shop that could translate for me. However, many young people in France study English as a second language and are willing to work for little money, so that problem isn't as difficult as it seemed. Also, many of the shop owners were bilingual and offered to handle the customers.

By the end of my trip, I felt certain that I could airbrush in a T-shirt shop in either London or Paris, where there were plenty of tourists. Making money would not be a problem because I had spent hours watching the shops and saw for myself how much the tourists were spending and what they bought. The quantities of T-shirts sold equaled or exceeded those of any T-shirt shop on the Florida coast or in a U.S. winter resort.

Artist Spotlight: My Trip to the U.S. Virgin Islands

I had just finished a successful Christmas season of airbrushing in a mall near San Francisco, and was ready for a change to a warmer climate. My intention was to paint from February until May, then move to the Florida coast and work the summer season. I knew I could probably find work in the Caribbean because their high season was in the winter, when people from the North flock there to escape the winter cold.

I went to the public library and checked out all the travel books they had on the Caribbean. I looked in the atlas to get an idea of the islands' populations and to find out which islands depended on the tourist trade as their main source of income.

The next decision was to choose an island. I couldn't go to a foreign-held island because the legal formalities would have taken longer to organize than I planned to spend painting there. After finishing my homework, I decided on the U.S. Virgin Islands—St. Thomas, specifically—because it promised the most tourist trade, over three million visitors per year. This was more traffic than in any town I had ever painted in before. I felt sure that if I could find a shop to set up in, I would do well.

I called the chamber of commerce in St. Thomas and requested a photocopy of the Yellow Page listings of local T-shirt shops, wholesalers and souvenir shops, along with a local newspaper and a map. When I received the information, I found so many T-shirt shops and potential places where I could airbrush that calling all the leads would cost a small fortune in telephone bills.

To minimize my expenses, I decided to write a letter to all the shops, introducing myself and spelling out everything that was involved in airbrushing.

I mailed out thirty letters in the first week of January and by February had received only one reply thanking me for the offer but explaining that they had no place where I could set up. If I wanted to go to the Islands, I would have to call the individual shop owners. The letters helped when calling shop owners because some remembered my name and what I intended to do. All of them appreciated the offer but made some excuse about why they hadn't replied.

I found the retailers to be rather relaxed and unaggressive. They didn't feel they had to change or add anything to their shops because things were going well. This was an attitude I had never encoun-

tered. Businesspeople in the United States are always looking for ways to improve their shops and constantly try to add new and interesting products to their stock.

I was getting somewhat discouraged, but on the fifteenth try I struck gold. I talked to a man named Richard, who owned the Mountain Top store. The facility had a restaurant, bar, and several retail shops. They were "enjoying healthy business because the cruise ships full of tourists were still docking in St. Thomas." The only problem was that their building had been badly damaged by hurricane Hugo several months before.

Richard told me that everything was still functioning, but because the building was so badly damaged, the retailers and restaurateur relocated to the parking lot. The shop owners built small wooden huts with two-by-fours and plywood sheets. I would also have to construct a building at my own cost— about eight hundred dollars—if I wanted to work there.

I asked Richard how many tourists visited his location each day. If at least two thousand people per day passed an airbrush location, enough business would be generated to earn a good living, plus sock a little away in savings. Richard said that on an average day, close to 3,500 people visited the Mountain Top. We settled on a 25 percent commission, and I said I would call him back the next day to let him know my final decision.

After talking to Richard, I added up all the costs involved in moving and setting up once there. I was surprised to find that I could recoup my investment within six weeks. The expenses for the trip were:

Flight (round-trip)	$1200
Lodging (averaged over six weeks)	$1260
Food (estimated $20 per day)	$ 840
Building (one-time cost)	$ 800
Opening T-shirt inventory	$ 500
Total	$4600

I divided the total expenses of $4600 by the forty-two days (six weeks) and figured I needed about $110 per day of income to recoup my investment in six weeks. Since I had from February 1 to May 1 to make money on St. Thomas before moving to the coast of Florida for the summer season, I actually had closer to sixteen weeks to earn back my investment. The numbers looked good, so I called Richard back the next day to set a date for my arrival in St. Thomas.

I took only my equipment and enough clothes to last between washings. I put the rest of my belongings into storage, packed in shipping cartons, so they could be forwarded easily if I chose not to return. I hoped that with such a long season in St. Thomas, I might be able to do well enough to move there permanently and air brush year-round. If not, I planned to move back to the San Francisco Bay Area.

I landed in St. Thomas at about nine in the morning, took a cab to the hotel and checked in, then another cab to the Mountain Top. (I would quickly learn that taxi cabs rule the tourist trade in St. Thomas because the most efficient and cost-effective way for tourists to get around the islands and see the sights is to take a cab. I made it a point to get to know some taxidrivers, gave a couple of T-shirts to them, and soon all the cab drivers began parking in a new spot where the passengers had to walk past my airbrush shop.)

The Mountain Top caretaker and I built my shop. We trimmed the roof with palm fronds, and with a little creative use of dried sugar cane stalks, the shop looked like a native beach hut. It took John and me about two days to complete the building. Within five days I had painted and displayed a basic set of designs and T-shirts. The sales started as soon as the displays went up on the walls.

The taxi cabs stopped at the Mountain Top for only fifteen to twenty minutes, which meant sales had to be earned fast. I couldn't even offer custom work because there was no time to paint the orders. On the other hand, golf hats sold extremely well because many cruise ship passengers are senior citizens who play a lot of golf. I charged twelve dollars for a hat that cost me $1.35 and took less than three minutes to paint. These hat sales more than made up for lost custom sales.

Now that my shop was set up and open, I turned my energies to finding a place to live. When I asked Richard if he could recommend an inexpensive place to live (my hotel cost forty-five dollars a night—more than I wanted to spend), he suggested that I move into the old building that had been damaged by the hurricane. I thought he was joking at first, but he was serious. We went down the steps leading to the damaged building. This original building stood on a cliff overlooking the beautiful blue waters of Megan's Bay. The retail section of the building had been hit worst, but the section that had housed the

business offices, public bathrooms, and storage rooms behind was completely untouched.

Richard said that he hadn't settled with the insurance company yet and didn't know if he would have a lease after May first. He told me that he didn't want me to go through all the trouble of renting an apartment, buying a car, and all the other necessities and then not have a place to work in May. He then suggested that I camp out in the old building until the lease was settled. Richard opened one of the office doors and I was overwhelmed by the view. At one end of the office, there were six floor-to-ceiling windows that looked out over Megan's Bay. He didn't have to ask me twice. When I asked Richard about rent, he told me not to worry about it and suggested I paint him a couple of T-shirts.

That's about the way things went for the next twelve weeks. I had no trouble earning my daily overhead. I settled into a routine of filling stock in the morning, before the cabs arrived. The late morning and much of the afternoon was spent talking to customers and making sales. The Mountain Top closed down around four in the afternoon. Sometimes I would go out with the other retailers or walk to a nearby restaurant, but most nights I spent in my room over Megan's Bay.

My stay on the island lasted from February 7 until May 1. During the three months I spent on St. Thomas, I earned almost $200 per day. To get an accurate net income, subtract the cost of the blank garments from the two hundred dollars I earned. The cost of the blank garments constituted about 30 percent of each sale, or $60 out of the $200. This left me with daily net sales of $140; that's about $4,200 per month, or $12,600 for the three-month period. The cost of plane tickets, the airbrush shack, food and other expenses totaled less than five thousand. I would leave St. Thomas with about eight thousand dollars in my pocket.

As the first of May approached, Richard announced that his lease would not be renewed and he would be moving back to the States. The other retailers began negotiating leases with the new landlords, who planned to rebuild the Mountain Top, complete with condos, a new restaurant, and lots of retail space. For me, the trip was over on the first of May when I flew to Pensacola, to start a new season on the Gulf of Mexico.

Chapter Four

Airbrushed Artworks on Canvas

You can paint any subject on canvas with an airbrush, but there are two main approaches to making money this way: commissioned subjects — where someone pays you to paint a specific person or object — and "completed artwork" — pictures you create and sell once they're finished. Which of the two you choose will depend on what you enjoy painting and how you are most comfortable creating and selling your art.

The market for commissioned works differs greatly from that for completed paintings. Not only will your approach to your customers vary, but you'll find them in very different places. Art festivals and galleries attract people interested in purchasing finished art. It would, in fact, be almost impossible to create a commissioned painting in such a setting because of the distractions and interruptions. It's easier, and more appropriate, to solicit commissions where you find people eager to celebrate a special life event or to have a record of a prized possession. I will first explain how to sell your skills as an artist when seeking commissions. After that, I'll discuss the varied subjects and categories of the prepainted art markets that are available for airbrush artists.

Airbrushing on Commission

To get commissions, you must seek out people who want a specific subject painted (a person, a car, an animal, a building). Once this person is found, you can sell them on the idea that you are the best artist to render their request. Once you have sold the customer, you will be expected to execute a painting in the same style represented in your portfolio. The most successful commission artists try to make any subject they paint attractive, even if they find it ugly.

Commissioned art is really a market for the realist. Abstract artists usually have a hard time making money in the commissioned art field because they sometimes abstract the subject matter to an almost unrecognizable degree. That doesn't mean you can't paint in your own style or interpret it according to your own vision, but the owner of a hot rod should be able to tell that it is his car in your painting.

You will create these paintings from photographs that you or your customers take. Although you could do portraits from life, as an oil painter would, I've always found it better to work from a photograph, and of course, it's not practical to paint a car or boat from life. You'd spend more time dragging your equipment around and setting it up than you would airbrushing.

Many airbrush artists do create portraits and other commissions freehand. But if your drawing skills aren't as strong as your airbrushing skills, you can use the opaque projector to create your sketch.

Even with an opaque projector you should look at your work and decide what kind(s) of subjects you do best. Although you can use the opaque projector to develop a good sketch, capturing subtle flesh tones for portraits requires different airbrushing skills from creating the metallic highlights on a car. So it's a good idea to stick to what you do well initially and expand your range of subjects and markets as you increase your skills.

Who Commissions Airbrush Paintings?

What moves people to commission a portrait is usually to commemorate special moments — weddings, births and, unfortunately, deaths — or to honor a special person. People rarely commission a portrait of themselves, though they will sometimes ask to be included in the painting. Husbands request portraits of their wives or vice versa, and the same applies to boyfriends and girlfriends. Parents request portraits of their children, especially newborn babies. Parents may also commission wedding portraits. Older people often request portraits of their deceased parents. Thirty percent of all the portraits I have painted have been of deceased people at the request of relatives.

Painting dead people can be a little disquieting. I felt a little odd the first time I was asked to paint the portrait of a person who had passed away. But after a little reflection, I came to the realization that I was honoring this person. Most of the time, I had only old photographs to work from. The finished product always looked better than the cracked and peeling photos. I was helping these people to remember their deceased loved ones in a way only an artist could. No machine can take old photographs and breathe new life into them. (No pun intended!)

People will commission a painting of basically anything that is important to them. You can get commissions to paint the things people love, like their cars, boats, airplanes, pets and homes. I have painted thousands of show cars and race cars throughout my career. And thousands of pets. I

believe pets become like any other family member after a while.

To make money you have to let people know that you can paint any image they want on a canvas. But how do you find people who will want you to paint someone or something for them?

Where to Find Commissions
The most important aspect of selling your art is to get your art in front of the people who are likely to want it. Since we know people who order portraits want to honor certain persons or things, the place to advertise is where large numbers of these people go.

The simplest way to advertise your service is with flyers. (See pages 51-52 for how to create a flyer.) You can put up flyers almost anywhere; you never know when a potential customer will see it. You can post flyers on bulletin boards, walls and windows. Advertise for both portraits and commissioned art at these locations (after getting permission to do so, if necessary):

- Colleges and high schools
- Day care centers
- Hospitals
- Laundromats
- Churches
- Meeting halls and clubs
- Large company cafeterias
- Stores with public bulletin boards, such as supermarkets, discount houses, drugstores, etc.

But the best way to reach many potential customers is through stores where people buy goods or services associated with special life events. For example, people celebrating the birth of a newborn baby can be found at baby stores, where they will be buying new clothes, strollers and other necessities. These are some places people typically go when something important is happening in their lives:

- Baby stores
- Tuxedo rental stores
- Bridal shops

Another avenue to explore is stores where people acquire or buy things for special possessions. People love their pets and possessions and will commission a painting if they know the service is available. Try these places:

- Pet stores
- Kennels and dog grooming shops
- Auto parts stores
- Custom auto detail shops
- Exotic car dealerships
- Exotic boat dealerships
- Marinas

Retail outlets can be excellent places to advertise your portraits and commissioned paintings. You gain the exposure needed to generate enough customers to support you and your work. To increase business, you need only establish more distribution outlets. This type of marketing will also help you establish your reputation throughout the community. As your reputation grows, you will find yourself in demand. And once the demand for your portraits and paintings increases, the price you can charge also increases.

Often you will be a welcome addition to a retail shop because the shop owners may rightly view you as a new source of income—with little expense to themselves. Many retailers will allow you to leave flyers in their stores. Some will let you put up a small display. Others will even take orders for you for a percentage on any art you sell through their shop. This is a simple deal and the arrangement can last for years, as long as you fill the orders the retailer takes for you.

To negotiate an arrangement with a retailer, visit store owners in person; don't approach them on the telephone. I recommend going in person so the shop owner can actually meet you. This is important because *you* are the product. You are selling a service through the retail shop and the owner would naturally want to meet the person who fills the airbrush orders. He or she will also want to see your work. While you are talking you can show your portfolio, carefully prepared with large color photographs of the types of paintings you want to sell through the store. Most retailers are used to having salespeople show up unannounced all the time, so don't worry about just walking in.

The type of arrangements you make with the retailer will depend on how involved you want to make it. I have had the greatest success with approaching the shop owner in stages. Rather than asking them to put up a display and train their employees to take orders, I ask them if I can just leave a few flyers on their counters "just to see if this will work out." This slower approach will keep the shop owner from getting too nervous at too much change, too fast. It will also let you test the location before you invest any money in a display.

If, after a few weeks, I've landed several jobs from the flyers I left in a shop owner's store I might ask her to try and take a few orders at her store and offer a commission. This will put some money

in the shop owner's hands and put you in the position of producing income for them. Your position will become more secure once you put some cash in the shop owner's pocket.

Once a shop owner is taking orders for me on a regular basis I ask her if she thinks a display might increase sales. By consulting the shop owner you put her in the position of power. This will keep her defenses down and almost insure a positive answer. The shop owner will probably ask what you had in mind.

Your best position is to have a display in a store and have the store take orders for you. This arrangement makes you a product offered by the store—part of the inventory, you might say. Your position will be more secure; the more time that you work through the shop the less likely the shop owner will be to ask you to leave, because your service will become known by the shop's clientele.

On the other hand, several shops I've put flyers in for several years have never wanted to put up a display or receive a commission. These shop owners don't mind helping an artist. (I have found that people generally like helping others when they can.) In cases like this, customers contact me from the phone number on the flyer and make arrangements to come to my home to place orders.

No matter what arrangement you establish you will most likely make money. Be flexible and tailor each arrangement to suit the individual shop owner.

Placing Flyers in Stores

Flyers are the least expensive way to advertise your business. (A thousand black-and-white flyers will cost about sixty dollars.) If a retailer does not let you put up a display or a display is not really warranted, leave flyers to be placed on the counter. I use flyers exclusively in auto parts stores, because the people who want a painting of their car, boat or motorcycle often call long after they have picked up the flyer.

You can create one flyer that advertises several different products, such as cars, boats and motorcycles, or just one product like portraits. You can also offer different variations of the same product: color portraits, black-and-white portraits, pencil sketch portraits. This is something you really want to think through, because one flyer can service many markets and save you printing costs.

Always have a visual of any product you advertise on the flyer. You'll need to get a halftone made from a photo to have it reproduce well. Photocopies save money but don't look as good. (For more

on getting halftones made and printing, see pages 32-33.) Most of the flyer will be taken up with copy promoting your work and giving ordering information. This can be handwritten, typewritten or, if you can afford it, typeset. Once your photos and copy are ready, take them to the printer for reproduction.

The information on the flyer should include:

The headline. This is the largest piece of text and states exactly what you want to offer. For example: CUSTOM AIRBRUSHED PAINTINGS OF CARS, MOTORCYCLES, AND BOATS.

Your name. You are part of the product you're selling. You are also trying to establish a reputation through references from satisfied customers and other people who have heard of your work. If they don't know your name, they may call someone who does similar work instead.

Body copy. A short paragraph should give more detail about what you offer. It tells how your customer will benefit from having your painting. "Celebrate that special moment with a portrait of your loved one." Or "Have a painting of your boat where all your friends can see it. More dramatic than a photo."

If you want to offer "satisfaction guaranteed," this is the place for it. Just remember, if you offer it you'll have to stick by it. I always include this statement and I have never regretted it.

I do not recommend putting prices on your flyer. If you ever want to increase your prices you will have to throw away your "priced" flyers and this will increase your overhead.

A "call to action." This is a statement that moves the customer to take action: "Call Today" or "For More Information Call. . . ." You can also use a special offer at this point, such as "25% Discount With This Flyer" or "Ask About The Special Offer With This Flyer."

For special offers, you can offer the customer a canvas one size larger for the same price as a smaller one. Another special offer could be to include some free lettering. Many people name their vehicles; including the name of the boat, car or motorcycle is not very difficult and can add value to a painting.

Ordering information. Give a phone number where you can be reached for orders. I work at home and can take calls during the day. If you work during the day, add "evenings only" after your telephone number. Customers will not be put off if they know you have another job. But it would be better to invest in an answering machine so customers can leave their names and numbers and

even a short message for you any time instead of having to wait until evening. That way they won't lose interest or forget to call.

Creating a Display
There are many different ways to make displays, but this is the way I have always made displays, and it has worked well for me over the years. What I am going to outline here is just that, an outline. You should feel free to add any special touches you want. You can use bright-colored mats around your photos, custom typesetting, or fancy calligraphy for the lettering. Remember, this should be fun as well as profitable.

Your first step is to ask the shop owner how much space you can have. Often, he will ask me how much space I need. In this case, I tell him I need about 20×30-inches. I have tried larger and smaller displays, but this size seems to get noticed the most.

Once the shop owner has allocated a specific amount of space, I buy a picture frame and glass of that size. I always try to match the frame style with that of the shop. Then, I cut a mat with four openings. In three of the openings I put 5×7-inch photographs of my work that are appropriate for the store. Obviously, you don't want to put bridal portraits in a baby store or vice versa. Paintings of cars won't get you many commissions in a marina, nor will paintings of pets.

Use actual samples of paintings people have commissioned you to do, because these will best represent what you do. If you display very professional-looking work, then deliver anything less, the customer may get upset. I make a point of delivering paintings that look as good—if not better—than what is displayed.

In the fourth mat opening I put signage about the artwork I do and how to order. The signage includes the same information as your flyer (see pages 51-52), but you can tailor the headline to the store.

The headline is still the most important element of the signage. Make it the largest piece of text and appropriate for the type of store it will be in. In a baby shop, I'd put "BABY PORTRAITS" as the headline. In a tuxedo rental store, I might just say "PORTRAITS," because people renting tuxedos do so for many different reasons. Be as specific as possible.

The headline can be done in color, fancy type or calligraphy, just as long as it remains readable.

Your name comes after the headline. This is important, because while you are trying to make sales in this particular store, you are also trying to establish your reputation. Once you get a reputation, work will also come your way by word-of-mouth. While you want to keep getting orders through the store, it's nice to get additional sales that you won't have to pay a commission on. Even more important, word-of-mouth sales are an indication that demand is being established for your work and that you will eventually be able to raise your prices.

The body copy below your name, a short paragraph, gives potential customers more detail about the product, tells them to order at the counter inside the store, and tells them how long it will take to process the order. If customers think they have to contact you personally, you have defeated the purpose of the in-store display. I do not recommend putting prices on the display, because if you ever want to change the pricing, you will have to rework the display. Typical display copy might be like this: "Celebrate the birth of your new baby with an original portrait by Joseph B. Sanchez. Capture a likeness that will last for generations. Only the best materials are used, and there are many sizes to choose from. Satisfaction is guaranteed. It's simple to order, just ask at the counter."

Again, I always include a statement guaranteeing a customer's satisfaction because I never want a dissatisfied customer. This is important if you are trying to build a reputation. Much of your work will come from word-of-mouth. If you have dissatisfied customers, you will not only lose their future business, but they will also talk negatively about you if you do nothing to correct the situation. (See page 112 on resolving a situation where a customer isn't satisfied.)

Whenever a shop owner is taking orders for you, provide him with a price list for the different sizes of canvases and explicit instructions on taking an order. I always urge shop owners to call me immediately if they have any questions, and they usually have a lot. Customers will want to know if a pet can be included in a portrait of a person. They will ask the shop owner if you can paint on cars and garments. No matter how thorough you make your set of instructions for taking an order, the shop owner, sales clerk or customer will come up with something unexpected. The best way to handle it is to get them in the habit of calling you. Most problems can be handled with a phone call. They will need to call you anyway to let you know you have an order.

(*Note*: When first setting up in a shop, call about three times a week just to see if they have taken any orders for you. It is not uncommon to find that

orders have been taken and the employees have forgotten to call and let you know.)

A Sample Price List for the Shop Owner:
Airbrush Canvas Portraits Price List
Prices include canvas and one figure (excluding frame):

11 × 14 up to 16 × 20 } Color—$110
B&W—$60
With additional } Color—add $35
figure B&W—add $25

18 × 24 up to 30 × 40 } Color—$140
B&W—$80
With additional } Color—add $45
figure B&W—add $35

40 × 50 up to 50 × 60 } Color—$200
B&W—$110
With additional } Color—add $75
figure B&W—add $60

Note from Artist to Retailer: If a customer has questions or is interested in something other than items listed above: 1. Call me at 555-5555. 2. If there is no answer, please take customer's number and pass it on to me later or leave a message with the customer's number on my answering machine. Be sure to:
1. Have the customer sign the Airbrush Order Form.
2. Get the customer's phone number.
3. Collect for the order in full.

Besides the display and price list, I also give the store owner about a dozen airbrush order forms. The form requests the name, telephone number and address of the customer, along with a written explanation of exactly what the customer wants. The shop owner or employees fill out the form and place it with the order for you to pick up. This gives you a way to contact the customer if you have any questions and also covers you in the event a shop employee made a mistake when taking the order.

Meeting the Customer
Some retail shops you approach may not be interested in earning a percentage from you yet will allow you to put flyers in their shops. They may be letting you test the market at their location, the results of which may warrant further involvement on their part. In the meantime, you will have to meet with the customers and close the deals yourself.

The first meeting with a customer will be conducted over the phone when they call you. Tell him that you will need a picture of what he wants painted, and remind him that all orders are prepaid, so he will need to bring cash or a check (if you want to accept checks).

Customers are usually a little wary of giving you cash in a public place; they'd rather see you in a home or business setting. Invite the customer to your home, if you can, because it will give him a sense of security. However, you may want to approach this meeting cautiously. In some cases, inviting a stranger into your home could be dangerous. If you have any fears, just arrange a meeting in a public place. If the customer has reservations about paying you in full, accept half down with the balance to be paid on delivery.

At this meeting, show the customer several samples of your work, so he can see what the finished painting will look like. When I meet a customer for the first time, I present my formal portfolio of color photographs.

Pricing Commissioned Paintings

Pricing is difficult to discuss because artists work at different speeds and produce a wide range of quality. Where your work is displayed will also affect your pricing; obviously, high-end locations will yield more than low-end locations. Different subjects also command different prices. A painting of an adult person will generally yield more money than a painting of a car, though I've found that paintings of pets command a higher price than paintings of infants. Throughout this book, I have recommended a uniform approach to pricing: Set an hourly rate for yourself and price your art accordingly.

Prices of around $100 will generate a lot more work than $300. If you can somehow work in even lower prices, you may find yourself quite busy. For example, I offer black-and-white portraits and pencil sketches as well as full-color portraits. Because these renderings can be done faster than full-color portraits, I can price them lower. These lower-end products account for almost 50 percent of my work.

I have always charged the same amounts whether I pay a commission or not. At first glance it might make sense to increase prices when you are paying the store a commission and reduce prices when you take an order directly. But paying the commission can sometimes save you money. If the retail shop sells the customer and takes an order, you won't have to meet with the customer; this

can save a lot of time. If you have to wait around your studio to meet a customer, you may be losing time that could be spent making money elsewhere.

The truth is, you will spend as much money as a commission just on driving to deliver flyers to locations that don't charge commissions. Keeping twenty or thirty locations stocked with flyers will take about two days a week. When you consider travel time and gas, wear and tear on your vehicle, and then time spent meeting with all the customers that respond to your flyers, you are spending at least 25 percent of the income you generate.

I do not recommend offering framing for your art. People want to choose from a variety of moldings and mats, and keeping all that in stock can be a lot of trouble, not to mention expense. Also, framing is a rather involved craft and requires specific equipment to do a good job. Most people don't mind going to a frame shop. I don't believe not offering framing has ever cost me a sale.

There is one final aspect of pricing I would like to mention. You will have to adjust quality to meet your prices. You can't charge different prices for your art and then paint every painting with the same high quality. If you charge someone thirty-five dollars for a painting, don't put a hundred dollars worth of time into it. Many artists work just as hard on a painting they have priced low as on one they've priced high. This will cost you money in the long run.

Where and How to Sell Completed Artwork

What subjects you paint and why you paint them are very personal matters — and outside the scope of this book. But it is harder to predict how some subjects will sell than it is with others. Some artists who focus on expressing their creativity to the fullest, painting only what they want to paint, make a good living from their work. Others, equally good, never find a market for their work.

Some artists consciously choose to paint subjects that appeal to a specific market. They're comfortable painting pictures of popular subjects, such as rural scenes or cute animals, in a realistic, accessible style. Or they become known for a particular style or type of art; H.F. Giger, for example, is known for his paintings of nightmare monsters.

To have the best chance of selling your art, choose a specific market. I don't want to tell you what to paint; I'm only suggesting that you review what you paint and recognize what market it belongs in. You don't have to stop painting what you love, but you do have to accept the fact that painting what you love may never be financially rewarding.

Most of the markets are divided by subject matter or categories. Wildlife, Americana, domestic and rural subjects such as old barns and Raggedy Ann dolls are popular mass-market subjects. They sell well at art fairs and shows and to art publishers in the low-end and middle markets. Realistic paintings also work well in these mass-appeal markets. Galleries, art publishers, and interior designers and decorators who purchase art to be used as decoration in homes and offices generally accept a broad range of art. But even in these markets, many focus exclusively on a certain type of subject or style of work.

Most canvas art is sold either through galleries or directly by the artist at art shows or fairs. I include the art and poster publishers in the gallery category because they also purchase art for resale. The difference is that art publishers sell prints of art rather than originals.

The art show or fair market is the easiest to enter, although as noted above, the types of art that work well in this setting are somewhat limited. You should also be comfortable working with the public. Although you will have entrance fees and travel expenses, your overhead will be fairly low. Galleries, on the other hand, accept a fairly broad range of art but are harder to break into. They will display and sell your art for you but may charge as much as a 40 to 60 percent commission.

Because the art show market is easier to break into, we'll look at it first.

Selling Your Art at Shows and Fairs

All art shows and fairs are not created equal. Some have a reputation for drawing more customers than others — and a high-traffic show increases your chances of selling your art. You can find the art shows and fairs listed in the art industry's trade magazines:

- *Southwest Art*
- *Art New England*
- *West Art*
- *Artweek*

These magazines list shows that occur all over the country and list many types of different shows, too: craft, sculpture and ceramics, as well as canvas art. To find out if a show is right for you, write for information. Don't waste time traveling to a show that isn't right for your product.

Some of the shows will be juried; that is, a panel

What Kind of Artist Am I?

What is it about a painted piece of canvas stretched over a wooden frame that motivates people to spend millions of dollars? Must an artist have a reputation in order to be successful? Must an artist's work be of superior quality to achieve greatness? Many artists spend their entire lives looking for the answers to these questions. And sadly, many leave the field altogether because the answers are so difficult to find.

Before we can consider this further, I want to distinguish between commercial art and fine art. I personally define commercial art as art that is created to be sold. Fine art is everything else. Fine art is created by an artist with no considerations other than those that lie within his own heart and mind and for whom the experience of creating the art is more important than the finished piece of art. I'm not implying that commercial art is without heart or mind. A piece of my creative essence is in every painting I do. The difference with commercial art is that there is a set subject.

In commercial artwork, the artist's spirit is integrated with a particular subject. Sometimes this subject is set by a client and sometimes not. My art was extremely controlled during my years as an art director. Other times, I was given only the idea and was free to express it in my own way. The logic of commercial art is simple: The person who pays picks the subject. Artists can render any image on canvas. To earn money with this skill, they have to put images on canvas that someone is willing to pay for. If you want to do your own thing, you may be your only customer.

Many artists fail because their goals are unfocused. The creative side of a personality wants to make a grand statement, while the practical side wants to make money and enjoy a sense of security. Let's face it: nothing beats the act of creating. You may never experience the same fulfillment when you paint to make money as when you paint from the heart. At some point, you may have to make a conscious decision whether to make money or pursue some artistic ideal.

Deciding on your direction can actually improve your art. Your commitment to paint for money or to pursue your own concept will clearly define your finished artwork. Failure to draw a clear distinction can cause your painting to become a confusing mix of self-expression and an attempt to please others. This confusion radiates from the art and is obvious to everyone.

I'm not suggesting that artists sacrifice their integrity for money. Every artist should experiment and grow to the fullest. I am simply cautioning against merging art created solely for self-expression with art produced to make money. The two should be kept separate. When you feel motivated to try something new, do it. However, don't display these paintings with the art you've painted to make money. They will detract from your commercial art, which is designed for the buying public.

of judges will preview your art. Most artists think the jurors are looking for quality when in fact they are looking for art that is pornographic, politically unsavory, or offensive in some other way. Families are the primary customers at art shows and fairs and art that offends this group will probably not be allowed.

Sometimes, if the art show or fair is a sellout—meaning that all the available display space has been sold to artists—the jurors will choose the best art from the entries. This is rare. Most shows do not sell out, and as long as your art is basically acceptable, you will be accepted.

Most juried shows require you to send slides rather than photographs. If it is not mentioned in the show advertisement, you can assume slides are required. Send only the number of slides the jury asks for; they will not be impressed by a large body of work. And send your best.

The best-selling subjects at the shows are the classic realistic floral still lifes, wildlife, landscapes, Americana and Western scenes. You can paint any of these genres in any realistic style. Photorealism is not required. Feel free to express yourself with impressionistic or contemporary styles, as long as the subject can be recognized.

Don't forget to design a simple order form for people who may want a custom painting. Many customers will see a certain style they like at a show, but the colors may be wrong for their decor. These people will often ask you to do the same painting in different colors.

The general public still does not go in for abstract paintings. There are exceptions to the rule, but abstracts represent less than 5 percent of the art show and fair markets. If you paint in an especially unique style it will have to have wide general acceptance to be successful. In this book I am only

recommending the surest ways to make money, and unfortunately, abstract art does not fall into this category.

Displaying your art. How you display your art at the art shows and fairs can significantly affect sales. Most believe that the larger your display and the more inventory it includes, the greater your sales will be. The size of your display can have a psychological effect on a customer. The customer assumes that the artist with a large display is doing well and is therefore a good artist. And this is generally true, because only artists that are doing well can afford a large display.

If you plan to make a living in the show and fair market, your display should be given considerable attention. There are many manufacturers of displays for artists, and they can be found through your local art stores. Few art stores will have a display in stock because displays are expensive and move slowly. You will probably have to choose a display from a catalog.

An average display designed for a standard 10×10-foot area will cost between $400 and $1200. Some artists have displays that cover 10×20-foot and even 10×30-foot spaces. These artists rent two or three spaces, tripling their rent costs. I don't recommend artists start this way, but if you are serious about pursuing the show market, you should know what will be expected of you in order to be competitive.

You could even build your first display out of wood and chicken wire. I don't recommend this, however, because juried shows sometimes require a photograph of your display. If it is unattractive, they will not let you into the show. This will only happen with sellout shows, but these are the most profitable.

Manufactured displays usually have some sort of lighting system available as an accessory. This is important. At many shows, the fire marshal will not let you use extension cords or poorly designed electrical systems. Most artists at shows and fairs have spent considerable time and money on their displays. To be competitive you will have to do the same.

Framing your art. I cannot stress enough how much quality framing and matting will increase your sales. I have seen pathetically poor art, mounted in a nice frame with complementary matting, sell for hundreds of dollars.

I know this can be extremely expensive, but the investment will pay off. If you cannot afford to properly display your art you will not be competitive and will almost surely fail. By the same token,

if you do follow all the rules of a successful marketing plan the sales will come.

If you are not certain that you want to make such a large investment, start small. If you use a homemade display and hang your paintings unframed, you can be certain that any sales you make could be doubled if you "packaged" them better.

Inexpensive frame sections can be purchased through the mail. You can find sources in most of the art magazines. Expenses can also be reduced by using precut mats.

Many people will buy your art unframed, so you can reuse your frames. Over time you will build up a stock of frames and the cost will not have such an impact.

Selling Your Art Through Art Publishers

Art publishers buy the right to create multiple prints or posters from a single original artwork, including airbrushed paintings. (Remember, you are not selling them the original artwork, only the right to print reproductions of it.) A reproduction is simply a photomechanical or offset copy of a preexisting art piece printed on a printing press. So any number of reproductions can be made. Limited edition prints—only a set number is printed and then no more—are considered to be more valuable, simply because there are fewer available. Art prints are sold through many different retail outlets, such as department stores, poster shops or interior decorators.

Most art publishers have a method of distribution for the art they print. Typically, they act as salespeople in that they sell the art they purchase from you in the form of prints. Beware of art publishers who want to print your work as a service to you or want you to pay for prints. It is the art publisher's job to print your art and sell those prints to a preexisting market. When a publisher charges you for the printing, they are no longer acting as an art publisher, but rather as a printer. Unless you know you can sell all the prints you pay for, find another publisher.

Art publishers look for art with mass appeal, colors that complement neutral decorating colors, and images that can be easily seen, even from across a room, so the work can be distributed to many points of sale. This has two advantages for the artist. First, the artist can put a lot of work into a single painting and then recoup his investment through multiple sales. This allows you to do the best artwork you can, rather than adjusting the amount of work you put into a painting to keep the price down.

Case History: Learning What People Like

I met Don Hubble at a mall art fair, where he was displaying airbrushed paintings. Although he had studied art at the internationally acclaimed Art Students League in New York City, he felt many contemporary artists were out of touch with what people want.

"Today, the big thing [in art] is Abstract Impressionism. The Abstract Impressionist is painting strictly from the emotions evoked by the line, shape, form and color. These artists don't paint realistic images because they believe the realistic image will interfere with the emotions of the line, shape, form and color.

"Most people don't know what the Abstract Impressionist is talking about. After studying the movement for quite a few years, I'm still not sure I know. New York, Paris, and all the other art centers in the world are embracing Abstract Impressionism and rejecting the realist. The problem is that the general public doesn't like Abstract Impressionism.

"People like the emotions evoked by the image along with the line, shape, form and color. The truth is they view Abstract Impressionism as a rip-off, because without the image, they only get half the painting. The general buying public likes the old Impressionist school, paintings done in the early part of the century by Monet, Cézanne and Gauguin. These paintings enhance reality and add to it in a new refreshing way.

"When I sell art here in this mall, I sell only realism, and I sell a lot of it. I used to display some abstracts, but they never sold. I started selling at art shows because I enjoy realism. I like to paint things that look real, but back at school everyone would look down their noses at this type of art."

I asked Don what images sold best.

"Anything empowering to people. I like to view my paintings like an advertising poster for life. Take anything people like and then make it look better. You can do it with flowers, landscapes, or paintings of people. Did you ever go on vacation and notice that the pictures you took always have a telephone pole or some obnoxious neon sign ruining the composition? A painting removes all of these real-life flaws. The general public likes to see the fantasy of life, that perfect scene. When they look at a painting they want to be taken into a different world. It's escapism, no different than watching a movie or reading a good fiction book."

"Don, is there anything you don't recommend painting?"

"Yes, nude women. I think women are just beginning to attain equality and painting them in a sexual or suggestive way is counterproductive to their movement. Displaying them in public also goes against my grain because, often, children come to these shows.

"The truth is, I don't paint anything that's not empowering. Negative images don't sell. You might sell a political painting to a news magazine, but the average person walking through a mall won't be interested. I'll bet even the editors of most news magazines don't have a bunch of political paintings hanging on their walls at home. I think the job of all artists is to take people away from their woes and portray the world as it could be.

"Artists are the spirit of society; what the demands of life take away, the artists put back. When you come home tired from work, you might put a CD in the player and relax to some music, or slide a tape into the VCR and watch a movie, or you just might sit in the quiet and stare at a painting on the wall. It's the artists, musicians, filmmakers and writers that sing in celebration of life. I get upset when I see artists painting negative images; it feels counterproductive and they don't last long here on the show circuit."

The second advantage to selling multiple prints is that the prints will be more affordable to people, increasing the exposure to your work. Having a popular print in circulation can also help you land offers from different art publishers and gallery owners. Also, if the print becomes very popular, the price of the original will soar.

Art publishers are looking for art that average people want. Most people buy art to decorate their homes and because they relate to the art in some way. People identify with the art they surround themselves with. Because people use art this way, they identify more readily with realistic images. For this reason, abstracts often don't do well in the print and poster market.

The images portrayed in prints include almost every known subject and motif. Some subjects that sell well are animals, landscapes, children, and floral designs. Country or, rather, Americana paintings also sell well. To see some print artwork, you need only visit interior decorator and furniture shops. Magazines such as *Architectural Digest* and

Art Publishers' Contracts and Your Rights to Your Art

Art publishers offer either a flat fee for rights to your art or a royalty based on a percentage of sales. Royalties for reproductions range from 2½ to 5 percent. For limited edition prints, the royalties can be higher, ranging from 5 to 20 percent. Royalty rates are based on the art publisher's cost of printing and distribution, the artist's skill and reputation, and potential sales.

Any contract you sign should include an outline of exactly what promotion you will receive. Check up on the publisher. Talk to other artists they represent to find out if they pay on time and similar information. Make sure the rights to your art are spelled out clearly. For example, can the publisher print your art only on paper, or can they also print it on coffee cups, T-shirts or hats? Be sure a description of the art—identifying or naming the painting being reproduced—the size and type of reproduction, payment schedule, insurance and copyright terms, including mandatory artist credit and placement of your copyright notice on the reproduction—are all covered in the contract.

Interior Design have articles covering new trends and ideas in the print market.

For local art publishers, check your Yellow Pages and with galleries, museums, framing stores and other art supply stores, and any other store that sells reproductions. Usually employees in a store can tell you who supplied a print or prints. For national listings, check *Decor Source Book*, a periodical which lists publishers, distributors and suppliers (see page 127 for publisher and address). The *Artist's Market* also lists art publishers.

When you contact art publishers, send a letter with a brief bio about yourself and a list of any galleries that have carried your work. If you send slides, be sure you write the following on each one: your name, address, phone number, artwork size, and medium. You should also indicate the top and front sides on the slide.

For one sale, you will have to send out a *lot* of slides. What you are actually searching for is an art publisher that has developed a market for your type of art. Publishers may actually like your art and still not buy it because it is not right for their market. These people are pros, and they don't just buy art because they like it; they buy it because they know they can resell it. It is not unusual to contact from sixty to a hundred art publishers before you receive one positive response.

It is often easier to break into smaller art publishers and then gradually move up to larger publishers as your reputation grows. But don't be afraid of the big companies. If your art is good, it won't matter what your background is, how long you've been painting, or what art school you went to. Large companies have the most money available to purchase new art, and their large distribution networks offer the greatest exposure. Big companies know how to develop your reputation as an artist and make the most money for both you and them.

Galleries

An art gallery sells art that it has either purchased outright or accepted on consignment from an artist. Your art will be marketed in an aggressive fashion and handled by a professional sales staff. This will allow you to spend your time creating and not worrying about sales. Galleries charge a 40 to 60 percent commission to display, sell, promote and publicize your work. This may seem expensive, but if you start to add up the cost of a building, payroll for a sales staff, and all the other expenses related to owning a business, this charge is fair.

The artist-gallery relationship is mutually beneficial. Galleries provide display space and sales staff for artists. Artists create a product that the galleries can sell. This arrangement frees artists from the pressures of marketing their art and leaves more time to create.

Gallery owners look for a proven track record from artists they invite into their galleries. They prefer to represent artists who have had shows at fairs, universities or other galleries, or who in some way show a forward momentum in their careers. They also look for a body of work in a definite, recognizable, consistent style to see if you have found your own approach and settled into it. They will be developing a market for your work over a long period, and that's hard to do when your style is changing every week.

If you are not careful, you can become typecast. "Oh, yes, he's the artist who does sports characters" or "She does those beautiful floral scenes." If you change directions in your work, the market for that work can be affected negatively, at least in the short term. However, that doesn't mean you have to stagnate. You can explore a wide variety of subjects as long as your style remains consistent, distinctive and recognizable. I know an outstanding

Cooperative Galleries

Sometimes finding any gallery can be difficult because you have no reputation. If you find yourself in this situation, approach the cooperative galleries. To become a member of a cooperative gallery, you will have to submit slides of your work to a jury of members. If accepted, you are usually allowed to work at the gallery instead of paying a commission. These galleries are usually much more liberal about who is allowed to join.

Make sure you can take time from your painting or other work before you commit to a cooperative gallery. You will be asked to help with sales, maintenance and janitorial services. Sometimes a co-op gallery will also take a small percentage of your sales as a commission, but this is sure to be less than that of a commercial gallery. Cooperative galleries usually ask for about 20 to 30 percent of a sale.

Involvement with a cooperative gallery will help you understand the entire industry. You will gain experience in dealing with the buying public, like the commercial galleries. Understanding what the public wants will help you fine-tune your own money-making style. Most companies test a new product with selected members of the buying public before engaging in full production. You can, too.

watercolorist in Washington whose paintings of people and still lifes are both in great demand.

Approach local galleries first. Obviously, they're the easiest to find and to find out about. The galleries in your area are listed in the Yellow Pages under "Art Galleries." Quite often you will be able to tell something about the gallery from a display ad. A gallery specializing in seventeenth-century oils would not be worth pursuing, whereas a gallery specializing in contemporary art would. You can also get leads on galleries from other artists, local art associations, your state and local art councils, the art pages of newspapers, and in some areas, local gallery guides. Often a local art association, the chamber of commerce, or some other group will put together an artist's guide to finding galleries that will accept their work. If such a guide is available, you can usually locate it by calling the local library, art association or chamber of commerce. (These guides are especially helpful when you're looking for galleries outside your local area.)

Once you have established a local following, you can approach galleries outside your local area. Most successful artists grow in stages, starting with local galleries and branching out to other regional or national galleries. Once the demand for original artwork exceeds what an artist can produce, she can develop a line of prints or reproductions. The reproductions open up a whole new area of distribution and eventually lead to more income. An artist I knew in Florida began selling her paintings in a small gallery in Pensacola. Her art sold very well, and within two years her distribution had grown to over twenty-five galleries along the coast. Her art was carried mainly by galleries located in resort hotels like the Hyatt and Hilton.

As her distribution grew, there were no longer enough hours in the day to paint enough paintings to keep all these galleries stocked with two to four of her paintings. So she decided to have reproductions of her art made. The reproductions sold for a fraction of what the originals cost, but because she sold so many, she earned more. Granted, she lost some of the galleries that wanted to carry only her originals, but the distribution of her prints grew much larger. Ultimately, she earned much more than through the original distribution in the galleries.

Here are some publications that list galleries (contact information and addresses are included in the "Resources" chapter, see pages 126-128):

- *Artist's Market*
- *Art in America: Annual Guide to Galleries, Museums, and Artists*
- *Art Now USA*
- *Art Now Gallery Guides* (regional guides)
- *The Artist's Guide to Philadelphia Galleries*
- *Washington Art: A Guide to Galleries, Art Consultants and Museums*
- *Art Gallery*

The following regional art publications list galleries looking for work to exhibit in their area:

- *Southwest Art*
- *Art New England*
- *West Art*
- *Artweek*

When you've developed a list of galleries, visit them in person. (This may not always be possible when you're approaching a gallery outside your local area, but try to schedule a trip to see several galleries in the same area.) Look at the art hanging on the walls, because this is the art that is selling. If it were not selling it would not be hanging. If

your art is as professionally finished as what you see hanging in the gallery, there is no reason your art shouldn't be hanging there, too.

As you walk through the gallery, notice whether it is neat and clean, how the art is displayed, and what the staff is like. These are all factors that tell you about the gallery owner. If the gallery is dusty and dirty, you may find an owner that is unhappy with the business or simply burned out. An unmotivated staff is a sign that the owner has trouble dealing with people, or he may be an outright tyrant. This is not someone you would want to enter a business arrangement with. You can often tell whether or not a gallery is right for you without ever saying a word.

If the gallery meets your approval, the next thing to look at is the price range of the works displayed. Do the prices seem reasonable to you? Are they too high, too low? You will be the best judge. If the work is priced too high, it may never sell. If it is priced too low, you may not make what you need.

It is important to carefully consider a gallery before you make any commitments or sign any contracts. I always wait twenty-four hours before I sign anything. I do this to let the moment of excitement pass, and to take a crystal clear view of any agreement. Most galleries will want exclusive rights to your work, at least in a specific area, and you'll want the best representation you can get in that area.

If you believe that your artwork would nicely complement the art that is already in the gallery, and the gallery seems attractive, ask a salesperson when the gallery views new art and to whom you should direct your submissions. Take slides of your art with you, because the gallery owner may want to see your art right then. This is very uncommon, but it has happened to me. I always visit a gallery when I know it will be slow, just in case the owner is open to a little conversation. The best time is late in the morning on weekdays.

Once you have found out when the gallery views new artwork, make an appointment to show yours. Take only your best recent artwork to show: two or three originals of your best work and slides of any other work you want to show. Slides should be properly mounted and labeled, and a slide list should be included. Also, provide a resume listing your art experience and include any newsclippings or other reviews of your work (the latter items to show your work's had exposure). Some artists provide an artist's statement that briefly describes what they paint and why.

Present artwork that shows exactly where your

style is today. Continuity of style will show that you have consistency. The gallery needs to know what to expect from you so they can build a clientele that will buy your artwork's style. The paintings don't have to look alike, but they should be similar in the handling of the medium.

You need to be on your best behavior during the review. The gallery owner is reviewing you as well as your art. You should dress well and project an image of dependability. The gallery owner wants to know that if your work sells, you can be depended on to produce more of the same.

Many art books suggest that you have brochures made to either leave behind with the gallery owners or to actually present your work. If you can afford this, it probably wouldn't hurt. However, no artists I have talked to have ever had a gallery call them because of some material left behind on a previous visit. Full-color promotional material can be very expensive, and I have never seen it return the artist's investment. Brochures and other material should be used for self-promotion after your art is in the gallery and has been selling consistently. Promoting a product without demand will not increase sales, whereas a product that is already selling well will sell even better when a promotional program is added.

When you present your art to a gallery, the person reviewing your art will say whether or not the gallery is interested. There is really no selling involved. The gallery owner knows what her customers want, and if your art fulfills those criteria, you will be accepted.

Many artists who become upset when they are rejected by a gallery don't really understand marketing. Gallery owners are businesspeople who must match a product to their customers. When they turn you down, they are not judging your work. They are merely saying that what you paint is not right for their customers. This will happen a lot when you submit work through the mail, because you will not be able to see the gallery and make your own assessment of their clientele.

Ivan Carp, owner of the prestigious O.K. Harris Gallery in New York City, once told me that an artist must have a salable style. This means that your art must appeal to the buying public. The key to success is not to give up; if one style doesn't work, try another. If one gallery rejects you, send your work to another.

Also remember, you do not have to get locked into one gallery forever. Gallery hopping for upward mobility is standard operating procedure for advancing an artist's career. Try new galleries that

are looking for new artists. You can work your way up from a small or new gallery to the more established galleries. And if you develop a new style, don't hesitate to send samples to galleries you've already submitted to.

If you plan to solicit galleries out of your area, you will have to send slides, a resume, and a cover letter. You should also send a list of any showings you have had. If you include a self-addressed, stamped envelope, your slides will be returned and you will be able to send them out again. Getting multiple usage out of these slides will recover your initial investment in them. When a gallery is interested in your art, they will let you know.

Keep track of all the galleries you contact. Make a note of what art you sent, what was returned, and the results of the contact. It is difficult, if not impossible, to store all this in your head. Keeping notes will help you develop a mailing list with contacts, saving you time in the future when you plan to resubmit.

Once that wonderful day comes when a gallery agrees to handle your artwork, you will have to negotiate the deal. Have a lawyer, if you can afford one, review the contract before you sign it. But first let's look at some of the most common terms laid out in an artist/gallery agreement.

Commission vs. outright sale. Most gallery agreements are consignment arrangements. If this is the case, be sure to agree on the commission split in writing. Average gallery commissions are between 40 to 60 percent. If the gallery wants more than 60 percent, you should ask why the commission is so high. Unless they plan to spend a lot of money promoting your art (which is rare), commissions over 60 percent are too high, and you may want to find another gallery.

If the gallery wants to purchase your art outright, give them a price that you think is fair. Gallery owners are also experienced in business, so in anticipation of a little haggling, you should ask for about 10 to 20 percent more than you actually need to receive.

When you sell a painting outright, the gallery will want a receipt from you. You can purchase a receipt pad from any office supply store. The gallery may also ask you to sign a statement giving them all rights to the art; if you are selling outright, you should sign. Once you have received income from a gallery owner you will be responsible to pay taxes. This is covered in chapter seven, "The Business of Airbrush."

Pricing of works sold on consignment. When setting prices for artwork sold on consignment, the galleries will know best how to price your art and usually ask for more than you would have expected. It's not a good idea to dictate pricing, but you should have an idea of what you need to get for the painting, and this minimum should be covered. Most of the time, the galleries will discuss pricing with you and some compromise will be reached. When you deliver the artworks with the consignment agreement, include a list of the works you've brought and have the gallery owner write down the agreed-upon retail price for each. This gives you a legal record of what you brought in and the initial pricing. You'll need a record when you end a relationship with a gallery to verify what has and hasn't sold and to prove your right to the work if something happens to the gallery. (Some legal experts strongly recommend doing this for reasons cited.)

Accounts. Make sure there is a statement in your contract that lists a schedule of accounts. This is an accounting statement that lists what has been sold. These are especially important when working with galleries that are located out of town, but should be included in local accounts as well. For each sale the statement should specifically state the title of the work sold, the date of sale, price, and the amounts due both to the gallery and to you. If possible, get the name and address of each purchaser, too. The gallery may object to doing this, because you could approach the purchaser directly and cut the gallery out of commissions on future sales. But try to get at least the purchaser's name so you can demonstrate in other promotional efforts that your work is being bought. Having a work in a prestigious collection can really advance your reputation, and you'd want to publicize that. Along with a statement of accounts, you should agree on a payment schedule. Some galleries don't pay until your contract expires, others pay every ninety days. This should be discussed before you sign a contract or deliver any art.

Termination (terms for ending the agreement). Set a time limit on any agreement. The initial agreement should last no longer than six months. After six months, the agreement can be renegotiated. If the gallery has several pieces of your art and doesn't sell them quickly, it is not earning you any money. Limiting the term of an agreement also helps you get a better deal or move to a new gallery if your career takes off.

Exclusivity (where and what the gallery represents for you). Do you want to grant a gallery exclusive rights to represent you, and if so, in what area(s)? Don't give away rights you don't have to. Unless it is selling art to an international clientele,

a gallery doesn't need complete exclusivity. If you grant complete exclusivity, no other galleries can carry your art. This means fewer people will see your art. Always seek as many points of distribution as possible.

Most galleries sell to a local market, such as a certain city, town or county. It is fairly common for a gallery to ask for exclusive representation within a specific geographic region—understandably, they don't want to see your art in every gallery in town. Be sure the geographic area you are granting exclusivity for is clearly specified in your agreement, and keep the duration of the agreement short, as noted above. You can also specify that only one type of work will go to that gallery. If you do both seascapes and still lifes, for example, you can put the seascapes with one gallery that specializes in seascapes and the still lifes with another that specializes in still lifes.

Beware of clauses that benefit the gallery at your expense. For example, sometimes a gallery's contract will have a clause that states that the gallery is entitled to the agreed commission for any sales you make for a given period *after* your agreement with them has expired. The gallery may try to justify this by claiming that the gallery's promotion may be the reason you will continue to make these sales. I would urge you *not* to sign a contract with this clause in it, because it's not fair to you. You may also want to limit your contract to a certain portion of work currently being created—one particular subject or style—and specifically exclude any commissions on work created for gifts or for shows. It's often a good idea to specify that the gallery has no rights in any works created before the agreement was signed or after the agreement expires.

Promotion, insurance and shipping. It is standard operating procedure for a gallery to pay for promotion of your work. Promotions include press releases, newspaper ads, flyers and, sometimes, a magazine ad. Galleries also pay for in-house insurance, which only covers the art while it hangs in their gallery. Always ask how much you will receive on an insurance claim—either a dollar figure or a percentage of the value of the work—and make sure that's written into the contract. Shipping costs are usually split evenly between the artist and gallery.

Although neither this book nor any other can be a substitute for professional legal advice, there are several good books available on legal matters. *The Artist's Friendly Legal Guide, Business and Legal Forms for Fine Artists*, and *Making It Legal: A Law Primer for Authors, Artists and Craftspeople* are all helpful, easily understood books on legal issues (see page 127 for publication information).

Building Your Reputation

I constantly hear artists talking about the day when they will land an art agent or publisher who will take their art, sell it worldwide, and promote their name into the art history books. The common theme among these people is that they are all waiting for someone else to make them famous. But agents and publishers are looking for artists who already have a name, because their art is easier to sell. So here we confront the age-old question, "If I have to sell my artwork to get a reputation, but I can't sell my art without a reputation, how will I ever sell any art or get a reputation?"

No one gives you a reputation; you take it. You must find ways to get your art in front of people in a way that fits your time and budget constraints. So if your goal is to make money with your art, then you should develop techniques to market your art as well as painting techniques.

Part of your job as an artist is to find new and creative ways to promote yourself. First, try to develop a local reputation. This will lead to invitations from local galleries to display your art. Once you have a local reputation, you can expand. You may want to make your name known in neighboring towns by simply repeating what you did in your hometown. After you have expanded locally, you can start thinking of ways to work into the regional and eventually the national scenes.

If you prefer to start small, there are other places you can display your art besides galleries. These locations can be listed on the resume you send to galleries and art publishers. Some of these locations are:
- Banks
- Churches
- Bookstores
- Restaurants
- Coffee shops
- Local businesses
- Furniture stores

These enterprises are usually happy to have original art hanging on their walls, and they are simple to contact and organize. Just decide on a business that you think your art would complement and then ask the owner or manager if you could hang your art in his establishment. If he says no, call another.

Once you find a location, set a date to hang your art. Set starting and ending dates for your show, too. If you want, you can make it an ongoing arrangement, just as long as you both agree that the arrangement can be terminated by either party at any time. You don't want your art tied up in the event you get accepted by a gallery or print publisher.

Sometimes the business owner will ask for a commission. This is to be expected, although the commission should be less than a gallery would charge. Each arrangement will be different, and you can always raise your prices to cover the commission, but at this type of location I question paying anything over 30 percent.

Not only can you hang your art in businesses around town, but you can also set up your equipment and paint around town. Personal appearances can get you a lot of notoriety, quickly. Arrange to "capture" local events, anything from a Renaissance fair to a church bazaar—the whole point is to let people see you painting. You could gather names and addresses, set up your own show at a local coffee shop, and invite potential customers. You have to *make* your own market. You can't sit in your studio expecting the phone to ring. Be brave, have fun, get out there and sell some art.

When you arrange to display your art in a business or to make a personal appearance during a local event, be sure to send out a press release to the newspaper to get free publicity. The living section is difficult to fill, especially in a small town paper, and you never know when they will run your notice.

Your press releases and other correspondence should be printed on nice stationery. Business cards are also important. They can be handed out at personal appearances and left with any art you have on display. This can lead to many future commissions.

Special attention should be paid to your resume. List every place you have displayed your art, including the dates your art was on display to show that you have been actively promoting your own art. You should also list any special awards you have received or commissions you have painted.

Finally, keep an eye out for unusual opportunities or chances to link with any newsworthy event. If you can align yourself with a highly publicized event you can gain exposure. The trick is to know what's news.

And what is news? Politics, celebrities and charity events. Volunteer services for big community events and get publicity from that. When political battles erupt in your own town, contact the political organizers and offer them your services as an artist. Your art could become the logo for the political battle and be shown on television or featured often in the local newspaper.

If you can, arrange for popular local personalities to hang some of your art in their home; the publicity can be invaluable. Imagine being able to say that the mayor has two of your pieces hanging in her living room. This type of publicity can be used at all your shows and lends credibility to your art. Does this sound a bit calculating? Remember, your competition may be doing the same thing.

Of course, I'm assuming that the mayor won't hang bad art in her living room and that your art has developed to a point where it is pleasing. All other things being equal, it would be better for your art to hang on the mayor's wall than on some other artist's wall. Politicians entertain a lot of influential people. All those people passing through the mayor's living room will see your art and, by association, may want it, too, or tell others about it.

How do you meet the mayor? How do you get a local celebrity to sit for a portrait? You do it by networking and exploiting any and all connections. If you don't have any connections, get out and make some. Get involved with local artists' groups or community organizations. You can't get famous alone.

Tools and Materials

You need the right tools and materials to make money airbrushing. The following is a brief listing of the items you'll need to airbrush paintings on canvas and what they're used for. I mention brand names only when there is no other brand on the market or when no other available brands serve the purpose as well.

Airbrushes

Canvas is a hard surface, and airbrushing it can be difficult. A small airbrush, such as a Paasche V-Jr., Aztek, Iwata, or Thayer-Chandler, will make getting into those tight spots easier, but practice and experience really pay off here. The paint will want to caterpillar when you spray too close to the canvas. The only way to avoid this is to make quick, repeated passes with the airbrush, laying out paint before the air can blow it outward. This will build up an opaque layer of paint. In the airbrush trade, these quick, repeated passes are called "strokes."

To alleviate this problem somewhat, the Aztec airbrush has an air pressure valve that allows you

Breaking Into the Big Time

Many students have asked me, "How do you make the really big bucks with art?" There isn't any one answer to this question. There are as many ways to do that as there are artists who have made it into the big time, who make a lot of money and enjoy national acclaim. Some have risen through special publicity, such as through association with a major international event or a prominent celebrity. Others have been promoted aggressively by a well-known gallery or a collector. Let's look at the careers of several prominent artists and airbrush artists to see how each achieved success.

Leroy Neiman has achieved international success through his sports-related paintings. His illustrations of major sporting events for *Playboy* brought him to the attention of the national news media. ABC sent him to cover the world chess championships in Iceland because TV cameras weren't allowed. He subsequently covered the Olympics in Munich. The publicity his work received from the Olympic coverage increased, reaching a peak with the 1984 Olympics in Los Angeles.

Neiman was able to capitalize on his connection with an international sporting event. He got excellent free publicity—his work for the Olympics was essentially a "free commercial" for his work—and it paid off handsomely. The key to selling your art is to get it in front of as many people as possible. Leroy Neiman reached millions of people by painting at the Olympics.

This form of publicity doesn't cost anything; it just takes creativity. The news media are always looking for interesting subjects to cover. You need to find some way to attach yourself to an event that is in motion. I could see a portrait painter tying in with the presidential convention in the same way Neiman did with the Olympics. The media cover conventions extensively, and between speakers, a camera could flash on a portrait artist just like Neiman at the Olympics.

Patrick Nagel was a commercial/editorial illustrator whose career took off after he painted a portrait of Joan Collins. His association with the film and television star did for Nagel what the appearance on the Olympics did for Neiman. If people learn an artist has painted a picture for someone famous, they will want the same painter to paint them—it's a way to identify with the rich and famous. The news media gave Nagel a lot of free publicity. It is well known that if you can get the rich and famous to accept your product, everyone else will.

One interesting thing I've noticed about nationally known artists is that their careers are dynamic. They start in graphics, perhaps, and then progress into fine art. Both Nagel and Neiman worked as illustrators long before they made it big. Illustrators work in the advertising and promotion industry and are privy to the way promotion works. After all, selling art is no different from selling any other product. Commercial artists work closely with marketing personnel, and these relationships can be very helpful to an artist entering the art market. Most successful artists learn the value of publicity at some point in their careers; that's when they take off.

You must develop your own promotions and ways to get your name out into the market. If you can do this, galleries will call you; art agents and publishers will want to represent you and distribute prints of your art nationwide. Promotion takes no more talent than painting and can be tailored to your time and budget.

to adjust the air pressure with the same trigger that is used to regulate the paint. With the Aztec, as you press down on the trigger, the air pressure increases; when you pull back on the trigger, more paint is allowed to pass through the nozzle. Yes, this is one tricky airbrush to handle, but getting used to it is worthwhile.

Just as you want a small airbrush to get into the tight spots, you may want a larger airbrush to handle large blends. Using a small airbrush to blend large areas can leave uneven patches. The Paasche VL or the Iwata HP-BE are both fine for this type of large area work.

Compressor
For painting canvases only, a one-tenth horsepower compressor that pumps out a constant thirty pounds of pressure will work fine. The compressor costs about $130 and runs off of a 120V outlet. It is easy to repair and portable. The only problem I've ever had with this compressor is that the main piston bearing burns out in about six months to a year, depending on use. A replacement bearing can be purchased at an industrial bearing supply house and installed at most machine shops for about fifty dollars.

Large compressors (one horsepower and up)

seem to break down much more often than the one-tenth horsepower models. Their weakness seems to be the switch that turns the power on and off when the holding tank is full. They are also cumbersome to haul around (especially to the repair shop) and very noisy, which is not conducive to good art. Some artists attach long hoses to the big compressors so they can put a lot of distance between them and the noise.

Many artists use an air tank, a tank of compressed air similar to a scuba tank, instead of a compressor. They claim that the air comes out more smoothly with a tank, and this is true. The pumping action of a continuously running compressor will sometimes create a dotted-line effect when the artist tries to spray a fine line. However, this is actually caused by the artist. Anyone who experiences this problem should develop the airbrush stroke, which is a quickly drawn line that can be opened wider and moved more quickly by the artist, creating the same line as that produced with less paint and a slow movement. Air tanks are handy if you plan to work away from your studio or where there is no power. I see no other value for them because they have to be constantly refilled.

Brushes

I use both the paintbrush and the airbrush in every canvas. If I want a solid panel of color, I'll use a paint brush. When I need a continuous tone, I'll use the airbrush. Detail can be rendered with a brush and then softened with the airbrush.

I recommend soft animal-hair brushes because the finished texture of the brushstrokes will be smooth and match the airbrushed texture. Don't use hard bristle brushes because they will create a texture that looks odd when combined with airbrush.

Remember to thin your paint with the proper thinner when using animal-hair brushes, because unthinned paint can damage them. Also, wash your brushes often when using acrylic paints, because they dry quickly. Once paint dries in a brush, it is ruined.

Edge brushes look just like the one you use to paint house trim. They are used for applying paint to large areas or coating the canvas before painting. You can also use them to edge different images. Recommended edge sizes: 1-inch, 1½-inch, and 2-inch.

Flat brushes are used to apply solids in small areas. Flat brushes look like a smaller version of the edge brush. Flat brushes come in a shorter-bristled version called brights, but I prefer the longer-bristled flats because they hold more paint, allowing you to pull a longer line. You will use these brushes primarily to paint solids and edge images, so pull the longest line possible and avoid restarting a line in a tight area. Because you will not be blending with these brushes, you won't need to be as concerned with all their different idiosyncrasies. Recommended flat sizes: ¾-inch, ½-inch, ¼-inch and #6.

Script brushes are round brushes that end in a point, designed for painting detail. They are used to paint blades of grass, hair, eyelashes or anything linear. A long, tapered version of the script brush is also available, sometimes called a lettering brush. The long hair script is an excellent brush for pulling extremely long fine lines. Recommended script sizes: #6, #5, #3, #1, #0 (long script) , #3/0, lettering script.

Paints and Clear Coats

The basic rule to follow with paints is to match the bases. If you like to paint with acrylics, all your paints should be acrylic, including the clear coat. If you like oils, use only oils. Unmatched paints can cause cracking or bleeding. When working with canvas, I use Liquitex Acrylic Airbrush Paint with Liquitex Acrylic Artist Color in a tube for brush work. Matching company brands helps ensure compatibility.

A clear coat that works well with acrylic paint is called Aqualyte. It is a multipurpose, water-based clear acrylic spray paint that works great on canvas. You should clear coat your canvas art, because the airbrush spray is very fine and can be scratched easily.

Accessories

You may want some of these accessories to make your airbrush business run more smoothly:

Paint tray. A flat tray with six to twelve indentations to hold different colors of paint. Some have a larger indentation in the center for either water or a dab of black and white for convenient blending. Buy a paint tray that has a top to cover the paint and retard drying.

Rags. Keep some around; you'll need them.

Fishing tackle box. Great for carrying all your airbrush equipment.

Ten-foot hose. This length of hose makes moving around a lot easier.

In-line water trap. The trap catches any moisture that forms in your airbrush hose. Water that condenses and gathers in the hose can spray onto

Artist Spotlight: Jürek

Jürek specializes in fine art airbrush paintings on canvas. When he arrived in the United States from Poland in 1978, the airbrush had just emerged as a kind of American folk art. Jürek had heard about the airbrush in Europe, but it had not achieved the level of popularity there it was enjoying (and still enjoys) here. Although he had previously painted with oils, Jürek's first investment on arriving in America was in an airbrush; he liked its speed and quality. Jürek finds the airbrush to be "a unique artistic experience, because the artist never actually touches the surface he paints. Once an artist has achieved mastery of the airbrush, he can freely render any artistic thought at the precise moment it enters his mind."

When Jürek was first learning to airbrush, he attended an art fair on Long Island where a friend had set up an airbrush booth. He asked to use the airbrush during the friend's lunch break, and when his friend agreed, Jürek went to work. He was unaware that his friend's paint bottles had not been cleaned in a long time; the vents that ensure good airflow were clogged. When Jürek set one of the bottles on his friend's table after finishing a design, the clogged bottle suddenly exploded, sending a stream of neon-colored paint onto the back of a woman standing at the next booth. At just that moment, his friend returned. Jürek thanked him for the use of the airbrush and left immediately.

Despite that early disaster, Jürek began his career airbrushing garments at street fairs in New York. He soon became unhappy working in this environment. Now, many artists enjoy working around crowds; Jürek knew a Florida artist who played the violin during his breaks at shows to attract customers to his airbrush business. But standing on your feet for over eight hours producing art for a demanding audience isn't for everyone. Jürek found it "exhausting to the psyche" and felt that his work's quality was suffering.

So Jürek decided to start a mail-order business, offering airbrushed celebrity portraits on sweatshirts. Instead of dealing with a multitude of different design requests, Jürek could call the shots by offering only a stock set of celebrity designs. This mail-order business for a select clientele continues to supplement the income Jürek earns from his canvas art.

Today Jürek's work is being shown successfully at several galleries in Provincetown, Massachusetts, where he now lives. Shortly after moving there, Jürek met a group of influential artists who helped him place his canvas art in Provincetown galleries. Jürek has commented, "This town is a true art colony, a haven for artists and those who appreciate art. Provincetown is a place of inspiring natural beauty where I can rediscover nature."

Jürek feels "canvas art is much more challenging. Airbrushed garments are easier to produce and sell, but are less fulfilling technically than producing canvas art. Garments are vanity or costume pieces,

Sky

as opposed to canvas art, which truly reflects the artist's artistic vision.'' However, on the practical side, he still earns 75 percent of his income from airbrushed garments and 25 percent from canvas art.

His current work focuses on his interpretation of outer space. Jürek says, ''It is challenging to render abstract themes in a way that is humanistic and not completely alien.'' He has perfected a technique that involves mixing paints with a flammable fluid. The mixture is poured over the canvas front, lighted, and allowed to burn. Although the flames burn fast, they burn at a low heat. The resulting patterns suggest star nebulas.

Space #008 (33 × 40), **three-dimensional mixed media.**

Jürek then uses the airbrush to add touches that further evoke images of outer space. Jürek uses both a Paasche VL1 and VL3 air gun because the VL series accommodates his large hands. His air compressor is a Jun Air, which he uses at varying pressures between 60 and 80 psi, with moisture traps and oil filters. Jürek paints at extremely high pressures so he can spray thicker paint with more pigment and achieve more vibrant colors. He has been encouraged by the response to this novel canvas art form,

which continues to increase in popularity. Perhaps, Jürek muses, these paintings touch a primal chord in his audience that helps to sell them?

Jürek also works with a new paint called ''interference'' paint. It is a refracting paint that reflects different colors depending on the light source. Although this paint has no true tone or value, when the painting is viewed from a 45-degree angle, blues, purples, reds, golds or greens begin to appear. Jürek describes this as, ''A unique luster that occurs as a result of the phenomenon of light interference which is most familiar to us in the shimmering effect created by a layer of oil on the surface of water. But this is apparent only from a certain angle.''

To produce this effect in the painting medium, platelets coated with extremely thin layers of titanium are mixed into a transparent mat medium. When light reaches these platelets, the light undergoes reflection and refraction. Refraction is the change in the direction of a ray passing from a medium of one density to another of a different density. The result is a strong color stimulus. This paint doesn't tarnish; it is also highly resistant to water. You can order this paint from Createx Colors, their toll-free number is (800)243-2712. Jürek feels that this new paint ''adds a dynamic, subtle, stunning touch to the composition. It works best on canvas because the canvas surface is less porous than cloth.''

Fantazya, **fiber.**

the canvas and cause the paint to spread uncontrollably, ruining the painting.

Mounting stand. Attaches to an easel or table and holds your airbrush. A dropped airbrush is the leading cause of bent needles or torn tips. It doesn't happen often, but dropping an airbrush can bend the joint where the head assembly joins the body, and the airbrush will never spray correctly again.

35mm camera. Photograph your artwork as soon as you finish it, so you'll have good photographs of your work to show prospective customers and slides for submissions to galleries, art publishers, shows and fairs. If you can't take tack sharp, perfectly lighted photos of your artwork, have a professional photographer take them for you. It's not cheap, but you need high-quality photos or slides to get into galleries, especially out-of-town ones.

Studio easel. An easel holds your artwork still while you paint details or trace an image from the opaque projector. A good easel lets you easily adjust the vertical and horizontal position of your painting so you can work comfortably.

Soft lead drawing pencils. The #3B, #4B and #5B work especially well on canvas.

Speed Production Techniques for Canvas

Here are some techniques to help you reduce painting time when you're working on canvas.

Block in Solids and Shades

The quickest way to paint a canvas is to block in all solids with brushes and then add gray values, tones and colors with the airbrush.

You should block in any area that has an overall tone, too. If a figure is wearing a blue, mix a middle value of blue that can be darkened or highlighted later. Even linear areas should be painted in. These could be areas of fabric with stripes, prints or plaids. Once these areas are painted in with colors that match closely, you will be ready to tone them.

Block in your painting with colors that can be toned later with matching transparent colors. You can also use a color less harsh than black in skin tones, such as yellow ochre or sepia. Once you have applied the color, you can lightly go over flesh areas with white to tone down the colors and add a translucent effect.

Don't Use Stencils

There is no reason to cut a stencil when painting a canvas. If you paint the foreground image first, you can edge the image with a regular paint brush before painting the background. This removes all the overspray from the background area. This system is also quicker than cutting a stencil.

Work in Black-and-White Only

I offer black-and-white canvas portraits for about 20 percent less than color portraits, because they are so easy to paint in this manner.

I first block in the background and any other solid areas, such as clothes and jewelry, with black paint. In the facial area, I block in the pupil, the upper eyelash, and the mouth line between the lips. Painting these few facial features makes the airbrushing step easier.

I follow the photograph when airbrushing the face and neck, painting all the dark tonal values as closely as possible. Very often, I will have to work back into the skin areas with white to soften some of the areas where the black was too harsh. You can work back and forth between these two colors until you get it just right.

Once the face and skin areas are done I move to the clothing and jewelry, following the same process. After that, the entire figure can be edged with a brush and the background painted. If you choose to make the background black, you can edge the painting at the same time. Sometimes I simply mist the background with a soft gray, blending it into the overspray and eliminating the need for edging altogether.

The last thing I paint is the hair, because if the painting is to look real, the hair must overlap the face and the background. If the person I'm painting has dark hair, I paint it black and then go over it with white airbrush, adding a few individual hairs with the #0 lettering brush. If the hair is light-colored, I use the airbrush to define soft shadows in the hair, then bring out individual hairs with the #0 lettering brush and add gray and white shades over the airbrushed shadows.

What you have at this point is a finished black-and-white painting. You can add color to this painting if you want or sell it as is. The next section explains how.

Colorize Black-and-White Artwork

Using transparent color over your black-and-white paintings, you can tone the color almost automatically. When the transparent paint is laid over the

dark and light areas, it becomes tinted by the underlying tones.

Avoid Blending on Canvas With the Airbrush
Overspray from the airbrush will build up quickly when you try to blend two or three colors. Also, trying to build a certain density of brown requires that you first spray yellow, then red and finally blue. If you spray the first color at the wrong density, the entire color will be wrong. This problem is compounded by the fact that you will have to do this blending in and out of the dark areas and bright areas. It can get messy. That's why laying down a dark color with a brush, then going over it with a lighter spray can be much simpler. I suggest you try different approaches and settle on the one you feel comfortable with.

Chapter Five

Painting on Metal and Sign Painting

Vehicles, metal accessories and signs are more of a high-stakes game than the other markets covered in this book. You can make very good money if you work hard, but start-up costs are somewhat higher and the market is tougher to break into.

I include glass etching in this section because it is a service usually offered with custom auto painting.

Vehicles

This is the most fickle of all the airbrush markets. Airbrushed murals on vehicles come in and out of fashion all the time. The best indicator of the trends is the custom auto magazines. One year you'll see that most of the cars displayed in the magazines have fancy striping. The next year they will all be painted in pearlescent solid colors. And then, like magic, the next year everyone will be showing cars with airbrushed murals.

For several years, custom-painted vans with elaborate airbrushed murals were extremely popular. Then in the late 1980s, car makers changed to vans that looked like large station wagons. With much less metal area available for painting, the market for airbrushed murals nose-dived. Many airbrush artists who jumped into the field during the boom period for vans are still working and have created a tough, competitive market. This doesn't mean you can't make money painting vehicles, but it does mean that you will have to work hard to break in.

Not many artists paint metal because the work is so inconsistent, but if you can put a little energy out into this market, it will make you a return on your investment. It may not pay to do it full-time, but when you do work, the money is good. In the slump periods, you may want to switch to T-shirts and canvas work. Many airbrush artists paint T-shirts, canvases and metal. They often view metal painting as gravy, because while this market is up and down, there is a lot of money to be made when you do land a job.

Special Skills Required for Painting Vehicles

A basic knowledge of auto body work can be helpful when painting airbrushed murals on vehicles. For example, you should be able to recognize whether the base coat is in good condition. A customer could get quite upset if you paint a mural on a car that will need an entire paint job in just a few months.

Your customers will expect you to know all about painting cars even though this knowledge is not required to paint a mural. Cars are first painted with a primer coat to seal the metal and provide a good surface for the finishing coat of paint. The finishing coat of paint is applied over the primer coat and then buffed with a polishing compound to bring up an even shine.

Once you paint a mural on a vehicle a clear coat is required to seal the airbrush. Without a clear coat the airbrush will be very fragile and susceptible to weathering. This clear coat is just like a regular finishing coat and will require buffing.

Potential customers expect the artist to be an expert with all the different types of pearl, metalflake and crackle paints. You can learn about these by reading the information provided by manufacturers. You will have to write to them; their addresses can be found on the labels at the retail store where they can be purchased.

There are many books on custom painting vehicles to be found at your local library. You may also want to take a few courses at your local junior college. Junior colleges usually offer courses on basic auto painting.

If you want to paint metal but don't want to become a professional auto body repair person, you can team up with a body shop already in operation (see page 74 for more on getting work from a body shop) or hire a body shop to do work for you.

You could subcontract work to auto body shops. For example, you can arrange to have a body shop put on the base coat and do any necessary body work. After you paint the mural, you can send the vehicle back for the final clear coat. Then you can charge the services provided by the body shop to the client as part of his bill or have the shop bill the customer directly. No shop will refuse any work you may bring. Have potential customers meet you at this body shop, where you can give them a quote on any body work or base painting, along with the airbrush costs.

If you plan to pursue metal painting, you should take the time to learn pinstriping and lettering. Knowing these two techniques can double your income, and mixing them with airbrush can create beautiful effects. Most people who can't afford a full-blown airbrush mural will opt for some pin-

striping. There is also a large following of auto enthusiasts who don't really want a loud paint job and prefer just a few pinstriped accents.

Pinstriping is easy to learn and inexpensive to start up. A starter set of dagger brushes—long and tapered so they will hold a lot of paint, allowing you to pull a long line—runs about a hundred dollars. Every pinstriper I know uses One Shot Lettering Enamel, which costs about six to nine dollars per half-pint. Most books that describe how to paint cars will have a section on pinstriping. The key to success is practice, and I suggest you do so until you feel comfortable with the medium before soliciting general customers. One pinstriper told me he went to a junkyard and practiced on the wrecked cars.

Lettering can be done with the airbrush by masking off the letters and then spraying them. Letters can be drawn by enlarging them with an opaque projector, tracing them onto paper, and then using the drawing as a stencil for airbrushing. Strip magnets will hold down the paper stencils on the metal. After the letters are airbrushed, they can be outlined with your pinstriping brushes. The final result is quite dynamic.

Car owners will often come to you with some idea of what they want painted on their vehicles. To help customers refine their ideas, you may want to do some sketches. It is important to clarify what the customers want; once the painting is done it will be too late. A few sketches could save you many hours of redos.

Finding Work

Once you have developed your metal painting skills, you need a place to use them. You can paint in your garage as long as it is clean—you don't want dust falling into your art. You can also make an arrangement with a body shop (this will be explained later). You don't really need a special spray booth to airbrush vehicles, but you will need one to apply the clear coat.

The next questions to answer will be where and how to find work. The following sources can be pursued one at a time or in conjunction with each other. To paint metal, you will have to actively market yourself and seek out customers.

Motorcycle, van, boat, and car clubs. Motorcycle, van, boat and car clubs are some of the best sources of work you will find, though you have to be a bit of a detective to find these people. The work is not going to drive into your studio. As you get to know them, your name will spread. If you do quality work, your reputation will grow.

There are clubs in almost every town, usually listed in the Yellow Pages under "Automobile," "Van," "Boat" or "Motorcycle Clubs." You can also find clubs by striking up a conversation with employees at auto parts stores and speed shops—specialty shops catering to the auto enthusiasts who want to customize their vehicles. Visit local boat, motorcycle and car dealers and ask the salespeople if they know of any clubs. If they don't know, they usually know whom to ask. They might refer you to a mechanic in their repair department, to a marina, or to a specific auto parts store.

Once you locate the clubs, find out when they meet and go to their meetings. Call the president of the club before the meeting and ask him to introduce you. You can prepare a small presentation of your work, pass out business cards, and answer any questions members might have. Most questions will be about cost and turnaround times. After the meeting, you can expect several members to approach you about certain designs they were interested in having painted on their own cars or motorcycles.

Again, it takes time to develop a reputation. You have to understand that car and motorcycle enthusiasts usually build their vehicles over several years. They save a while and then buy a nice set of tires, a new engine or a custom paint job. And when you add the cost of body work, which is usually expensive, the cost of the base color, and your airbrushing on top of that, it's not unusual for a completed paint job to cost over five thousand dollars.

When I started painting metal, I painted several friends' cars so I would have work to show potential customers. I photographed my friends' cars and developed a small portfolio. Eventually I took the portfolio to a car club meeting and showed it to all the members. From the thirty people I talked to that night, I landed two jobs that netted me over seven hundred dollars. Over the next several months, four more members contacted me to paint their cars.

Motorcycle exchange stores. Motorcycle exchange stores are stores where riders can trade in old sets of fenders and gas tanks for sets that have been custom painted. The traded-in fenders and tanks must be in good condition or they will not be exchanged. These stores allow motorcycle enthusiasts to pay just for the artwork (along with a discount to cover the cost of base coating the traded-in fenders and tanks). Customers also get instant satisfaction in that they don't have to wait for their motorcycle to be painted.

Only a large town can support this type of opera-

tion. You can find exchanges in the Yellow Pages under "Motorcycle Accessories" or through the same detective route mentioned in the previous section.

To work at an exchange store, take some photographs of your art to the store in person and ask to see the owner. Then show him your work. He will say either yes or no. Sometimes the exchange is owned by artists and there isn't enough work for an additional artist.

Sometimes the exchange store is part of a motorcycle dealership. You can even start an exchange in a dealership that doesn't have one. First you have to approach the dealership owner and ask to do it. Tell the dealer you would be willing to paint some of the fenders and tanks that he has in stock (once things get rolling you will paint the trade-ins to restock). The dealership owner can earn a percentage of what you charge for the sale of your art and the cost of the stock parts. I recommend giving up no more than 25 percent of the price you want for your art.

The motorcycle dealership owner may have some reservations about letting you walk out of his shop with several hundred dollars' worth of stock. You may have to offer him some sort of deposit that he will return to you when you return with the painted gas tanks and fenders. Have the dealer sign a receipt and write up some sort of agreement clearly stating that you will get your money back when you return with the parts and not when they sell. (More about contracts on pages 108-109.)

The designs you paint for display should be kept general and have mass appeal. Avoid nudity in your painting as this can be offensive to some people. Look through motorcycle magazines to get some ideas. Mountain and desert scenes have always been safe.

After you paint the fenders and tanks, return them to the dealership owner. Itemize what designs you brought in and how much you want to charge. Write this out on a two-part receipt and have the dealership owner sign it. You should arrange a time, at least once a month, when you will return to see if anything has sold. You should also ask the owner to pass out your telephone number to customers who want custom work.

This can also be set up so the owner gets a percentage of any custom sales. The owner may even arrange a meeting between you and customers at the dealership, so that he can offer your services as a part of his dealership. This is an excellent arrangement that can be quite lucrative, but it usually comes about over time as you and the dealership owner develop a trusting relationship.

One of the best places to find airbrush work is at the car, van, motorcycle and boat shows. If you are bold enough, you could even set up an airbrush booth at the show, so people can have you paint their vehicles on the spot. Because of the fumes and other hazards you will have to be either outside or in a well-ventilated place. Be sure to tell the show promoters what you plan to do. Another option would be to set up a booth to paint T-shirts or sweatshirts. You could pass out business cards at the same time and display pictures of your custom metal painting. I do not recommend renting a booth just to display your work; these booths are expensive.

To set up a booth, you will have to contact the show promoters and request a spot as a vendor. Most shows rent out spots to different vendors as another source of income. The promoters will send you a layout map and a contract with terms, conditions and costs. Occasionally they will ask to see photographs of your display booth and your work. You will have to sign the contract and return it with a check.

Different promoters charge different fees, so it is difficult to say how much a space will cost. The average runs between $75 and $300 per day. This fee usually pays for power and a space about ten-feet square.

You may also find that an airbrush artist has already reserved a spot in the show. Don't be discouraged; many artists have worked the same shows for many years. Part of finding a spot is waiting for these artists to move on to something else. Waiting isn't fun for anyone, but remember, when you do get a spot, it will be secured for you, too, year after year.

Car, boat, and motorcycle race tracks. A race track draws many potential customers for you. However, you will find it difficult to set up to paint vehicles at these events. Because the customers are only there for a short period, it will be difficult to paint enough vehicles to make it worthwhile. It would be better to promote yourself at the track by painting T-shirts and sweatshirts. You can display your metal work, pass out business cards, and still make money on the spot with garments. Potential customers can call you at some other time to make an appointment with you to talk about painting their vehicles. You can also make appointments for estimates or take orders on the spot—do sketches, schedule the work, and get your deposit.

Small, local race tracks are usually easy to set up

in, and the tracks often have weekly events, so you are sure to establish a regular source of income. The large tracks, like the Daytona International Speedway or the Indianapolis Raceway, are not the place to find metal work. These race tracks will be more difficult to set up at, and because many of the customers will be from out of town, not much work will be generated.

To set up at a race track, call the track owner and tell her that you would like to display your metal painting and paint airbrushed T-shirts at her race track. Make an appointment so you can show the owner samples of your work and negotiate a percentage on the T-shirts you sell there. The track owner should not be paid for any work you do away from the track. You are only offering a percent on sales of T-shirts at the track. The section "Approaching an Owner" in chapter two outlines how to approach a business owner and persuade her to let you set up in her establishment.

Once the track owner has agreed to let you set up, you should suggest that she place you near the other vendors. This will guarantee a steady flow of people past your booth on the way to get sodas and hot dogs. Your display should be set up behind you, so that customers can't touch it. There's nothing worse than having your display knocked over in the middle of a sale. The pace is usually fast, because you need to finish any orders you take before the race ends, and you don't need any unnecessary disturbances.

Remember to stop taking orders long enough before the race is over to finish them all. Customers don't want to wait around after the race for you to finish their T-shirts.

Auto, boat, and motorcycle body shops. People looking for custom paint jobs will naturally contact a body shop if they don't know where else to look. If you can intercept them at this point, you can land the custom portion of the paint job. To do this, contact all the body shops in your area and try to develop a relationship with the salespeople at each. Tuck your portfolio under your arm, go out, and talk to these people.

A good metal artist is hard to find, and most auto body shops will be happy to offer a new custom service, but it will take more than one visit to get them to start sending you work. There are several reasons for this. First, after just one visit, they may forget you. They normally don't have a lot of call for custom paint jobs. Second, it's often easier to talk the customer into something the shop can do rather than to call and arrange a meeting between you and the customer. The natural tendency

of the shop will be to service the customer with what they already have in-house.

It will take several visits before the auto-body shop owners begin to take you seriously. You don't have to do a hard sell every time you visit their shops. On the contrary, you want them to be happy to see you. Stop by about twice a month and tell a good joke, then ask how business has been. Then subtly ask if they've heard of anyone looking for custom work. Do this at least a half-dozen times before you give up. If you don't get a lead after six visits, you should drop them.

You may want to price your art high at these outlets, so that you can offer the shop owners a high commission. Auto body shops work on a tight margin, and you will have to make it worthwhile for them to send work your way. You may lose some customers because the prices are high, but it has been my experience that pricing your work so that it includes a healthy commission for the shop owners is the best policy in the long run.

You will have to screen out the auto body shops that don't send you any work and cultivate the ones that do. A display at the auto body shops that have been producing for you will get you even more work from the customers who see the display and realize that the service is available.

Your display doesn't have to be elaborate. You can mount some blown-up photographs of your work in a picture frame or even paint some actual metal samples to hang on the wall of the shop. The body shop should have an old trunk lid lying around. A trip to the junkyard will produce a metal piece just as well.

If you stick to this program, you can have displays in all the major body shops in your area. This type of exposure will grab the customer at the moment he is ready to buy.

Pricing

When pricing metal painting you should establish a dollar-per-hour figure for yourself and then add any expenses on top of this figure. The price should be agreed on when the customer approves your sketch. I recommend that any subcontracted work be handled by the customer. If the vehicle needs a base coat or body work, have the customer do that first and then bring the vehicle back to you. After you have painted the vehicle, the customer, again, should deal directly with the body shop for the clear coat and final buffing.

Always get a deposit, or if you can, full prepayment. Make sure the deposit is large enough to cover the cost of your materials and some of your

time (try for about half of your time). If a customer wants a rush job, pass on the job rather than charge extra.

Unless you have the customer sign a very complicated contract you will not be able to hold the car should the customer refuse to pay. Your only recourse will be to take the customer to court and get a judgment. To get the contracts necessary to hold a customer's car, you will need to contact a lawyer—and in some states holding a car is not legal at all.

Because customers don't understand all the intricacies involved in auto painting, they are often shocked at the quoted prices. Metal paints are very expensive, and they don't store well. A lot of masking is required when you work on metal, and because you have to work in demanding physical positions, the painting takes longer. What would cost $25 on a T-shirt could easily cost $150 on an auto.

Because airbrush on metal is expensive, customers will constantly ask you to modify your quote to make the price lower. I have had customers ask me to simplify the design in order to lower the price. This is a dangerous game and it could end up costing you money. No matter what customers say, they expect a certain standard of quality, and if you skimp on the design, the customer may refuse to pay. And since they own the car on which the painting is painted, you will have a hard time collecting.

If you want to offer customers a lower price, have them do some of the prep work. Tell them to take the car to the body shop and have the surface stripped and sanded for painting. You can also have them do the taping and masking work. The customer can also assume the responsibility for having the final artwork clear-coated and buffed. But never skimp on the art. If the customer insists you skimp, refuse the job.

When customers ask me to skimp on the art, I ask them to choose what to leave out. I suggest putting only three legs on a horse or just one front tooth in the mouth of a figure, then leave it up to them. Being silly like this will help the customer understand that what they are asking is unacceptable, while at the same time diffusing the situation in a humorous manner.

Vehicle Accessories

Over the last few years painters of license plates and van tire covers have been cutting out an impressive niche in the metal market. These items are popular because they are relatively inexpensive. A custom tire cover can be painted for less than a

hundred dollars, and the license plates sell for about fifteen dollars.

Van Tire Covers

Van tire covers are used to cover the spare tire that is mounted on the back of most vans. The covers can be made of metal, canvas fabric, vinyl or Naugahyde. For years van owners have customized their tire covers with many different designs.

Some van owners like to have their names painted on the tire covers, others have beach scenes or some other nature scene; still others prefer humorous cartoons.

Once painted, the van tire covers are displayed in dealerships, auto parts stores and customizing shops. Just like the prepainted motorcycle tanks and fenders, the van tire covers should be painted with general designs so they will have a large mass appeal. Nature scenes, beach scenes, and attractive animals such as eagles and lions have always been strong sellers.

Van customizing is an aftermarket operation, and many dealerships use a specific company to customize their vans and handle custom requests. Contact dealerships and ask them who does their customizing, then follow through and contact the customizing shops.

Set a time to meet with the customizing shop owner and show him your portfolio. You don't need to show samples of van tire covers, but you should have samples of metal painting. Your portfolio should look as good as you can afford but doesn't have to be fancy or expensive.

You will have to negotiate pricing with the owner. This could be in the form of a percentage paid to the customizing shop owner or a flat rate. Whatever price you settle on, make sure you are getting enough money for your work. Remember to pay yourself a fixed dollar amount per hour and then add expenses to that. Most airbrush artists earn between twenty and sixty dollars per hour.

Frequently a shop owner will ask you the price of one van tire cover, which sets you up for the next question, "How much if I buy a hundred?" This is a typical negotiating technique that can get you in trouble.

If you spit out a price because you are eager to land the work, you may forget to include something and end up not even covering your costs. If the customizing shop owner asks you how much a hundred van tire covers will cost him, tell him you will have to get back to him in a couple days with a quote. This will usually let him know that you are

Artist Spotlight: Pooch—Airbrush and More

Pooch offers pinstriping and full custom painting on cars, boats and motorcycles. He also offers glass etching—done with an airbrush—and sign work, making himself a one-stop shop for custom work.

Pooch got started airbrushing at fourteen when his parents bought him his first airbrush. He soon combined his passion for airbrushing and his passion for cars into his first paying job. A member of a local car club discovered that the boy who spent so much time admiring their cars was pretty good with an airbrush, took the boy under his wing, and bought Pooch a pinstriping kit. Pooch quickly became a pinstriping expert and financed part of his college education with his profits.

Today he paints award-winning designs on automobiles and motorcycles and such large scale projects as fifty-foot-long offshore racing boats. He even airbrushed a mural of boxes of detergent on a Westinghouse washing machine for an ad produced by a New York ad agency. One of his favorite projects involved gold-leaf work on a fire truck that the client wanted to match three previous fire trucks dating back to 1927.

During a peak period, he may paint a truck a day on average, including all work on doors and body, lettering (including chrome or neon effects) and glass etching. Pooch preps the metal surfaces and then applies the base color. The other colors are airbrushed over the base color, wet on wet, which produces a solid bonding of colors. When the airbrush work has been completed, Pooch sprays a clear coat to seal the work.

The current trend is toward lettering that looks like neon tubing and futuristic, chrome bevel-edged letters. Three-dimensional effects—letters that create an illusion of depth—are also popular.

Pooch offers glass etching in addition to his custom painting work as an extra service (for which he charges). Glass etching can add as much as 15 to 20 percent to a complete customizing paint job. It gives him a competitive edge, because not many other custom painters do it. The most frequently requested designs are those that tie into the theme of the overall design, whether it is a wildlife scene for a bigfoot truck, or a seascape for a fishing boat. Pooch uses a tool called the Air Eraser that sprays an aluminum oxide cutting compound to etch the glass following a stenciled design. He can engrave fine lines or add shading with a Dremel tool or make a background tone with a sandblaster. With these

Glass etching done with Dremel and Air Eraser.

tools he can create complete murals etched in glass. (For more on this, see the "Tools and Materials" section of this chapter on pages 83-86.)

This process takes about as long as any stencil illustration, so it is priced the same way. Often the rubber stencils for a job can be saved and used later. The charge for a job depends on how long it takes. If the customer wants a custom design, Pooch has to buy the stencil material, draw the design, cut it out, apply it, and etch the glass. The customer is billed for Pooch's time on the job and any materials used.

Pooch feels that educating the public is the toughest part of doing custom metal painting and glass etching. People don't know what can and can't be done for them and often find the prices hard to swallow. He finds it helps potential customers to under-stand the process of creating airbrushed vehicles better if he shows them his portfolio. Looking at his portfolio, customers see interesting designs or ideas that Pooch has rendered for his clients, and this veri-fies the quality of Pooch's work. Of course, the slug-gish economy in 1990-1992 has meant that busi-ness is slow in general, because clients tend to put off customizing their cars in favor of more practical purchases. Being able to offer so many different ser-vices helps Pooch keep his business going despite troubled economic times. Because Pooch has been in the custom painting business for over twenty years, he has a steady flow of commercial vehicle and signage work that offsets any decline in demand for customized car paint jobs.

Airbrushed helmet.

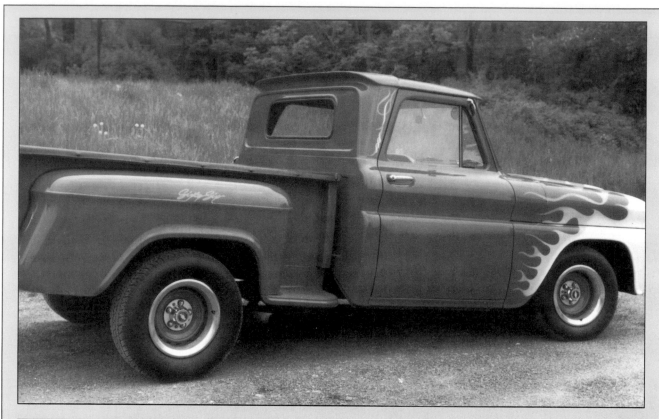

Airbrushed pickup truck and detail of pinstriping and door panel.

Artist Spotlight: Chris Cruz

Chris Cruz credits his high school art teacher for recognizing and helping him develop his innate artistic talent. Under his teacher's tutorage, Chris successfully entered and won a national contest, producing an outstanding congressional portrait that is now on permanent display at the Center for Judicial Studies in Washington, D.C.

His artistic aptitude, however, presented a challenge. Chris's father owned a motorcycle repair shop and expected Chris to help him continue operating the family business. Chris wanted to help his father but also to develop his artistic talent. He found a way to do both by getting into airbrushing murals on metal.

Chris began experimenting with the different metal paints available in his father's shop. Through trial and error, he learned which types of paints yielded the best results. Today, Chris airbrushes his designs and murals on most metal surfaces and on other hard surfaces such as fiberglass, wood and glass as well. The bulk of his work appears on motorcycles, cars and boats. Chris showcases his work at car shows, where cars he has painted often win top prizes.

The most intriguing challenge Chris faces is finding out what the customer really wants him to paint. Offering the potential customer a lot of different ideas to choose from is a key to helping the customer develop a design. It is also important to be flexible in offering design ideas: produce quick sketches, have some art books available for the customer to leaf through, or better yet, present the customer with a portfolio containing photos of the airbrushed artwork you have produced for other clients.

He has developed a bustling business, handling

as many as thirty cars in one week. Chris advises the beginning metal painter, "After learning the basics, do freebie work so people can see."

He believes that "sales come out of good exposure, and the value of your work spreads fast by word-of-mouth." An accomplished metal airbrush artist can earn up to forty dollars per hour, but the artist who owns his own shop can earn even more. Although it varies from year to year, Chris's income averages in the mid-fifties.

Freehand airbrushed mural on a metal tire cover.

Freehand airbrushed mural on a fiberglass motorcycle sidecar.

not going to fall into the trap, and he will then make a more solid offer.

If he does insist on a quantity price, tell him that you'll need at least half down. This will discourage any dealer who's only trying to drive a hard bargain. Most of these companies only do six or seven vans per week, and they don't have enough cash flow to pay you a large deposit. My point is this: Be careful when negotiating, because once you make a deal, you will have to live with it. It is always better to walk away from a bad deal than to end up working for free.

If the customizing shop owner likes your work and you settle on a fair price, he will be able to offer custom van tire covers as part of his overall customizing package. You will have to establish prices for specific custom designs. This way, you will get work every time a local dealership sells a custom van. This could result in a lot of steady work.

Van tire covers can also be sold through dealerships and auto parts stores as well as customizing shops. Displays can be set up in the dealerships or stores or in other places people go to buy stuff for their vans. You can also set up an order/commission arrangement like those discussed in canvas painting.

License Plates

Personalized airbrushed license plates can also be a steady source of income. These are painted with either stock or custom designs similar to those painted on T-shirts. Airbrushed license plates were first offered through T-shirt shops along the Florida coast. But now there are shops that offer them as their main product. Personalized license plates are very popular in states that require only one state-issued license plate, but they obviously will not sell as well in states like California where license plates are issued for both the front and rear of cars. If you plan to offer license plates, check with your automotive registration office to check their legality in states in your region.

The low cost of license plates adds to their popularity among airbrush artists. Three hundred blank aluminum plates, at .025 gauge, will cost you about sixty cents each. They retail for up to fifteen dollars. (For a list of places where you can order blank, ready-to-use plates, see page 125 in the "Resources" section.) You can paint them exclusively or add them to your current product line.

License plates can be sold in the same way as any of the products discussed in this book. I in-

cluded license plates in this chapter on painting metal only because they require metal paints.

Recently, people have been setting up kiosks in malls exclusively to sell license plates. A kiosk is a freestanding retail outlet, usually found in a mall. If you are interested in setting up a kiosk, you will have to contact the mall management for a copy of a lease and the mall's requirements and restrictions. They can usually recommend someone who can build your kiosk to meet commercial codes and mall standards. The finished kiosk may be quite expensive.

Many malls will arrange rent based on a percentage of your sales. This usually ranges between 10 percent and 25 percent of gross sales.

Sign Painting

Sign painting is a commercial application of your artistic skills. You are expected to bring your design and rendering skills together to help promote a business, product or service.

In this section I discuss mainly the airbrush applications used in sign painting, but I will also touch on the other media in sign making to illustrate both the diversity and the alternative money-making opportunities within this industry.

You will be asked to paint on many different surfaces, such as metal, plywood, aluminum, cloth banners, windows, walls, and so on. Some people will want signs painted on their vehicles as well as indoor and outdoor display signs. You may also find yourself mixing mediums: computer-generated vinyl lettering enhanced with the airbrush, for example.

If you plan to paint signs full-time, learn brush lettering and striping. The airbrush is great for adding blends and shading to a sign. But when it comes to the line work, you will have to use a brush. You will not be able to mask off line work in a sign as fast as you could paint lines with a brush. You would have to charge so much for a sign done this way that your prices would not be competitive.

Dagger brushes make all the difference. Most people have used canvas paint brushes, which pull very short lines. This scares people away from sign painting, because they can't imagine restarting a line every few inches and keeping the line straight at the same time. Dagger brushes let you pull a line up to several feet without reloading paint.

There are also many tricks sign painters use to keep lines straight. Some sign painters lay down tape and follow the edge when they have to pull a long line. Or they use opaque projectors and type-

setters to enlarge and trace copy. With a little practice on your part, sign painting will return a steady income for many years.

Offering only airbrush signs can put you at a disadvantage, because the range of your services will be very limited. A potential client may not want an airbrushed sign and will ask instead about lighted signs. At this point, you will have to say that you only do airbrush signs or that you can also provide lighted signs. Refer or subcontract a job unless you are absolutely sure you can do a professional job.

Selling Your Services

Unlike all the other markets we've discussed in this book, sign painting is a service sold mainly to businesses rather than individuals. You will have to take a different approach to locating potential customers. Logically, most sign work is purchased by businesses just starting up. You can find work with existing businesses, but they will never have the same volume of work as they did when they first opened. Your energies will be better spent looking for businesses just starting.

Your local business license division could be your best source to locate new business start-ups. Most license divisions provide a new business list for a small fee. This list can cost anywhere from $25 to $300, depending on which city you're dealing with. The list will give you the names, addresses and telephone numbers of the person or persons who will be controlling the business.

If your city does not provide a new business list, you can monitor newspapers in your area that print the Fictitious Name Statements—a business that goes by any name other than its owners' is operating under a fictitious or assumed name and must file a record of that name with the county government. These statements do not give you as much information as the new business list, but they usually provide a name that can then be found in the telephone book or through telephone information. With a little phone work, you should be able to contact most of the principals.

Local designers, contractors or architects might provide you with leads in return for a percentage of your earnings. These people can be found in the Yellow Pages of the phone book. Call them and tell them you are a sign painter looking for work, then listen to what they say. Some may say they never work with sign painters directly, in which case you can ask them for other leads. Some may ask to see some of your work, in which case you can set up an appointment or put a few photo-

In-Store Signs

Malls and other shopping centers have become more style conscious, and the in-store sign business is booming. In-store signs are simple signs that advertise sales and special offerings. These signs were once done by an employee with a little spare time. Most leases in posh malls and shopping centers no longer allow signs that are done in an unprofessional manner.

The old poster board and felt-tip pen sign has been pushed out of the market by sign painters. The signs these stores need are still hand-lettered, but they are now done by people experienced in type fonts, color usages and composition.

The airbrush lends itself extremely well to this new market. Letters can be drawn on using professional markers and drop shadows and background colors added with the airbrush. These signs can be done quickly with the airbrush, so the price can be kept very competitive. They typically take less than fifteen minutes to do, and you can charge between eight and fifteen dollars, depending on the amount of lettering.

To market this service, you need only develop a few samples and take them around to high-end stores and malls. When you enter the stores, ask to speak to the manager or owner. Remember, as with any other sale, a store may not need any signs right away. If you drop by the store once every two to three weeks, though, you will soon be taking orders. You can expect most of your orders to come during the three months before Christmas, especially the six weeks prior. After-Christmas sales also increase your business, so mention this to the store owner as Christmas approaches.

graphs in the mail. If you mail photographs, follow it up with another call to your contact in about a week.

Once you have the names of some potential customers, the next step is to let them know about you and your service. Have a clear understanding of exactly what you will and will not do for a potential client. You know that you will be offering your airbrush skills, but will you also be offering standard brush signs? Your whole business must be planned before you make the first sales call. If you understand exactly what you want to do and know your limitations, sales become easy, even fun.

Try to relax. Fear of making sales calls is the leading reason people fail in business. The main

reason people dislike sales calls is the word "no." It's hard not to take a refusal personally.

When you call potential customers, think of them as good friends. Imagine that you are calling to tell a good friend about a good deal you've found on a set of tires. Now, if your friend says thanks for telling her, but she just bought a set yesterday, are you going to be hurt? No. Or if she says she had her heart set on a different brand than the one offered in the sale, are you going to get upset and take it personally? No. You will still feel like you did her a favor just thinking about her.

It is no different when you are talking to a stranger. You basically ask potential customers if they need signs for their new businesses. They are going to answer yes or no. They may already have arranged to have signs painted. Or they may not yet be ready for signs. Many people starting businesses get their licenses before they even choose a location, and without knowing the specs of the location, you can't paint the sign. Other people may not even need signs because their business is mail order.

You can expect to hear many reasons why a potential customer doesn't need your service, but you will rarely hear a "no." Ask customers who tell you they're not ready for signs when you can call them back. Work with them. It will be a rare occasion when a customer says, "What a coincidence, I was just thumbing through the Yellow Pages looking for a sign painter."

Most potential customers will have some sort of time line or schedule that they are following when starting a business. The chances of the customer needing you at the moment you call are slim, but if you keep a list of these people and call them back when they are ready, you will land the jobs. By the way, most of the schedules these new businesspeople set for themselves are unrealistic, so don't be upset if they are still not ready when you call back the second or even the third time.

You may not even close your first job until a month after you start calling, but the trick is to keep calling. When potential customers reach the point with their new start-ups that they need signs, they will give you the work. Some people may ask to meet with you to work up quotes but may not order for several weeks or even months. The key to success is to stick with it and set a certain time each day to sit down at the telephone and make calls.

No matter how much you need the work, never take on an unsecured customer, especially a new business start-up. An unsecured customer is one who has no credit history or references. New start-ups are known for being underfunded and running out of money, often before they open the doors. You could be out quite a lot of money if this happens to your customer.

Subcontracting Your Services to Sign Shops

If you are not interested in approaching customers directly, you can subcontract your airbrush services to other sign shops. Paint some samples of what you can do and then photograph the samples. With this portfolio, you can visit sign shops and solicit airbrush work from them.

When you visit the sign shops, the owners or managers are going to want to know what you charge for your airbrush art. Establish a flat labor fee and then add any materials on top of that if the shop owner will not be supplying the materials. Rates vary widely throughout the United States, so I can't give you any specific figures. Talk honestly with the shop owners. Tell them you are just starting out and you really don't know what to charge. This may seem like you're putting yourself in a risky position, but if you ask several shop owners what you should charge, you should be able to put together an average price you can charge.

Tools and Materials

You need the right tools and materials to make money airbrushing. The following is a brief listing of the items you'll need to airbrush on metal and similar surfaces and what they're used for. I mention brand names only when there is no other brand on the market or when no other available brands serve the purpose as well.

Airbrushes

Painting metal or signs requires metal-based paints, so you will need an airbrush that can handle thick pigments. The Paasche VL series and the Iwata HP-BE will give you the finest spray with metal-based paints. You may also want to consider the Paasche AUF, which is used for a two-inch and larger spray pattern. It is also handy when doing a blend across a 4×8-foot sign.

Paints and Clear Coats

Every pinstriper I know and many sign painters use One Shot Lettering Enamel (also called Sign Painter's One Shot), an oil-based, high-gloss enamel.

Most artists use enamel paints to paint license plates and then shoot a clear coat over the entire

Artist Spotlight: Mr. J

As a teenager, Mr. J (Julian Braet) was fascinated by Ed Roth's and Mouse's T-shirt art (the "monster art" craze) and wanted to imitate their work. He was also attracted to the bright, eye-catching lettering that he saw on race cars that came into New Jersey from the West Coast. His enthusiasm for that lettering style landed him his first job, when he became an apprentice in a sign shop.

He soon bought his first airbrush, but he couldn't find anyone to teach him how to use it. No classes were available. So, Mr. J learned how to airbrush by trial and error. Apparently he had a good teacher, because he started his own successful lettering business after five years in a sign shop.

Airbrushing is an extra service he can offer clients besides traditional signage to give him a competitive edge. In fact, other signage shops that don't offer airbrushing recommend Mr. J's services. He is best known for his custom lettering, cartooning, and

graphics on vehicles. Because he has done a lot of race cars, his work has been widely promoted.

Mr. J does not believe that advertising, at least in the Yellow Pages, has helped his business. He has found that "usually callers from the Yellow Pages just call for price quotes and the lowest bidder often wins out. Because I want to provide quality, I specialize in high-end airbrushed signage." One of his biggest gripes in general is people who don't understand the amount of work it was for him to get to where he is now. "Because this is an instant gratification society, most people believe the cheaper, faster approach is the best." Customers often don't understand that what Mr. J sells is not the time it took to airbrush, but the expertise.

Mr. J warns the beginning airbrush artist to keep quality standards high. "Word-of-mouth is the best and cheapest form of advertising. If you treat your customers right, they'll become your best salesmen. Word-of-mouth and your work will speak for you." On the other hand, business can be adversely affected if you don't have a good reputation.

Although his business in 1990 and 1991 was affected by the sluggish economy, his livelihood has not been challenged by computerized lettering. The computer can't produce the custom lettering effects possible with an airbrush. People continue to request custom hand-lettered work, and his average yearly income still averages between $100,000 to $150,000 per year. Mr. J believes that an airbrush artist with average or above average airbrush skills can easily earn about $35,000 to $50,000 per year in an area with a large commercial base.

Mr. J has had a difficult time getting apprentices to work in his shop, but a close-knit organization called "Letterheads" has helped to bring new people into sign painting. Mr. J is a member of this organization, which has one of the primary trade publications for signage artists. By subscribing to a signage publication, it is possible to find announcements of Letterhead meetings and/or trade shows in various areas around the country. Mr. J recommends that the beginning airbrush signage artist get in touch with someone who uses the airbrush in the signage business and try to find out more about the craft. Signage magazines and books can be found in the library and in art supply stores.

It's also important to look at signage work. Start seeing what looks good and what doesn't. Take photos of work you like to get good ideas. Don't be discouraged or afraid to ask signage professionals "stupid" questions. "Remember," Mr. J says, "you're never too old to learn, and even as you become an expert, you continue to learn from students."

plate. Some artists have been known to use the same paints they use on T-shirts and then use a clear coat to protect the paint. However, T-shirt paints fade quickly in the sun, and the clear coat will peel because it only has the T-shirt paint to adhere to.

Accessories

You may want to purchase some of these airbrush accessories:

Dagger brushes. Long, tapered brushes that hold a lot of paint, allowing you to pull a long line. Vital for lettering and pinstriping.

Respirator. Be sure that the filters are rated to filter out the particles you are spraying.

Compressor. Because you are spraying thicker paints you should use a compressor that produces at least 40 psi.

Supplies for Glass Etching

Glass etching is a simple process. The surface to be etched is first covered with a ¹/₁₆-inch sheet of rubber. The design is cut out of this material and then etched into the glass using the Air Eraser.

The Air Eraser is made by Paasche Airbrush Company and lists for about forty-five dollars; it sprays an aluminum oxide cutting compound that can etch glass, plastics or metals. *Warning*: The aluminum oxide cutting compound used in the Air Eraser is very fine and may cause severe health problems if a respirator and eye-protection gear are not used. Don't let your customers stand by and watch you work in the same room. Put a drop cloth down to protect the area where you will be working. Then use a small hand-held vacuum to clean up after you have finished.

The rubber for the stencil can be purchased in sheets up to six feet square and costs about $1.75 per square foot. Look in the Yellow Pages under "Rubber."

You'll need spray mount or some other sort of spray adhesive to hold the sheets in place. Use a utility knife with a #11 blade to cut the rubber stencil.

Blank License Plates

You can buy blank license plates that have been sprayed with a white base coat and are ready to paint. I recommend a quick wash with a mild soap and water solution to remove any grease that might cause the paint to repel, creating what is called a "holiday."

Speed Production Techniques for Vehicles and Signs

This section describes some techniques used by top-earning airbrush artists to speed up their work and thereby increase their income. Some of these techniques are simple and some are difficult, but you will find them very profitable if you take the time to learn them.

Use End Rolls Instead of Butcher Paper to Save Money on Stencils

End rolls are rolls of paper that are left over from a web printing press. Web printing presses use a roll of paper that feeds through the press rather than precut sheets of paper. Printers will stop a web press before the roll runs out of paper to save the time it would take to reset the press, hence most web printing companies will have lots of end rolls. Since the printing companies have to pay to dispose of these rolls, they are usually eager to give them away. Most end rolls will have hundreds of yards of leftover paper, and the rolls can be as wide as sixty inches. I have an end roll that I got five years ago and I still have half left.

To find a web printer you need only look in the telephone book under "Printers." Look for the word "Web Press" in the ads. If no printers advertise web press work, call any printer and ask where you could find one. You should ask for the largest web printer so that you will find the widest end roll.

Learn to Use a Computer

Most towns now have copy or print shops that rent time on computers. It would save you a lot of time and money if you could learn to use the computer typesetting programs. Using a computer is easier than most people think and can be learned in only a couple hours.

With the computer you will have hundreds of lettering styles to choose from, and the computer can align the letters and words any way you want them. All the letters in a word will be automatically spaced. This will save you hundreds of hours sketching and laying out letters by hand.

Once you have arranged the letters you can print them out on a laser printer (also at the copy or print shop). The laser print can be placed in your opaque projector, sized, and traced onto paper.

The most "user-friendly" computer system (for graphics) is the Macintosh. It costs about seven dollars per hour to rent this type of system, and each page of 8½ × 11-inch printout from a laser printer costs about fifty cents. With only a little

practice, you could typeset twenty to thirty words in about fifteen minutes at a cost of about $2.25. Most of your jobs will only require a few letters, so with this system you could print out several jobs on one sheet of paper. This same amount of typesetting could cost well over twenty dollars from a professional typesetter.

Transfer Designs by Pouncing

Pouncing is a way to transfer your sketched artwork or lettering to the surface that is to be painted. It works like this: The lines of your sketch (traced on paper) are traced again with a device that punches holes in the paper, in effect creating dotted lines. The paper sketch is then placed into position on the surface to be painted and secured with tape or magnets. Then a pouch filled with a powdered material is tapped against the paper sketch. The fine grains of powder are forced through the pouch and through the holes in your paper sketch. This leaves a powdered-line drawing on the surface to be painted.

Pouncing requires two tools: one tool that punches holes in your paper sketch and the pouch filled with powdered material. Some artists use a "marking wheel," which is a spur-like device used in sewing. Other devices for punching holes can be found at any sign-painting supply store. Sign-painting supply stores also carry the pounce bags and powder used with them. You can find sign-painting supply stores in the Yellow Pages under "Signs — Equipment and Supplies."

Use Shortcuts in Glass Etching

The most time-consuming aspect of glass etching is cutting the stencil. Develop quick ways to cut stencils and simple ways to register multiple stencils.

Of major concern when cutting stencils are the free-floating areas. These are the areas where circular shapes are created. For example, to create the letter *O* you will need to cover both the inside and the outside areas on each side of the line. The free-floating area inside the letter will be difficult to reposition once it has been moved.

Use this simple technique to solve this problem: Leave small tabs at evenly spaced points around the free-floating areas that can be cut quickly, once the stencil is in its final position. If you plan to cut a permanent stencil to use as a stock design, use tabs on the first application. Then use pieces of tape to hold the free-floating areas in position until the next time.

Many times, a single stencil will not work for a design. Either there are so many cuts that the stencil falls apart or a different effect is desired. In these cases, cut several sheets of the rubber stencil material to exactly the same size, for example, a one-foot square. Cut as much of your design as you can out of the first piece. Then line up the cut stencil over a second sheet of rubber and line up the corners. Spray a light coat of white paint through your top stencil to achieve a ghost image on the bottom stencil. Now remove your top stencil and continue cutting on the bottom stencil, using the ghost image as a guide.

To register the different pieces, use masking tape to mark the corners of the first piece and then line up the other pieces to the tape. To check the registration, you can look through the back of the glass. Always check the registration before you etch. Replacing glass can get to be very expensive.

Chapter Six

Small Specialty Markets

I call fingernail painting and cake decorating small speciality markets because they usually don't yield as much income as the others discussed in this book. These markets can yield good money, but most people involved in this work either use it to supplement income or consider it part-time.

There are other markets not included in this book where money can be made. Some artists are making money doing taxidermy. Others paint ceramics that they market in a number of different ways. Still others paint models and enter competitions where cash prizes are awarded. I did not include these other small markets because they are highly specialized, require prerequisite knowledge, or simply don't yield enough money for the time and money invested.

I do not mean to discourage artists who want to pursue these markets or any new market. In fact, many of the markets covered in this book were started by artists looking for something new. Fingernail painting and painting on license plates would stand as testimony to this. Try new avenues. It can be profitable and rewarding.

Fingernail Painting

Fingernail painting, in which a design is airbrushed onto a person's natural nails or artificial acrylic nails, is the newest addition to the growing airbrush markets. The fingernail painting fad has swept across the country. There are nail artists in every major city in America and their numbers are growing. When you can earn about a dollar a minute, you don't have to wonder why.

The nail must be prepared in the traditional manner—sanded, filed and buffed—before you can paint on it. After the design has been applied, the whole nail must be covered with a clear coat of nail polish. Airbrushed nails typically last for two to three weeks.

The most popular designs are gradations, where a color blends from dark to light along the nail. Simpler designs can be done freehand, while stencils and decals are often used to execute more complex designs. Precut stencils are available from several manufacturers (see the "Resources" section for information), but experienced airbrush artists often create their own custom stencils out of tack paper (similar to frisket).

Airbrushed fingernail designs start at $10 for a set of ten (fingers), but fancier designs can cost as much as $45 per set. It takes as little as ten minutes to do a set. This averages to about a dollar a minute. The real secret here is to develop designs that can be painted fast.

The fingernail market has two major divisions. The first is licensed manicurists who want to expand their services to include airbrushed nails. The second is made up of airbrush artists who want to paint nails for fun and profit. Many states require that you be licensed as a manicurist to airbrush fingernails. Getting licensed involves attending a state-licensed beauty college (the manicurist course requires about 350 hours) and then passing a state test administered by the State Board of Cosmetology.

States with no laws governing manicurists allow the market to be accessed by anyone. Find out what laws govern the manicure industry in your state before you begin working.

To get started, you may be able to find a manicurist willing to teach you or a class offered through a beauty supply house. You can also order a starter kit from the companies listed in the "Resource" section of this book. These kits include everything you need to get started: the airbrush, paints, stencils and detailed instructions. How-to video tapes are also available.

LynnRae Ries of San Francisco Nails explains that her company was first interested in selling airbrush kits to licensed manicurists. Recently the demand has been spreading to other artists who view the fingernail as just another canvas. People who once airbrushed T-shirts now want to expand into fingernails.

Marketing Airbrushed Fingernails

Where can you find a lot of women interested in having their nails painted? Beauty salons are the most obvious venues for the nail-painting artist, but people also set up in tanning salons and any other place where they can find a group of women. Because this market is so new, you will probably find many locations that have never carried airbrushed nails before. You may even be living in an area that is open territory, in which you are lucky; you will be able to service as many locations as you can handle.

If you don't want to get a license to paint nails, you can still sell prepainted acrylic fingernails direct to the customer through manicurists or beauty

and tanning salons. If you are in a state that doesn't require a license, you can service several locations.

If you are a licensed manicurist or work in a state where no license is required, you can airbrush directly onto a customer's fingernails. Show the salon owner some samples of painted plastic fingernails. If the owner likes your product, you can ask to set up in the shop. (For more information on how to approach a beauty or nail salon owner, see the discussion on approaching a shop owner on pages 14-16.) If the salon owner is unfamiliar with airbrushing fingernails, you may have to explain how you keep from getting paint all over the customer and that the paints are nontoxic.

In most cases, no one location will support a full-time airbrush artist, so you can put up displays and take orders for prepainted nails. If you can paint on nails in a salon, you might work at one salon on Mondays and Tuesdays and at another salon on Fridays and Saturdays. You may even work a half-day at one location and a half-day at another. The important thing is to generate enough work to make as much money as you want.

Having multiple locations also gives you job security. If a problem develops between you and a salon owner and you lose a location, you will still have other locations that still generate income. You can find another salon to work at or expand the hours you are working at the current salons to make up the difference.

Selling prepainted fingernails is the easiest way to start in this business. You simply airbrush a few sets of plastic nails and take them around to different beauty salons. If the owners agree to carry your nails, you put a display in their salon. Displays should be as fancy as you can afford. There are many different ways to display the nails and each salon owner will have different ideas, so you will have to be creative.

Mount the nails in a recessed picture frame and hang this display on the wall. To display nails under a counter, stretch a piece of crushed velvet around a piece of cardboard. Then, glue on the airbrushed nails you wish to offer for sale.

Each set of nails in the display should have a name or a stock number to identify the design; be sure to include prices. Keep the salon owner stocked with prepainted sets. These can be kept behind the counter in small plastic bags marked with the design name or stock number. Visit the salon owner once in a while to check the stock and maintain your business relationship. To help your business, offer new designs as often as you can to give the customers variety. Try to go with seasonal colors and themes.

You will have to give the salon owner a commission. He should be paid between 20 and 35 percent, on a consignment basis. *Note*: You can sell prepainted nails to a customer without a manicurist license, but you will need a license if you want to glue them onto the customer's nails. The glue is considered a chemical, and use of chemicals on the body is regulated by the State Board of Cosmetology.

As of this writing, it is legal to paint directly onto fingernails with nontoxic water-based paints and cover this paint with a clear enamel paint (nail polish). The water-based paint and enamel paint are not considered to be chemicals. Be sure to check with the Board of Cosmetology in your state before you paint any nails.

Fingernail Painting Tools and Materials
Fingernail painting requires a fine detail airbrush. A gravity feed airbrush is suggested because they are easy to clean. The gravity feed airbrush also lets you use only drops of paint at a time, thus saving you money on paint. These are available from most airbrush manufacturers.

Lower the pressure of your air compressor to about ten pounds to help reduce splattering and caterpillaring. Experiment with different pressures to find the right one for you.

Fingernail painters use nontoxic, water-based paints. There are many different brands to choose from; suppliers are listed in the "Resource" section of this book.

Acrylic nails can be found at most drug stores and variety stores. They come in kits with different-sized nails to fit hands of many sizes.

Speed Production Techniques for Fingernail Painting
Use stencils whenever possible, especially when repeating a design. You can use any card stock (about the weight of a business card) to make stencils. Some artists prefer to use mylar, a clear plastic sheet of material that can be found at most art stores.

Paper stencils are easier to make and absorb moisture better, but they won't last as long as mylar stencils. On the other hand, the mylar stencils last, but because the mylar doesn't absorb moisture, paint can work its way to the other side of the stencil. You will have to try both and see which you prefer.

You can add detail and increase your speed if

Artist Spotlight: Kelley Swortfiguer

A trained manicurist, Kelley Swortfiguer was intrigued when she saw an airbrush artist demonstrate nail airbrushing techniques at a nail show in Long Beach, California. She believed this new application for the airbrush would give her the opportunity to combine her training as a manicurist with a new and exciting artistic tool. From her childhood days, she had exhibited an artistic aptitude and keen sense of design.

When Kelley bought her first airbrush seven years ago, she was unable to find classes on using the airbrush, let alone any on nail airbrushing. Even the store that sold her the airbrush didn't offer much advice on how to use the airbrush.

Kelley taught herself how to airbrush and then experimented on her friends' nails. She tried many different nail enamels, airbrush paints and techniques until she developed a combination of nail airbrushing skills and materials that produced excellent results.

"There are specific requirements you must meet to be a nail airbrush artist," Kelley says. "You cannot work on a client's hands if you are not a licensed manicurist. To complete training as a manicurist requires five hundred hours of manicurist work at a state-licensed cosmetology school. In most cases, you must graduate from a state-licensed cosmetology school *and* pass an exam from the State Board of Cosmetology. Sanitation laws are very strict." And although ten of her clients (in the last eight years) have gone on to complete cosmetology school, over half of them have not taken the State Board's exam.

Her advice to a beginner who has obtained a state license to work as a manicurist is to "develop patience and a can-do attitude when learning how to airbrush. And keep trying. The airbrush is very forgiving. You can even paint over mistakes. Before buying an airbrush, be sure to ask the store lots of questions. How to care for your airbrush, for example, or what to do if it clogs up." The store should provide some basic information on the airbrush, or at least a product brochure from the airbrush manufacturer.

Before airbrushing, the client's nails must be prepped. After prepping the nails, a base coat is applied. When the base coat has dried, the nails are ready for airbrushing.

Kelley relies on traditional water-based airbrush paints. She uses an Iwata HP (-A or -B) airbrush gun with a silent double air compressor that can shoot two guns at once. Typically, she sets the compressor at between twenty and thirty pounds of air pressure. Except for situations like shows when carrying a compressor isn't practical, Kelley does not recommend using canned air. She feels that for commercial work, "canned air is a waste of time."

After applying the airbrush design, the client's hands must dry. To seal and preserve the design, it is now necessary to apply two clear coats of enamel on the client's nails. After applying the first coat of enamel, allow it to dry before applying the second coat. It usually takes Kelley about fifteen minutes, from start to finish, to both manicure and airbrush

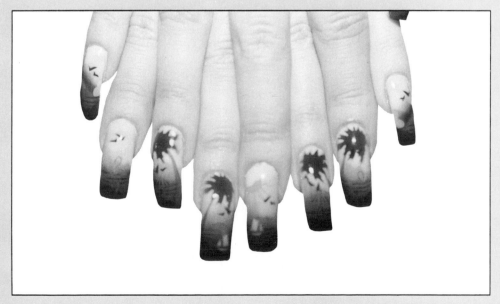

It's a good idea to start out doing simple scenes as Kelley did.

a client's nails.

Kelley insists, "You don't have to be really artistic to do nail airbrushing. People often are intimidated by the airbrush. Nail airbrushing is actually pretty simple."

What is not so simple, however, is finding out what the clients want airbrushed on their nails. A display containing samples or an album with photographs of airbrushed nails can be helpful when clients don't know what design they want for their airbrushed nails. First, find out what colors the client wants you to use. "You can ask the client if the nails should match an outfit that the client will wear later on. Often, especially with returning clients, customers will let you make suggestions and follow through with your ideas." Kelley has been fortunate; in the seven years that she has airbrushed nails, she has never been asked to remove a newly painted design from a client's nails.

Various techniques can be used to achieve different airbrush styles or designs. Paints can be applied in layers, blended or mixed to create a wide spectrum of colors. For heightened color values, Kelley produces tonal gradations, from dark to light or the reverse. Besides freehand designs, Kelley works with some stencil designs.

Kelley feels there is definite proof of the popularity of airbrushed nails. On average, out of ten to twelve clients that she sees per day, only two opt not to have their nails airbrushed. Now that she has her own manicure shop, nail airbrushing sets her shop apart from the competition.

The key to success in nail airbrushing, Kelley insists, is developing a clientele. Offering nail airbrushing as an additional service is a sure way to gain the attention of prospective customers. To market her nail airbrushing service, Kelley has demonstrated it at bridal showers, crafts and street fairs, and Renaissance fairs. Often, she offers introductory discounts, such as a two-for-one price for airbrushing nails.

Kelley believes it is easiest to keep your clientele local. "Participate in shows and fairs that are local, so your customers can come back to your shop. Your shop's location is also very important." Choose a central location in your town or city, or a location that enjoys a lot of visibility and traffic. Her own shop is in the central, older part of town, and luckily, it is a low-overhead location. The shop now employs four manicurists who have been trained by Kelley to airbrush nails. Kelley is not afraid of sharing her information; she feels that more people need to be ex-

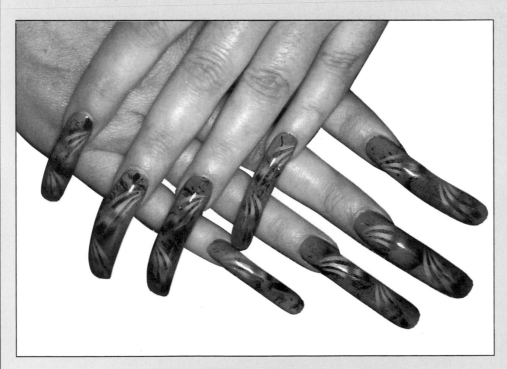

Once she could do simple designs quickly and easily, Kelley began developing more elaborate designs like this.

posed to the nail airbrushing service, and training others in nail airbrushing will create more demand. She also sends her manicurists out, from time to time, to conduct demonstrations at shows.

"Another important factor to consider is your people skills. Customers will come back if you are courteous and offer service with a smile."

The only drawback Kelley has encountered is the unsuitability of airbrush paints out on the market for nail airbrushing applications. Most of the time, the paint is either too thick or too thin. Kelley comments, "Watered down paint is very difficult to work with. Unfortunately, the airbrush paints themselves are not good." And more often than not, "the color consistency is poor. A customer is really happy with a certain color you used once, but when you reorder the same color, the next color lot might be a com-

pletely different shade."

The lack of appropriate paints for nail airbrushing is the inspiration for Kelley's newest business venture: a complete line of paints and enamels designed exclusively for use in nail airbrushing. She also plans to offer complete nail airbrush kits. (These kits will cover the paint level, but will not include the airbrush gun.) Her product line will make it easier to achieve success at nail airbrushing.

"Nail airbrushing is a potentially hot market and hasn't been exploited fully," Kelley insists. Between offering acrylic work, manicures, and nail airbrushing, her annual income is about $60,000 per year, and she has owned her own business for the last sixteen months. However, since it is new, most of her income is absorbed by the business itself.

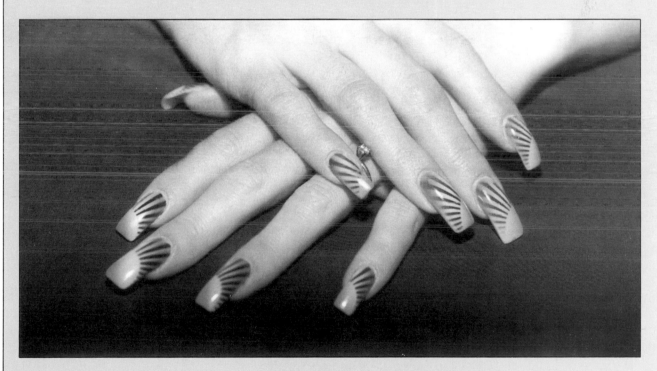

you use regular brushes along with the airbrush. Tiger stripes, zebra stripes, and any other fine-line work can be done more easily with a fine-hair brush.

Many artists interested in painting fingernails wonder how to avoid overspray on the cuticle and skin area around the fingernail. The answer is, you don't. Here's how it works: The basic design is painted on the nail with water-based paints with some overspray on the surrounding cuticle and skin. The water-based design is then painted over with enamel nail polish, applied to the nail area only with a fine brush. Since the polish is not water-based it will not wash off with water. So when the polish dries, the paint overspray is washed off the surrounding cuticle and skin area with soap and water.

Cake Decoration

The food painter's principal raw material is cake. You can make good money if you live in a city where there are a lot of bakeries, but if you don't work in an urban area, you may find there isn't enough demand to support a full-time cake decorator.

The cake decorator paints designs on the frosting of a cake and paints any design requested. You can expect most of your orders to be children's designs since the largest cake-buying group consists of parents buying children's birthday cakes.

Most of the work on cakes will be painted freehand since stencils tend to stick to the frosting on the cake. Stencils can be used if they are held slightly above the frosting surface. Fine lines can be made by using a pastry or decorating bag, a triangular bag filled with frosting. As you twist the large end of the bag, a fine line of frosting is extruded from the opposite end. The decorating bags also have different tips that produce different decorative patterns.

In the cake decorating business, you have to understand that cakes get stale quickly, and you have to be available to do your work within the time frame the bakery will allow in order to deliver the freshest possible cake to the customer. You will need to be especially flexible when it comes to scheduling.

You'll find the bulk of your work by subcontracting your art skills to commercial bakeries, large grocery stores, and other stores that have bakery departments. These bakeries produce the highest number of cakes, and they are most likely to require your services. To begin working with the bakeries, show them some samples of your work. Paint several cakes and photograph them. Then show your photographs to all the bakery owners in your town.

You may find that some bakeries already have someone decorating cakes or don't offer custom cakes to their clientele. Look for bakeries that show an interest in your service. Explain to the bakery owners how your custom-painted cakes will make their bakery unique.

Before you visit the bakeries, prepare a flyer with your name and telephone number on it. Bakery owners can contact you and refer to your price list on the flyer; this helps them figure out what to charge their customers. Remember, by selling your services through the bakeries, you have to set prices that the bakeries can mark up to the customer, so try to keep your prices reasonable.

Price your art so that you are paid a reasonable hourly rate and your expenses are covered. When first starting out, I recommend you keep your prices low. As you get more work referred to you, you can increase your prices. If you find a sudden drop in orders you have raised your prices too high.

Once you have found a bakery that agrees to use your decorating services, ask to set up a display there. Many customers never ask for custom cakes because they don't know the service is available. If you are allowed to set up a display in the bakery showroom, the customers can see what you do for themselves and request this service at the counter. If the salesperson is busy, they may not even show your photographs to potential customers. Most counter people earn the same amount of money whether or not they show your photographs. You could offer free or discounted art prices for counter people who sell for you.

The display does not have to be expensive. You can use the type of picture frame that has several openings for photos. Show samples of your work and leave one opening for information about your service and prices. (See pages 17-20 for more on creating your display.) You should leave easy-to-use order forms that the bakery employees can fill out and attach to the cake order and a price list, so they'll know what to charge.

With several displays located at different bakeries, you are sure to get work. If you want to increase business, you will have to establish more outlets, meaning more bakeries. The more you expand, the more money you will make. I suggest you expand slowly, not adding more than one outlet per month, so you don't find yourself overwhelmed with work.

Most bakers will let you work at their location.

I recommend this because the bakery has already passed the health department inspection and your kitchen at home has not. It would be much easier to take your equipment to the bakery, and much less expensive than bringing your kitchen up to commercial code.

The baker can call you when he has taken an order. Arrange a time to go to the bakery and do the painting.

Tools and Materials

Airbrushes for cake decorating must work well with low pressure. Any of the fine illustration airbrushes, such as the Paasche V series, the Iwata HP-BC, Badger 150 series, or Thayer-Chandler Model-A, will work fine.

Because the Aztek airbrush has a unique air pressure control located in the trigger it would work especially well for this application. This trigger allows you to reduce air pressure in tight spaces and increase it when working farther away from the surface. This will save a lot of time adjusting the air pressure valve on your compressor and allow you more versatility.

Several companies sell airbrush paints specifically designed for cake decoration. I suggest you buy your colors from these companies because they are preapproved by all government agencies. (One company is listed in the "Resource" section of this book.) These special paints may be hard to find; you may also want to contact a bakery doing airbrush or similar work.

Most compressors equipped with the proper air filters and a pressure regulating device will work for cake decorating. The thing to remember is that the surface of the cake is fragile, and high air pressure will blow holes in the frosting. To avoid this you will have to keep the air pressure as low as possible.

The opaque projector can also be used for cake decorating. However, when working with cakes the image is projected directly onto the cake rather than on paper. Using the projected image as a guide on cakes can result in very realistic renderings. This is important, as many requests will be for portraits of people.

You may want to invest in a set of cake decorating tools so you can add detail to your paintings. For example, if you have to paint a figure, you may want to draw the outline, eyes, nose and mouth with the line-drawing tool and then paint the larger areas of color and the shadows with the airbrush.

The shadow effects created by the airbrush will

The Health Department and the Food and Drug Administration

The Food and Drug Administration is concerned about the chemicals that you will spray onto cakes—not just chemicals in the food coloring that you spray with your airbrush, but also the chemicals in the air that flows through your air compressor. Your county health department is concerned about the cleanliness of your airbrush and the area where you will be painting.

In many states, painting cakes in your home is illegal, so you will have to arrange to paint the cakes at the bakery. It isn't difficult to take your equipment to the bakery. In many cases, bakers prefer this because cakes can be easily damaged in transit.

The food colorings that are sold in grocery stores are made from chemicals that are approved by the FDA, so this is not a major concern. Never spray anything on your cakes that you are not sure is safe. Call the FDA and your county health department; ask them for a list of regulations in your area.

The health department requires that you completely dismantle the airbrush and thoroughly wash it in hot, soapy water. Once cleaned, the airbrush must be stored in a place where it cannot be recontaminated. The health department does not require sterilization. In fact, most of the health agencies will tell you that, if you are careful to keep all your equipment clean, there won't be any problems.

The National Food Safety International requires the air from your compressor to be clean and free of impurities. Specific filters must be used to insure clean air. Arrow Filters produces three filters specifically for this: 1) Desiccant Filter (Arrow Pt# DO5-02): This is a filter filled with desiccant beads that filter out any moisture in the air. It is necessary to filter out the moisture so the carbon filter will work properly. 2) Carbon Filter (Arrow Pt# F-652): This filter does the actual cleaning and removes the grease and oil from the air. 3) Coalescing Filter (Arrow Pt# F500-01): This filter cleans any carbon flakes that may have found their way into the air line.

These filters will cost about $150 and can be purchased directly from Arrow Neumatics. (See the listings in the "Resources" section for Special Equipment.)

Artist Spotlight: Gary Longordo

Trained commercial illustrator and airbrush artist Gary Longordo faced a dilemma when his father became ill and needed his help in running the family bakery business. As the fifth generation of a family of bakers, he decided it would be easier to find ways to put his artistic talent to work in the bakery, rather than fight years of family tradition. With five years of art school, it was easy for Gary to branch into painting cake surfaces.

For the past eighteen years, Gary's usual painting surface has been a flat, solid piece of marzipan (almond paste). Instead of paints, he uses food coloring that several manufacturers produce for airbrushing cakes and chocolate. When a three-dimensional effect is desired, he sculpts stiff frosting with palette knives and then airbrushes the frosting.

Gary's specialty is portraits, but he has also done cars, airplanes and special scenes, such as a battleship for a Fourth of July celebration. Some common subjects for his cakes can include popular rock bands and cartoon characters. The most popular subjects are portraits and cartoon characters. His bakery now earns most of its income from custom cakes. Prices vary with the degree of difficulty involved in rendering a cake design.

Gary says he has to be careful with copyright infringements since many of his requests are for cartoon characters. Gary turns to a company called Stencil Air for stencils of copyrighted images. The owner of Stencil Air has secured the copyrights for many of the most popular characters requested.

Gary also enjoys producing the lettering on cakes. He says lettering is an art in itself.

Gary's first big break came when he did a painting for a United States senator. Once the political glitterati knew what Gary could do, they enlisted his services often. Gary's second big break came from a large advertising agency. Before he knew it, Gary was providing cakes for a number of Broadway stage show openings. "It's true," Gary says, "it's not what you know, it's who you know."

His clients now include the rich and famous — Ronald Reagan, Eddie Van Halen, Reggie Jackson and Frank Sinatra. Gary once airbrushed a cake for a party hosted by Jackie Onassis. After completing the airbrushed cake, he dropped it. Unsteady hands due to nervousness, perhaps, but the replacement cake was quickly finished.

Despite his busy career in the cake airbrushing field, Gary finds time to devote to a second career

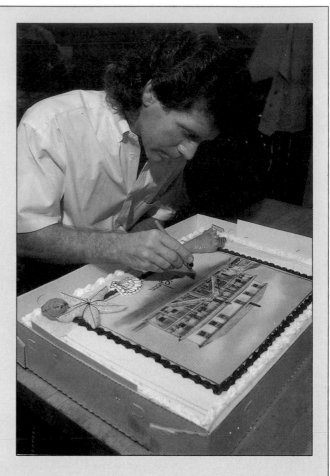

as a forensic artist. He started casually when a friend, police chief Joe Feltman of Chester, New Jersey, asked Gary if he could do a composite drawing of a suspect. Since then he has worked with various departments and agencies, including the FBI, and even worked with authorities in El Salvador. He has done composite portraits of suspects on several well-known murder cases, including the Son of Sam and the Hillside Strangler cases. Although much of this work is sketching, he does use the airbrush when he needs to get more realistic effects. He has also done some three-dimensional work. After a forensic sculptor has reconstructed a decomposed body in clay, Gary works from photographs to scale and re-creates a more realistic effect for the body's features, flesh tones and coloring.

I asked Gary if being in bakery business has helped him be a good businessman as well as an artist. His answer was surprising, "No! Artists make terrible businesspeople. I even prefer to let other people price my work because they charge much more than I would. I think it's because art is fun, and charging to have fun is . . . I don't know, I can only

be an artist.''

Gary advises airbrush artists to develop their drawing skills before learning to airbrush. This makes it easier to adapt to using the airbrush. If you understand rendering three dimensions on a two-dimensional surface, you can airbrush on cakes or anything else. With the airbrush, ''you can easily create the illusion of three dimensions. This makes the airbrush more versatile than most conventional art tools.'' It is the versatility of airbrush that allows competent artists to apply this tool to the markets of their choice. Airbrush can be used in many different fields with equal success. In other words, you can earn a living with the airbrush in the specific market you like.

make your cakes special. But it is important to use the right tool for the right effect. Don't be afraid to experiment with different tools. You can use watercolor brushes to add fine lines and small dots for texture, for example. If you take the time to practice using different tools, your cakes will look better.

Speed Techniques for Cake Decoration
Here are some techniques to help you reduce your painting time when you're working on cakes.

First, work on a light-colored frosting base. Food colorings are transparent, so they won't show up if applied to a dark surface. Tell the baker about this, so she won't present you with a cake that is frosted dark and expect you to paint it. The basic rule to follow is to start with the light colors and then blend in the darker tones. This way you can keep your design light rather than dark and somber — nobody likes a somber birthday cake.

Food colors can also be blended directly onto the cake, but this can have some troublesome effects. For instance, be careful when working with yellow and blue, because they will blend to a green. A green cake can be very unappetizing. If you have to do some sort of landscape where green is necessary, be sure to apply the yellow first and then the blue. A pleasant lime-green color can be blended this way. If you lay the blue down first, you are forced to continue to add yellow until the blend turns green. If you have laid down too much blue in the first place, you'll be stuck with a deep, muddy green.

The frosting on a cake is rather fragile, so you won't be able to get the airbrush very close. Of course, different frostings will have different limits; only experience will be able to guide you. Because food colorings are very thin, you should be able to turn down the air pressure to about ten pounds. That should help a little.

Chapter Seven

The Business
of Airbrush

*E*verybody—including me—would prefer just to think about doing airbrushing, selling our work, and counting our money. But there's more to making money from your airbrush than just painting and selling.

In this chapter I'll discuss not only some legal and technical business aspects of airbrush, such as bookkeeping and taxes, but also some business practices, such as establishing pricing, anticipating market trends, and avoiding problems.

Keep in mind that I'm not giving you legal advice; I'm giving you information about some issues related to your business. The information is accurate at the time I'm writing this, but things may change in the future. Neither I, nor North Light Books, is in the business of giving legal, accounting, or other professional business services. If you have a legal problem, see an attorney, or for a tax problem, an accountant.

Becoming an "Official" Business

If you are holding a full-time job and are just doing a little airbrushing on the side, you may not feel much like a business. I have worked for T-shirt shops as subcontracted labor and filed my income on a personal tax return. If you plan to earn only a little money out of your home you may not even need a business license.

But if you are serious about making money from airbrushing, especially if you hope to make a full-time living from it, you must think of yourself as a business and act like one. You should talk to an accountant and set up your business in the simplest way possible. Spend a few dollars for an accountant before you get involved with government licenses, permits, and tax I.D. numbers.

Your airbrush business will most likely be a sole proprietorship. That means you own and operate the business. Your earnings will be considered part of your income, and you will have to pay income taxes and the Self-Employment Tax (your contribution to Social Security) on them.

When you start your airbrush business every government agency that can will get involved. There are forms to file, licenses to obtain, fees to pay. Most of the licenses and permits you need will be secured through your city or county government offices. It would be wise to contact city hall or the county clerk on the telephone and ask exactly what you need to bring and how much everything will cost before you appear there in person.

Local Business Licenses
Virtually every business in the country is required to have a local business license. This is a "pay the fee and forget it" kind of license. The business license is usually required to be displayed within sight of your operation.

If you will not be using your own name as your business name—not "Fred Smith, Airbrush Artist"—and will be using a fictitious name instead—"Hotdog's Hot Air Designs"—you will usually have to file a Fictitious Name Statement (also called an Assumed Name Statement or a DBA in some states) before you get the business license so the business license will be in your business' name.

The fictitious name statement protects you so that no one else can legally use your business name. In addition to filing the name, you will have to publish the fictitious name statement in a newspaper "of general circulation." This is to let the public know who they are doing business with. (To avoid the additional expense and hassle of the Fictitious Name Statement, you can add your name to your business' name—"Hotdog Smith's Hot Air Designs.")

I find a fictitious name limits you by limiting your flexibility. With a fictitious name like Bob's Custom T-shirts, it's going to be hard to convince an auto body shop owner that you can paint cars, too. Or say you've just delivered a portrait and the customer asks, "Who do I make the check out to?" Do you really want to say "Angela's Cake Decorating"? By operating under your own name your reputation will grow under your own name, and you will never lose that.

Other Local Permits
Your business may be required to conform to local zoning laws, building codes, health requirements, fire and police regulations. If you are in the vehicle or sign-painting business, you should check into these carefully, especially if you plan to have your place of business in your home. Check into all regulations before you open your doors; you may not be able to legally work in your own backyard or to use the location you have chosen because it won't meet the standards. Sometimes the cost of bringing a place up to the code is prohibitive; it may be smarter to look for another place.

On some occasions you may need a special permit to paint at certain locations, such as outdoor events or state and local parks. Most outdoor art festivals have a license that you are allowed to operate under, but it would be wise to ask the promoters. Check with your local government if you plan to set up in any unorthodox locations.

State Occupational Licenses

If you're going to airbrush fingernails you may need a state occupational license—a manicurist's license, to be exact. I have heard of local health officials passing out warnings to airbrush artists painting faces during Halloween and Christmas, because one artist decided to use a toxic paint on someone's face. Technically, anyone applying chemicals to the skin must be licensed.

If you plan to pursue skin painting, contact the department of consumer affairs, usually located at the state capital.

Sales Tax and Seller's Permits

If your state has a sales tax, most of the work you do is taxable. If you sell a customer a T-shirt with a design painted on it or a portrait or a license plate, you need to charge the customer sales tax. If the rate of sales tax in your state is 5 percent, and you sell a sweatshirt for $20, you charge the customer $21. You report the $21 as income, send $1 to the sales tax department, and deduct the $1 on your business tax return.

States that collect sales tax will require you to get a seller's permit. The seller's permit is also called a resale number or a resale permit. Certain states also require a security deposit before issuing you a seller's permit, which is their way of insuring you will collect and remit the taxes you collect. If you don't want to tie up your cash, you may be able to purchase a sales tax bond from an insurance company. The insurance company will charge about 10 to 20 percent of the actual deposit amount.

The seller's permit allows you to buy goods for resale, both raw materials and finished products, without paying taxes on these goods. In other words, when you buy blank T-shirts or license plates or the paint you use on them, you can avoid paying sales tax. The reason for this is that the state won't tax an item twice—both when you buy it and again when the customer buys it. When you go to a supplier or a store to buy supplies for your airbrush business, tell the salesperson that what you're buying is for resale. You may be asked to fill out a form supplying your resale permit num-

ber. (Make sure you keep copies of all your receipts in case you're ever audited.) Of course, you are only allowed to buy goods that will be resold in the normal course of business. You can't make tax-free purchases for personal or nonbusiness use.

Federal Identification Numbers

Your business will be required to identify itself on tax forms and licenses by either your own Social Security number or a Federal Employer Identification Number. If you are a sole proprietor, you only need your Social Security number. However, if you hire any employees you will need a Federal Employer tax I.D. number. To get an I.D. number, file Form SS-4 with the IRS. There is no charge for this.

Don't apply for a tax I.D. number until you need one, because the paperwork involved is extensive. Once you file the SS-4 the IRS will begin sending you quarterly and year-end payroll tax returns that you must fill out and return, even if you have no employees at the time. This is a bookkeeping nightmare, and you'll be charged serious fines if you're late.

Bookkeeping and Taxes

If you are going to be a one-person operation with no partners or employees, your records can be kept quite simply. You will need a bank account (used exclusively for business), an income and expense ledger, and a few worksheets. If you plan to extend credit you will need a credit ledger, too.

I won't cover partnership or corporate books here because I have never heard of any artists operating in this way. You may expand your business in the future, perhaps establishing your own T-shirt, vehicle painting or sign shop, at which point your bookkeeping will become more complicated, but in this section I will only cover bookkeeping appropriate for the sole proprietor.

Your books will be relatively easy to keep as an airbrush artist, because the business is not very difficult to operate. Once you have purchased your basic equipment the only items you'll have to stock will be a few garments, paints and spare parts. You don't have to keep track of an inventory containing thousands of different products, nor do you have a lot of expenses to monitor.

This information on bookkeeping and taxes is intended solely to give you an overview of what is involved in managing your business's money. It is no substitute for good advice from an accountant, the Internal Revenue Service, or the Small Busi-

ness Administration, or for taking a bookkeeping class. Although it may seem like a hassle to acquire them, developing fundamental bookkeeping skills will repay your investment in a very short time.

Good, Free Advice
There are two ways to get assistance when setting up your books, and I recommend you take advantage of both. The Small Business Administration provides tons of free literature that covers all sorts of business-related information. They also provide a service called the Service Corps of Retired Executives (known as SCORE). If you call the SBA you can arrange to meet with one of these retired executives. They can be a great assistance when you're setting up your books.

The second way to get started cheap is offered through the tax services of H & R Block. They offer a complete set of books, ledger sheets and all, to small businesses for free. They will take you through the setup step by step, too. The kits are only available on a limited basis, so check with them long before tax time.

At the end of the year, if you keep your books with their system they can figure your taxes simply, but they do charge a fee that is based on how many forms you have to file. Contact your local office for more information.

Your Business's Bank Account
Open a bank account in the name of your business. If you use your own name you can open a personal account (you can have more than one personal account—one for your business and one for your own money) and save some money. I get free checking with my personal account if I maintain a balance of $100. When I had a business account I had to maintain a balance of $1000 to get free checking. Also, if you open the account in your own name, you won't need to have the fictitious name statement, thus saving you even more money.

Most banks require you to have a business license before they will open an account under a fictitious name. Operating as an airbrush artist you will not really need a fictitious business name. A fictitious name creates all sorts of little hassles—for example, when you open business accounts. A business account is more expensive than a personal account and doesn't offer benefits like free checking and high interest.

Here are three simple rules that will simplify all your bookkeeping and help prevent accidental overdrafts.

Rule #1: Pay all your bills and expenses with a check. It will be much easier to track your costs if you can refer back to a canceled check. Some payments will have to be made in cash, but try to keep these to a minimum.

To cover these small cash outlays, establish a Petty Cash Box in your studio in which you keep a set amount of money. Write one check to petty cash for that set amount, then place the receipt in the box each time you make a petty cash purchase. That way you can keep track of how much you've got left and have the necessary receipts for your bookkeeping and taxes.

Rule #2: Deposit all your income, especially cash, directly into the account. This way you will have documentation of all your income.

Rule #3: When you take money out of the bank for your personal use, write a check to yourself. You can then deposit this check into your personal, nonbusiness account or cash it. Do not write checks for nonbusiness bills directly out of your account. This can get very confusing and double the time it will take to balance your books.

As the owner of a self-proprietorship you cannot pay yourself a salary and take withholding taxes out of it, because the government considers all the profits from your business to be your income. But you can give yourself a regular weekly draw to help you manage your personal finances. You should always write a check to yourself for this amount.

Rule #4: Balance your account every month. It is easy to make a mistake, and bouncing a check on a supplier is a quick way to lose your check-writing privileges. Then you will have to go to the bank for every purchase, get the cash, and collect the goods. It is a hassle that can easily be avoided.

Rule #5: Keep your bank statements and canceled checks at least three years in case you get audited. The statutes of limitation for tax audits run out in three years in most cases.

Rule #6: Expenses that are partly personal and partly business should be paid from your personal, nonbusiness account. You can then post the applicable amount to your business ledger.

The Ledger
The ledger is the heart of your bookkeeping system. It helps you keep track of your sales, purchases, any credit accounts and cash and gives you the records you need to pay your taxes. It also helps you make and keep your business profitable. If you don't know what it costs you for your materials and your overhead (rent, insurance, supplies, utilities and such), you won't know how to price your airbrush art to make a profit.

I recommend single entry ledgers for the airbrush artist. These ledgers require a single entry for either income or expenses. This keeps the paperwork and arithmetic to a minimum. This system does not provide a complete record of inventory on hand, equipment, loans, and other assets and liabilities, but the simplicity of an airbrush business doesn't really require much more. There are other worksheets that can keep track of these particulars.

The alternative to the single entry system is the infamous double entry bookkeeping system. The double entry system provides a complete double-checking system and automatic balancing. It minimizes errors but maximizes time and effort needed to maintain it. For our purposes, let's stick with the single entry system.

Cash or Accrual Accounting

Once you've chosen the system you want to use, single or double entry, you will need to choose between the two accepted methods of accounting: cash or accrual.

The cash method records all income—cash, checks and money orders—at the moment they come in. All expenses are recorded immediately too. Credit and expenses to be paid in the future will not show with this system, and this can present an inaccurate picture of your income and expenses. The accrual system accounts for what the cash method does not but requires more work (naturally).

Consider how you will be operating as an airbrush artist before choosing a method. For example, if you plan to sell T-shirts through a T-shirt shop where all your sales will be on a cash basis, and you plan to buy your supplies at the local art store, the cash method will probably work for you. If, on the other hand, you plan to sell garments on consignment or wholesale, and you will be carrying a lot of credit, you may want to use the accrual method, which will help you track your accounts receivable.

What to Record

You need to record your income and expenditures regularly—every day if you are making a lot of sales or incurring many expenses—once a week if you're making only a few sales or spending only a little money. Although this sounds like a drag, it actually makes your life easier if you keep up with your bookkeeping. It will take less time than letting it all pile up and, perhaps even more important, will keep you from forgetting an item or losing a receipt.

To track income, you need to enter the date if you post daily or the dates covered if you post weekly (6/1-6/7). Then record your total sales for that date or period as income.

You can keep taxable and nontaxable sales separate if you have both kinds. For example, you may sell your painting services through a T-shirt shop where the owner sells the shirts—nontaxable in some states—and sell license plates yourself—taxable. You can also keep a record of the amount you've collected for sales tax separate from the total for the sales. Just enter these as separate income entries on different lines or in different columns. For example, 6/1-6/7: ten shirts: $350; 6/1-6/7: sales tax collected: $17.50. This will help you when it's time to pay your sales tax—especially if you must file and pay it monthly as is the case in some states.

Enter every expense whether paid by cash or check at the same intervals as your income. It will help you track your costs of doing business and know what you need for taxes if you use a ledger that lets you put each type of expense in a separate column and keep a running total at the end. If you're using only one ledger, you can bring both your income and expenses over to that total column at the end.

For tax purposes, you should try to keep separate columns for travel, entertainment, and nondeductible expenses if you don't separate out anything else. The IRS scrutinizes travel and entertainment expenses more carefully than just about anything else, and posting these separately from other expenses helps you not only keep an eye on them but also retain the receipts you must have if those expenses are questioned. Keeping all nondeductible expenses like your draw and purchases for equipment that will have to be depreciated (a computer or equipment for making vinyl letters, for example) in a separate column guards against mistakes at tax time.

If you are buying and selling a lot of T-shirts, fingernails, license plates or whatever in a short period, putting your inventory expenses in a separate column can help you keep track of what you have on hand as well as what it's costing you. It's also helpful to split out your inventory costs if you're selling a lot of work on consignment. You have an immediate, highly visible signal that something's wrong if you see a big expense under inventory that hasn't been balanced by the same amount under income.

If You Have an Employee

If you hire someone to work for you, you will have to withhold state, local and federal taxes on that person's salary as well as withholding money for Social Security and making your contribution as employer. You must pay these amounts quarterly.

Because the bookkeeping for payroll records is fairly complex, you should keep a separate payroll ledger and just report total payroll expenses on your main ledger.

Taxes

This section does not provide complete information on all federal tax laws, nor was it meant to. This is simply a brief introduction to the different taxes for which you may be responsible. You should get a copy of the Internal Revenue Service's tax guide for small businesses. It's free, surprisingly well-written, and revised every year.

You must pay all taxes on time or face stiff penalties. Taxes are not dischargeable through bankruptcy—you cannot escape them, and interest is added to any delinquent taxes until they are collected. You don't want to mess around with the tax man. The only way to beat the IRS is death.

There is, however, no reason to fear the government. Experience has taught me that if you make a mistake or misunderstand some aspect of the tax system, government agencies can be very forgiving and helpful. Though you may incur financial penalties, you will rarely face harsh criminal charges.

You must pay federal income tax, self-employment tax, state and local income taxes and sales taxes. If you have even one employee, you must pay withholding taxes, Social Security, and possibly an unemployment tax, too. Withheld taxes and Social Security deposits—and in some states, sales taxes—are due monthly. Most of the other tax payments are due quarterly.

The IRS requires every business to keep a set of books, so you have to have some sort of system in place to keep track of income and expenditures. If you maintain your ledgers throughout the year as discussed above, it will simply be a matter of adding certain columns to get your yearly totals. Your accountant will do the rest.

Although most of the IRS's regulations are devoted to getting money from you, some—those concerning deductions—can actually save you money. Some deductions you should investigate carefully are automobile expenses (see sidebar),

travel away from home, depreciation, utilities, equipment, insurance, freight, rent or home studio, moving and small tools (useful life of one year or less). Ask your accountant or contact your local income tax office for help in determining which, if any, of these you can take advantage of.

Competition

Unless you are the only airbrush artist in town, you have to think about competition. If you are one of ten artists set up in a row, what deciding factors will make customers buy from you rather than from another? Price? Quality? Unique products and services? Let's take a look.

Price

Many people think dropping the price will bring them more business, but this is a fallacy. Dropping the price will only cause other artists to drop their prices, which can continue until the person willing to work for the least amount stops lowering prices. If the price cutting goes on for very long, everyone loses money.

The person willing to work for the least is usually the worst artist in the group. This does not happen by chance. The untalented artist cannot compete with the superior quality and services offered by the other artists. This person's only option is to drop prices. If you have no talent and you discover

Automobile Expenses

The IRS allows two different methods of reporting auto expenses. You can keep track of the actual expenses, or you can take a standard mileage allowance. The standard mileage allowance is less of a hassle. You make all the entries in your ledger at the end of the year.

The second method requires you to keep very accurate records when they are incurred, and these records will have to be posted in your ledger regularly. You must keep a weekly record of the miles traveled, the purpose of the trip, and the date it occurred. And if the expense is questioned, the IRS will check your records to see if it looks like they were all entered at once or over a period of time—inks fade, people use different pens if entries are periodic.

Unless you use your car for business quite often, you'll probably be better off just taking the standard mileage allowance.

some sort of unique product, you still can't make money, because you can't paint.

Consumers will set the price of any artwork. This is called demand. If you offer a product desired by consumers, they will be willing to pay a certain price. The way to find the highest price they will pay is to raise the price until the consumers stop buying. If the product you offer won't sell no matter what the price, you have a product with no demand.

When I first started selling canvas art with my airbrushed T-shirts, I had no idea what to charge for my paintings. I based my pricing on the same criteria as my T-shirts because I didn't want to earn less painting canvas art than I could painting T-shirts. If it turned out that I couldn't earn the same, I would have to discontinue the item.

I soon discovered that I was selling more canvas art than T-shirts, and I also had more work than I could do in a day. I decided the canvas art had more of a demand than the T-shirts, so I raised the price of the canvas art. In fact, I doubled it.

As a painter, the only fixed variable you have is time. If you have more work than you can do in a day, then you are losing money. To make the most money and establish the best price for a product, raise the prices to the point where the work falls off and you can finish all the work in a day.

This is not written in stone, however. I have dropped my prices a little to get an order and at other times found myself very busy without lowering my prices. I don't think there is a working airbrush artist who hasn't experienced this. But when a customer asks me why I'm charging several dollars more for my art than the guy around the corner, I tell him it's because my art is better. Most people won't ask. They see the differences in my samples and photographs and pay a little extra for a better product.

Quality
The best way to battle competition is to produce better-looking art. Nothing beats quality. If your art takes longer to do, don't be afraid to charge a little more. People respect good quality, and they will say so with money. It is very tempting to lower your prices when other artists do. You may think they are drawing more customers, but this is untrue. They are earning less from customers who wouldn't have recognized the difference anyway.

Don't go overboard with quality either. If you spend all day on a T-shirt painting and charge $300, you won't sell many T-shirts. You have to know what prices the market will bear, and you can't

charge more. Your aim is the best quality within the parameters of what you can charge the market.

I always establish a dollar-per-hour basis to estimate custom prices and when designing stock designs. I currently charge a dollar a minute. Sometimes people ask me to paint difficult images that I know will cost more with my hourly figure, so I suggest changes that bring the cost down. When I design stock designs I keep in mind that, if I want to charge ten dollars, the design should take ten minutes to paint.

Unique Products and Services
Developing a unique product or service is the best way to dominate a competitive market. Airbrushed license plates originated with a T-shirt painter who wanted to expand his product line. Other artists have gone from painting T-shirts to painting on leather. Sometimes all you need is a different way of painting: Jürek (see pages 66-67) has had great success with paintings that feature unusual techniques.

The first year I added canvas portraits to my T-shirt product line, I painted them in a very traditional style. As other artists in town began painting portraits, I had to do something to set myself apart again. I still offer portraits painted in the traditional style but also do colorful abstracts, pencil and pen-and-ink creations and paint in a minimalist style much like Patrick Nagel's.

There are many ways to make your art stand out from others'. You can dress up your display, create different designs, offer different garments, or use Day-Glo paints. Being unique is a talent in itself. I have seen many talented artists lose money because they made no effort to stand apart.

You can count on the other artists copying you, but you will reap the greatest benefit if you were the first. If the other artists copy you, consider it a compliment but move on and do something else new. I used to start each summer season with something I'd never done before. Even if my idea didn't sell well, people would stop to ask me about the other unique products I offered.

Trends
Never forget that the popularity of airbrush rises and falls, just like a yo-yo. In any airbrush market you will probably experience high and low earning periods. And there are many reasons these trends occur.

Both the national and the regional economic situations can affect your business. In the late 1970s, the Gulf Coast tourist markets suffered a crippling

Copyrights and Copying

In all my experience working in tourist towns, it was standard operating procedure for artists to copy each other's designs. Nobody copied exactly; each added personal touches to the original idea. Some artists became very upset when one of their designs got knocked off, but I always shrugged it off. The truth is, it was actually an ego trip to see fifty variations of my design hanging in all the different shops.

The laws governing copyrights are very clear, but the average airbrush artist may not think they're very practical. It's impossible for me to tell you everything you need to know about copyrights, but I urge you to find out more about it. Every moment you invest in learning about copyright law will be money in the bank, because the laws exist to protect you.

They exist to protect other artists also. Whenever you paint Bugs Bunny, Mickey Mouse, or Garfield the Cat on a shirt, cake or license plate, you are infringing on another artist's property. Only people who have specially issued licenses are allowed to reproduce and sell images of cartoon characters like these. The same goes for copyrighted visual material such as album covers.

The way the airbrush industry works, it is smarter for you to use your creativity to come up with new designs instead of wasting a lot of energy worrying about who's knocking off yours. At the same time, however, I advise you to know your rights and to respect the rights of other artists.

blow because the gas shortage kept tourists away. I once set up a T-shirt operation in South Padre Island, Texas. This town on the Mexican border depended on tourists from Mexico for 90 percent of their summer trade. That summer, the value of the peso fell to record lows. Hundreds of rental homes sat empty, hotels and retail businesses failed, and so did I. On the other hand, the arrival of a new business that will employ many people in town or the opening of a new tourist attraction can suddenly set your business booming.

An oversaturation of artists can impair your earning potential; this is happening in many resort towns in Florida. A price war may force you and many other talented artists to move to more profitable locations. Styles or products may change, as has been the case with vehicle painting. Artists don't find as much work covering vans with murals but can make up at least part of that loss painting van tire covers or signs on commercial vehicles.

Remember that every market is always in motion. In addition to the economy, new innovations in technology have a major influence on the airbrush industry. With any luck, artists who stay informed will not be taken by surprise and will be able to reposition themselves.

Right now the computer is taking work away from the photo-retoucher and commercial airbrush artists because the computer can render the same kinds of images better and faster than the artist can. Airbrush artists who didn't anticipate the impact of the computer on the graphic art industry have found themselves with declining incomes or, worse, without jobs. Airbrush artists who anticipated the computer trend were able to adapt. Some switched airbrush industries, others changed their marketing approaches or their styles to fulfill special needs.

Business Troubleshooting

There are a lot of mines in the business battlefield. The best way to deal with trouble is to avoid it, and that is what this section is all about. Experience has been a great teacher for me, so I'll share some of what I've learned with you.

Prepayment

When you enter an agreement to do work for someone (even painting a stock design on a T-shirt unless you have a bunch of prepainted shirts), you can collect the money before you do the painting. If you don't, you run the risk of not being paid for your work.

For instance, a customer may decide to spend the money she had intended to pay you on something else. This means there will be no money when the time comes to pay you. I've heard hundreds of excuses during my career, and some of them have been real tearjerkers, but in the end I was the one who got stuck with a painting I couldn't sell and wasted time and materials doing it.

On some jobs, the customer may become as worried about your performance as you are about her intention to pay. In that case she may not want to prepay the full amount. Always get at least half down. I never take less than full prepayment on all materials and half down on my labor. And if you have any second thoughts, get all your money up front or walk away from the deal. Always trust your gut feelings, too. Every time I've been ripped off,

I've had a feeling that the deal wasn't going to work out.

When you're not getting full prepayment on a job, get something in writing that spells out the customer's promise to pay on delivery. You can put this on either a contract or a purchase order as "$700 paid. Balance of money due on delivery." In some cases, you may be able to write an agreement into your contract on what will happen if you don't get paid. Investigate standard practices followed by businesses like yours and check with a lawyer to determine what is legal in your state. (Please review prepayment guidelines for individual airbrush industries in the chapters on those industries.)

Get a Contract

Contracts are necessary when you are entering a business relationship where you are depending on the performance of another to make money. This is especially true if you are going to spend money either buying materials or special tools to fill orders.

For example, a salesperson says that he will buy a thousand T-shirts per month at a certain price. You agree and buy ten new airbrushes, rent a small studio, and buy the first thousand T-shirts. After you've spent this money, however, he says he will not be able to buy the T-shirts. Now, your only recourse for recovering your costs is to take him to court. Unless you have a written contract it will be difficult to prove your damages. Otherwise, he could say you misunderstood him, that he meant he thought he could sell a thousand T-shirts per month rather than that he would buy a thousand T-shirts per month. With nothing in writing, it's your word against his.

If a salesperson approached me and said he would buy a thousand T-shirts per month, I would ask him to start with one hundred instead. Then we would negotiate a written contract. I would ask him for half down plus the cost of the T-shirts before I began work. If he said he needed the garments at a certain price, I would agree to sell the first hundred at my cost or accept that I would make a lower profit just to see if he would perform. Both the selling price and my request for payment up front would be part of the contract.

For my protection, the contract would detail when the salesperson would pick up the finished shirts and pay for them—on delivery—and state that I retained copyright on the designs. For his protection, the contract would detail the penalties for me not delivering the shirts as promised (usu- ally at least the return of all the money he gave

Refunds and Redos

Once you have the money in your hand, it will be your decision whether to give it back. The only time you would want to do this is in an instance where the quality of your art is in question. This should be a rare occurrence if the customer saw samples of your art before placing an order and if you have painted the request to standards comparable to those of the samples. If this is the case, the customer will have no right to complain or ask for a refund.

Customers may bicker with you over certain points in the artwork and try to get a refund from you. From my experience, these people will try to intimidate you and hope you crumble under their pressure. They do this matter-of-factly, thinking it is worth a try. Artists are very susceptible to this tactic because art is personal and most artists take a great deal of pride in their work. When a customer complains, an inexperienced artist will take this criticism personally and agree out of shame to a reduced price or even to a full refund. Don't fall for this; stand up to this type of person.

While you should be wary of the person who appears to be picking nits just to get a refund, listen carefully to all your customers' concerns about the finished artwork. You want to have satisfied customers, and often the problem can be resolved by your repainting to correct a problem. It may take a try or two before you satisfy the customer, but it's worthwhile to keep a good reputation.

After two tries, you may have to conclude the customer cannot be satisfied. If you feel you have delivered a work commensurate with the sample the customer saw, let the customer know that you have done what you can and can do no more. Don't feel you have to offer a refund; generally a customer will accept that you have tried and leave it at that.

me). If he was from out of state the contract would also include a statement that any legal problems would be settled in the courts in my state. This would reduce my legal costs, not to mention time lost and the hassles involved if I had to take him to court.

As the relationship grew and I saw that I could trust this salesperson, I would invest the money necessary to produce the garments cheaper and faster. We would write a new contract to cover the

larger purchases and my additional investments in materials and equipment that reflected this trust.

It is better to grow more slowly and develop business relationships that are based on trust rather than to rely solely on a contract to enforce another person's morality. If a person believes he can make money for both of you, then he should also be willing to work within your constraints to make it happen.

Although there is very good money to be made from working with business customers, many airbrush artists—and I am one these days— prefer to deal directly with customers on a simple invoice or purchase order basis rather than getting involved with contracts. It's a matter of which airbrush industry you're in and what you feel most comfortable doing. Obviously you can't get into sign painting or into selling T-shirts in large volumes without running into situations where you must deal with contracts. (For more information on contracts, see "Using Fine Print Wisely," pages 113-114.)

Purchase Orders

Some situations don't call for contracts, but for purchase orders. Get it in writing. If someone places an order with you, make sure you write it down and have someone in authority sign it. (Many companies have their own purchase orders, which they will fill out, sign and give to you.) Don't start work without one. This proves that you had a legitimate order for the product from someone in authority.

Having a signed purchase order protects against personnel changes at a company. If someone leaves suddenly, the company may not know that person had ordered something from you. It also protects you from customers changing their minds. That way, if they get a lower bid than yours, they can't pull the job out from under you.

Never Work On Spec

Working on spec (short for "on speculation") means you do the work, and if the customer likes it, you'll be paid. This is not the same as selling on a consignment basis, where you can recover your airbrushed garments or whatever if they don't sell and take them elsewhere. I have never seen an on-spec arrangement work; on the contrary, I have seen many friends get ripped off.

Spec deals can very alluring. They usually start out something like this: "If you could paint up some samples I could sell a million of these!" Before long you start to hear, "If you could just lower your price a little I could sell a million of these!"

You will end up arguing with the person, saying that you seem to be the only one working and that you're not going to paint another thing until you see some sales. At this point the relationship comes to an end.

When people ask you to work on spec, ask them to perform first. See if they will provide a list of all the stores they intend to approach for sales. I've done this several times, and to date I have never seen a list. It seems like a simple request; I've often wondered why these people never followed through. I've never had a chance to ask, because I've never seen them again.

Be wary of businesses that ask you to work on spec. If someone wants to know what a finished sign or delivery truck will look like, show them sketches and take those sketches with you when you leave. You can always bring them back—and this way you won't suddenly see your design on a truck you didn't paint. Also, watch out for people who ask you to work for free in exchange for "throwing a lot of work your way" in the future. All too often that promised work never materializes.

What to Do When You Have Trouble

We've already looked at some of the most effective ways to avoid trouble in the airbrush business: get prepayment whenever possible, put everything down in writing in a contract or purchase order, and don't work on spec. There's no 100 percent guaranteed way to avoid trouble, but when the inevitable happens, there are things you can do to minimize the damage.

Take action immediately. The longer you wait, the worse your chances of resolving your problem. If a face-to-face meeting or a phone call doesn't get results (in a business, you can sometimes get results by calling your customer's boss or the person who owns the company), write a letter clearly stating the problem and how you want to see it resolved. Be clear and direct, always professional, and don't knuckle under at the first sign of resistance. You have the right to fight for the good of your business.

If a Customer Won't Pay

I have painted twenty-five thousand T-shirts over the last fourteen years, and the problems I've had with customers I can count on my fingers. In the vast majority of cases, you will be dealing with the customer directly in your airbrush business, one on

Case History: It Can Happen to You

Many people think I overreact when I talk about getting ripped off, and I admit my attitude is a bit militant. But that's because one experience in particular left me with an advanced degree from the school of hard knocks. Here is my story about the worst time I ever got ripped off.

I had decided to find a market that wasn't already oversaturated with silkscreen T-shirts, develop a line of designs, and distribute them into the market through a distributor who was already selling other products. Someone in this position would have a large distribution network and a sales staff.

The first step was to find the right market, and after extensive searching I settled on the scuba diving industry. I looked in all the scuba diving magazines and saw very few ads for T-shirts with scuba diving designs. Most of what I saw were T-shirts just imprinted with the brand names of manufacturers.

To make sure I'd chosen the right market I drove to every dive shop in the Bay area and asked the owners if they thought a nice-looking line of decorative T-shirts would sell well. Most of them thought the idea was great, so I asked them what they would be willing to pay. The prices they quoted seemed sufficient to produce a nice line of garments and make a decent profit. I felt ready to pitch the deal.

I returned to the magazines and made a list of scuba diving equipment manufacturers. The first few calls met with little success, but I wasn't discouraged. I was close to the end of my list when I found a distributor of scuba diving equipment who was interested. He was very cordial and seemed truly interested in my offer. He asked to see samples, but I had anticipated this, and I mailed him color copies of six designs the next day. As we negotiated there was a difference of opinion about a couple of the designs. The distributor suggested I just drop them, but I thought we needed at least six designs in the line. Eventually we settled on the six designs.

The next step was to produce samples for the sales representatives. The silkscreen was going to cost $3500, but before I spent anything I wanted to make sure this deal was sewn up tight. Following my own rules I asked for some money up front, half of any out-of-pocket expenses. I also wanted a written contract that stated each party's responsibilities, what we would both earn from each sale, and exactly how the transaction was to be made. I wanted the contract to make sure I would have recourse in

the event anything went wrong.

The distributor sent me a check for $1750, along with the signed contract. Within two weeks I shipped the distributor six dozen T-shirts, a dozen of each design. These shirts were to be given to his sales staff to show to the dive shop owners.

At this point in the deal, it was the distributor's turn to perform. After a week, I called him, partly to hear his opinion about how the shirts looked but also to get some sort of status report on how sales were going. I just wanted to know if the T-shirts were being well received.

It was then that the distributor dropped the bomb. The conversation went something like this:

"Hello, this is Joe Sanchez."

"Ah yes, how are you?"

"Fine, did you get the T-shirts?"

"Yes . . . they all look very nice, but we only want to buy two of them."

I couldn't believe my ears. "What did you say?"

He repeated, "We want to buy only two of the designs."

As you might expect, I was really mad. "The designs are not for sale. Our arrangement was that you would offer all the designs to your customers, and any sales you made I would fill."

"Yes, I remember, but I can't do that," he replied coolly.

I tried again. "But you signed the contract."

He didn't budge. "I know, but I can't do it."

"Why not?"

"Because I just want to buy two of the designs."

And that was that. He was prepared to totally ignore a written contract. Now he insisted on buying two of the designs and taking over production, cutting me out of the deal.

I told him I would call him back, and immediately called my lawyer. My lawyer said the distributor was definitely in breach of contract and suggested I sue. I began to feel better until he said he would need a check for five thousand dollars to pursue the case. I told him I didn't have five thousand dollars, and asked why he wasn't willing to take the case on a contingent fee. He said something about overhead, and this being an out-of-town case.

I called the distributor back and told him the two designs would cost $1750, what I had out of pocket. He told me he would pay $500, and I said I would toss the designs in the trash before I sold them for $500. We settled on $1000.

one. The other person asks you to paint something, you do, the person pays you, and that's it.

But in other areas of your business, you may find yourself in a situation when a customer fails to pay as expected. You may be tempted to panic or get angry, but before you do anything you'll regret later, there are some things you need to know.

The laws are quite strict about badgering people who owe you money. You can't call them on the telephone too often, or even at certain times, and no matter how much you may want to, you can't threaten them with bodily harm, or you may find yourself in big trouble.

Start by assuming you have a small problem, not a big one. Perhaps your customer honestly misunderstood something in your agreement or has unintentionally forgotten it. Call the customer and state your problem directly. Make sure you have your contract, purchase order, a copy of the bill you sent, or whatever paperwork you have on the job available so you can refer to it during the call. Keep your tone professional and upbeat so the person doesn't immediately react in a defensive way. Make a note of your call—date, time, and the response you got from the customer.

In many, many cases your problem will end with that phone call. But sometimes you'll need to take the next step. Send another bill to the customer, and stamp this one "overdue." (You can buy rubber stamps that say "Overdue" or "Payment Due Upon Receipt" or something similar at a business supply store.)

If the customer still ignores your bill, send another stamped bill and a letter. Refer in the letter to your phone call and how you've been trying to get the customer to pay you.

If the customer who won't pay you is a business, look into agencies that can help you. Call the Better Business Bureau or local chamber of commerce to see what advice they can give or what services they offer. Sometimes the state attorney general's office has a department that works on complaints like yours.

Only as a last resort should you consider taking a customer to court. Depending on the amount of money involved, you may be better off to bite the bullet, take the loss, and write it off your income tax. You'll save yourself hassle and the cost of going to court.

If the amount of money involved is less than a thousand dollars (in some states—check yours), sometimes it is worthwhile to have your case handled in small claims court. Telephone the clerk of the court for information on what you need to do.

You don't have to have an attorney, but going to small claims court will cost you something.

If you can't file in small claims court or for some reason decide not to, don't do anything else without consulting a lawyer. Your strategy gets quite a bit more complicated from here.

Remember that in court you can sue only for what you've lost. In the case we discussed before—the salesman who was going to buy the thousand T-shirts per month—you could sue for the cost of the T-shirts, the ten extra airbrushes you bought, and the money you paid out for studio rent. You would find it difficult to collect for the labor you put into painting the thousand T-shirts, because your labor doesn't cost you anything. Yes, I know that you could have spent that time earning money doing something else, but the courts don't see it that way. It is impossible to prove how much money you could have made, so that amount is often not considered in the judgment. You're always better avoiding problems regarding payment or resolving them as early in the process as you can.

If a Customer's Check Bounces
First, contact the customer. Probably the person will take care of it either by bringing you the cash or by asking you to send the check through the

Credit Cards

You can avoid some of the trouble involved in collecting money from customers if you set up a credit card account with your bank. By accepting credit cards such as MasterCard or VISA you won't have to hound people for money or fool with the paperwork.

The bank will charge a start-up fee and a yearly rental for the imprinting machine. You'll also pay a small fee per transaction: about 3 to 5 percent, depending on the number of transactions per month. The bank provides the forms you need and the signs with credit card logos for you to display.

When a customer gives you a credit card, you deposit the credit tag in your bank just as if you were depositing a check. The bank credits your account for the proper amount (deducting the service charge) and processes all the paperwork. Each month you receive a statement of credit card activity. You cannot mark up your sales price to compensate for the bank's fee, but you can offer a discount for cash, as long as it's offered to all your customers.

bank again. The bad check may have been an honest mistake, and if so, the problem is quickly solved.

The bank will let you redeposit the check only twice. After that you can "put the check in for collection." This procedure allows you to collect if any money is deposited in the delinquent account. Ask your bank how to do this, and if they charge a fee.

If you try this and still cannot collect, you may be able to file the check for legal action with the district attorney. Some states have harsh laws governing bounced checks. In California, for instance, you can collect three times the amount the bad check was written for.

If all attempts fail, the bad check can be treated as an expense, so keep all your bad checks in a separate file for tax deductions.

If a Customer "Doesn't Like It"

When I don't like something I've painted the customer never sees it, so in most cases I never have a problem. Unfortunately, that's not true of the husbands, wives, fathers and mothers who storm into the store after I've done a painting for their wives, husbands, sons and daughters.

This is what happens: A young heavy metal enthusiast asks you to paint a skull with a snake slithering out of one eye. You paint it, deliver it, and with a chuckle, collect your twenty bucks. About an hour later an angry, wild-eyed woman is yelling all sorts of insults at you. She wants to know what kind of low-life heathen would ever paint something like this on her son's T-shirt. She thrusts the T-shirt, skull and snake in your face and demands her son's money back. What are you going to do?

I would calmly read the clause off the back of the sales receipt her son received: "It is this artist's policy to give no cash refunds. Any technical errors (such as misspelled names, spilled paint and such) will be corrected at no expense to the customer. Because art is subjective (meaning everyone's opinion is different) absolutely no refunds are given."

Many times husbands will order something for their wives, and the wives will want a refund from you. Much of your work is for gifts; you can expect this to happen on occasion. However, most of the people understand that you can't take back custom work because you can't resell it.

If a Garment Is Damaged

Most paints for fabric have washing instructions printed on the bottle. As a customer service you should include a copy of the instructions with every garment order, and print them on your sales con-

tract. Even with these precautions customers will still return with faded shirts because they lost the washing instructions or never got them because the garment was a gift. You are not under any obligation to these unfortunate customers, but in these cases I usually retouch them at no charge and give them another copy of the washing instructions.

The Impossible Customer

There is one special type of customer I have encountered often enough that I feel a warning is necessary. This customer has a picture in his head and wants you to duplicate it exactly as he sees it in his imagination. Since you're not clairvoyant, you can't possibly capture what this person wants. He's . . . impossible.

If you have never encountered impossible customers, I can only say you will know it when it happens. Here's how to spot them: They explain what they want in incredible detail. They keep asking if you understand what they mean. They are more interested in talking about the idea than in getting it painted. When they see the finished product, they are extremely upset because obviously you can't capture their dream child. It's a sad situation for you. And to tell the truth, I feel sorry for them, too.

There is a simple way to solve this problem, but you have to implement this plan before the customer places an order. I use this technique every time I suspect I'm dealing with an impossible customer.

First, clearly explain that you are not a copy machine and cannot duplicate ideas exactly as they see them in their minds. Explain that you can include all the detail they request, but there will be some differences.

This sometimes worries these customers, so immediately add, "Now understand, I've been doing this a long time and I pride myself on being able to render the ideas of others. Most of the time I can even add to your idea and make it look better. . . ." This will either discourage them from turning you loose with their precious ideas or help them to accept that you are not God, just an artist. The aim here is to meet or exceed the customers' expectations, rather than let them down by not achieving their unrealistic expectations.

Special Hints for Working With Businesses

The average customer is generally tolerant and easy to work with. The most difficult problems I've

experienced involve commercial accounts or business sales. If you want to make your relationships with businesses run more smoothly, here are some things you can do.

Never Extend Credit
Because you are providing a service, you can't repossess your product. Once you paint something, you can never get back the time it took to do it. And since the courts shy away from compensating you for lost time, there is no foolproof way to insure you will be paid except to get the money first.

Unfortunately, businesses are not generally very free with money before they see a product. Often, you will have to accept a degree of risk when working with them. Most of the time the best you can hope for is to get half your fee in advance, with the balance paid upon delivery.

And by the way, if the business doesn't have a check ready when you deliver the final product, *don't* leave it. The product is your only leverage, and once you leave it you are open to a barrage of excuses. The accountant just left for vacation, they can't find the paperwork, or worse, "Who is this? What sign?" Always call ahead when you make a delivery to remind the company that you expect to collect your fee. To be really smart you should call again just before you leave to make sure the check is ready.

Companies that ask for credit are telling you they don't have much of a cash reserve. It is almost a sure bet that you will have trouble collecting. Before I had learned my lesson I rendered about three thousand dollars' worth of graphics for a new company. I got half down but agreed to wait thirty days for the balance. After thirty days I called the company and was told they were waiting for a large investment check. They swore the check was approved and that it was in the mail.

Three months later the company folded. During my last conversation with the owner he admitted that he had assumed I was a bigger company that could absorb the loss. I asked if he knew at the time he signed the contract for my services that he probably wouldn't be able to pay, and he said yes.

Using Fine Print Wisely
We've all seen the fine print on the backs of sales contracts, work orders and purchase orders. The fine print is designed to limit the recourse options available to customers in the event they're dissatisfied. Well, now that you're a business, you need to make good use of fine print. Here are some things you should consider including in your contract. I

Collection Agencies
Collection agencies save a company time by collecting debts for them. The collection agency makes calls, mails letters, and badgers debtors to the maximum legal limit. For this they earn a commission based on the debt they collect.

Naturally the collection agencies look for customers who have a lot of bad debts they can collect on in order to make a larger commission. Unfortunately, this means they will probably not be interested in handling your delinquent accounts. Thankfully, most airbrush artists don't accumulate a large amount of debt. The collection agencies have a minimum point where they will take on a client.

am not a lawyer, and the laws vary between states, so you should check with your own attorney before drawing up any contract.

Arbitration. Arbitration is an alternative to the standard civil court system. It is an arrangement between you and your client whereby you agree to settle any legal misunderstandings by presenting your case to an arbitrator.

The arbitrator is a qualified individual who is chosen by a rather involved set of rules. These rules also need to be printed on your sales contract in order for the clause to be legally binding. The arbitrator hears both sides of the case and passes judgment that is legally binding and enforceable.

You can settle legal disputes much more quickly with arbitration than with the standard legal system. If you want to know more about arbitration, contact the American Arbitration Association (see page 128 for the address). There is an office in most major cities. They will also provide you with the exact, binding legal clause that you can print on the back of your sales contracts.

Legal costs. Arbitration costs money, just like any civil court action, so you might want to include a clause that states that the client giving you trouble will have to pay all legal fees.

This clause goes something like this: "In the event any legal action arises from this transaction the below signed client will pay all legal fees incurred by (your name here)."

Again, I urge you to get the exact wording from your attorney. If the clause is not worded properly it may not stand up in court. In some states these clauses may not even be legal. And even if they are legal, your customers may not agree to the terms.

An alternative is to use another phrase that makes the offending party responsible for legal fees: "In any proceeding to enforce any part of this agreement, the aggrieved party shall be entitled to reasonable legal fees in addition to any available remedy." Since both you and your business customer are entering the agreement (assuming you won't be the offending party), as long as you honor the contract you don't have to worry about being stuck with legal fees.

Early and late payment. To motivate customers to pay you on time (that is, if you give credit at all) you can offer a small discount. You can print a clause right next to the box that has the total due that reads, "Less 2 percent if paid on or before thirty days." This means that customers can deduct 2 percent if they pay within thirty days.

If customers are late paying their bills you may print a clause on your bill (and, of course, on your sales contract) that states, "A 5 percent late fee will be added to this bill if not paid within thirty days."

But charging interest can from a legal standpoint classify you as a lending institution, and the laws governing that industry are extensive. Using these clauses can land you in trouble, so be sure to talk to your lawyer first.

Delivery attempts. These days, I always call before I deliver a finished product, and I don't even bother to make the trip if the check isn't ready. In the past I kept finding myself standing in my business customer's lobby with someone making excuses for why the check really wasn't ready, asking, "Couldn't you just leave it, and get the check later?" Every time I left the finished product without getting paid, I had trouble collecting—and in several cases, I never saw a dime of what I was due.

To solve this problem I added a clause to my sales contracts: "Each quote includes one, and only one, delivery attempt. All work is performed on a COD basis. If a check is not ready at the agreed delivery date and time, the product will be returned to (your address here). The customer can pick up the product at a prearranged date and time, or arrange for a second delivery. A 20 percent service fee will be added for each additional delivery."

Now, I always point this clause out to customers at the moment we negotiate a payment schedule and I mention it again when I call before delivering the product. I never have these problems anymore.

Taking Risks in Business

Going into business for yourself is risky. You have to accept all kinds of unknowns and learn to deal with the unexpected. But that doesn't mean you should launch blindly into any venture that looks as though it might make a buck.

Over the years, I have found that the times I was most vulnerable to a get-rich-quick scheme were when I was hurting for money. Anyone could talk me into anything when I was thinking, "Oh, well. I don't have anything else to do. I might as well take the chance."

When you're working—no matter how risky the job is—you feel better about your financial situation. The act of working actually takes your mind off your problems and makes you feel that you're moving in the right direction—even though you may be setting yourself up.

It is almost better to do nothing than to take a foolish risk. When you are doing well, and a problem won't emotionally or financially cripple you, then you can afford to be bolder. If business is bad and you start taking risks, you end up using materials that would be better used on secured jobs. The time wasted working on risky jobs would be better spent looking for more secure work.

When you are first starting out you should work part-time. Don't quit your nine-to-five job until you have completely replaced the income. You may find that you have to average your income because you make more money one month than another, but as you get to know these trends you can eliminate your other sources of income and begin airbrushing full-time. Starting a business in a position where you have to make money in order to survive puts you in a position of desperation. You will be tempted to take any job that comes your way, and this will lead to problems.

Once you are airbrushing full-time and you find you don't have enough work, don't get desperate. *Expand your markets.*

For example, let's say you've set up in a mall painting T-shirts, and you're making just enough money to get by. Or maybe you find yourself going in the hole a few hundred a month. Before things get out of hand, you could print some flyers advertising shirts painted with specific subjects, like cars and motorcycles. Then take the flyers to a dozen auto parts stores. If you offer a small discount with the flyer you will be able to monitor the customers you draw.

Now, if the flyers bring you three new customers, you will know that for every twelve auto parts

stores you will get three new customers. From this you can reason that if you put flyers in three dozen auto parts stores, you will get nine new customers. Nine T-shirts sold for a profit of $40 will earn you $360 and thus eliminate your deficit.

This is just one example of how you can control your own income by expanding your distribution. There is no rule saying you can't develop your own special niche or work in all the different markets outlined in this book.

I was not earning as much as I wanted to just painting T-shirts in the mall I had set up in, so I began offering canvas portraits; my sales doubled. By controlling your own income you will not feel pressured to get involved with anything risky.

Controlling your own income requires creativity on your part. You have to be willing to try new approaches when you are flush, not when things get desperate. You can't expect to set up somewhere and kick back for the rest of your life. Malls are replaced by other malls, fads come and go, and you will constantly have to adjust to the market trends. If you don't control the market, the market will control you.

Resources

Airbrush Equipment and Sales

Most art supply stores carry a wide range of airbrush equipment and supplies, so you should be able to find most products you need at your local store. For your convenience, the names of the major airbrush manufacturers are listed here.

Airbrushes (Brands)

Aztek
Badger
Binks
HK Holbein
Iwata
Kopykake

Medea
Paasche
Royal Sovereign
Skyward
Thayer & Chandler

Airbrushes (Suppliers)

Airbrush One, Inc.
1255 Belle Avenue #140
Winter Springs, Florida 32708
(800)332-6552
fax: (407)695-2322

The Airbrush Store
Daytona Beach, Florida
(800)852-7874

Artistic Airbrush
P.O. Box 3318
Portland, Oregon 97208
(800)547-9750 ext. 90
(503)249-6296

Co-op Artists' Materials
Atlanta Airbrush
P.O. Box 53097
Atlanta, Georgia 30355
(800)877-3242

North American Airbrush
2329 Blossom Street
Columbia, South Carolina 29205
(800)462-4382

Pacific Airbrush
440 S. Anaheim Boulevard
Anaheim, California 92805
(714)758-1638, (714)772-5571

Miscellaneous Special Equipment

Air Nouveau
P.O. Box 73
Lakewood, New Jersey 08701
(800)876-2472, (908)364-2111
(marketer of Stencil Burner)

Frisk Products
5240 Snapfinger Park Drive
Suite 115
Decatur, Georgia 30035
(404)593-0031
(manufacturer and distributor of artists' supplies including Frisk film, spray booths and CS10 illustration board)

Graphic Arts Systems
19499 Miles Road
Cleveland, Ohio 44128
(800)447-2349
(largest supplier of specialty plastic films to the commercial art market)

Paints (Manufacturers and Brands)

Acrylics

Badger Air Brush Co.
 Badger Air-Opaque

Binney & Smith, Inc.
 Liquitex

Bocour Artists Colors
 Aquatec

Charvoz
 Brera

Chroma Acrylic
 Atelier

Demco
 Demcryl

Golden Artist Colors, Inc.
 Golden

M. Grumbacher, Inc.
 Hyplar

HK Holbein
 Acryla
 Aeroflash

Hunt Manufacturing Company
 Speedball

Lefranc & Bourgeois
 Flashe

Medea Trading, Inc.
 ComArt Opaque
 ComArt Transparent

Pacific Airbrush
 Magic Touch

Salis International
 Spectralite

Winsor & Newton
 Artists' Acrylic

Fabric Paint

Advance Process Supply Co.
 Aquaset

Atlanta Airbrush
 Special T

Badger Air Brush Co.
 Air Tex

Binney & Smith
 Liquitex

Charvoz
 Air Pro

Crown Art Products
 Crown Thick Gloss

Decart, Inc.
 Deka Perm Air

Demco
 Demco Fabric Dye

Hydracolor Systems
 Aquaflow

Ivy Craft Imports
 Peintex
 Silktint
 Super-Tinfix
 Texticolor
 Tinfix

Lefranc & Bourgeois
 Elbesoie
 Elbetex

Medea Co., Inc.
 Com-Art Textile Colors

Salis International
 Spectra Tex

Siphon Art
 Versatex

Utley Co., Inc.
 Utley Ready "2" Use Fabric Paint

Gouache

Charvoz
 Maimeri Designer's Gouache

HK Holbein
 Holbein Acrylic Gouache
 Holbein Designers Colors

Koh-I-Noor
 Pelikan Designer's Colors

Lefranc & Bourgeois
 Linel

H. Schmincke & Co., West Germany
 Aero-Fienste

Turner Color Company
 Turner Designer Gouache

(602)966-7751, (800)289-7480
fax: (602)966-0087

California Shirt Sales
800 South Raymond
Fullerton, California 92631
(714)879-8590, (800)289-7478
fax: (714)992-4855

California Shirt Sales
7307 Edgewater Drive
Oakland, California 94621
(415)430-0486, (800)289-7479
fax: (415)430-9517

California Shirt Sales
4690 Cardin Street
San Diego, California 92111
(619)292-7572, (800)289-7480
fax: (619)292-1628

California Shirt Sales
460 East 76th Avenue
Denver, Colorado 80216
(303)289-5456, (800)289-7485

Foremost Athletic-Midwest
1307 East Maple Road
Troy, Michigan 48083
(313)689-3850, (800)433-9486
fax: (313)689-4653

Foremost Athletic-Southwest
10390 Shady Trail, Suite 100
Dallas, Texas 75220
(214)350-3591, (800)272-8700
fax: (214)350-3636

Foremost Athletic-West
1364 Parkside Place
Ontario, California 91761
(714)923-0666, (800)448-6344
fax: (714)923-1973

Full Line Distributors
1655 East Sixth Street B-5
Corona, California 91719
(714)736-8821, (800)621-4468
fax: (714)736-6416

Full Line Distributors
2349 Industrial Parkway West
Hayward, California 94545

(415)782-3400, (800)582-6660
fax: (415)782-1166

Full Line Distributors
1200-B Menlo Drive
Atlanta, Georgia 30318
(404)352-4571, (800)633-4571
fax: (404)355-2120

Full Line Distributors
2311 Duss Avenue, #15
Ambridge, Pennsylvania 15003
(412)266-4288, (800)323-3166
fax: (412)266-4245

Full Line Distributors
1215 North Post Oak
Houston, Texas 77055
(713)680-1765, (800)858-9001
fax: (713)680-2452

Good Buy Sportswear
2400 31st Street South
St. Petersburg, Florida 33712
(813)327-3773, (800)282-0974
fax: (813)323-4802

Gulf Coast Sportswear
9570 Tara Boulevard
Jonesboro, Georgia 30236
(404)471-6865, (800)554-4126

Gulf Coast Sportswear
1041 Lombard Road
Lombard, Illinois 60148
(708)953-8888, (800)800-2300

Gulf Coast Sportswear
900 N. Great S.W. Parkway, Suite 116
Arlington, Texas 76011
(817)640-0831, (800)392-2207
fax: (817)649-8544

Gulf Coast Sportswear
9282 Baythorne
Houston, Texas 77041
(713)690-4881, (800)334-2692
fax: (713)939-8925

J-M Business Enterprises
461 S. Dupont Avenue
Ontario, California 91761
(714)391-0101, (714)984-1546
(800)447-7794

Winsor & Newton
Winsor & Newton

Inks

Demco
Demco Waterproof Drawing Ink

Hunt Manufacturing Company
Speedball

Koh-I-Noor
Pelikan Drawing Inks
Pelikan Writing Inks
Rotring Artist Color

Lefranc & Bourgeois
Fluidine

H. Schmincke, West Germany
Aerocolor

Steig Products
Luma

Utley Co., Inc.
Higgins Pigmented Semi-opaque
Higgins Waterproof

Winsor & Newton
Winsor & Newton Drawing Inks

Watercolors & Dyes

AMI
Dia Dye

Binney & Smith
Liquitex Watercolors

Chartpak
Chartpak Aqua Dye

Charvoz
Colorin

Graphic Marker International, Inc.
Graphic Marker Dyes

M. Grumbacher, Inc.
Grumbacher Academy

HK Holbein
Holbein Artist's Quality Watercolors

Hunt Manufacturing Company
Speedball

Lefranc & Bourgeois
Linel

Salis International
Dr. Ph. Martin's Radiant
Dr. Ph. Martin's Synchromatic Transparent

H. Schmincke & Co., West Germany
HKS Color Dyes
Horadam

Steig Products
Luma

Winsor & Newton
Brilliant Design Watercolors
Winsor & Newton Watercolors

Paints (Specialty Suppliers)

Consumers Paint Factory
5300 W. 5th Avenue
P.O. Box 6398
Gary, Indiana 46406
(219)949-1684

Ivy Craft Imports
5410 Annapolis Road
Bladensburg, Maryland 20710
(301)779-7079

Sources for T-Shirts

Atlantic Coast Cotton
7890 Notes Drive
Manassas, Virginia 22110
(703)631-7311, (800)262-5660
fax: (703)368-3527

Basic Blanks, Inc.
1306 Hartman Ave. East
Omaha, Nebraska 68110
(402)453-1734, (800)851-6298
fax: (402)453-1606

California Shirt Sales
1505 West 17th Street
Tempe, Arizona 85281

J-M Business Enterprises
P.O. Box 3955
Seattle, Washington 98124
(206)682-8999, (206)623-0131
(800)678-4200

K Tees, Inc.
4915 W. Burnham Street
Milwaukee, Wisconsin 53219
(414)645-5444, (800)327-9871
fax: (414)645-4424

Kayman-Anaheim
2544 Miraloma Way
Anaheim, California 92806
(714)630-1550, (800)634-6340
fax: (714)630-5506

Kayman-Denver
4901 Ironton Street
Denver, Colorado 80239
(303)375-1400, (800)634-6340
fax: (303)375-0075

Kayman-New Orleans
5601 Caterpillar Point
New Orleans, Louisiana 70123
(504)733-2100, (800)634-6340
fax: (504)733-0665

Kayman-New York
240 Smith Street
Farmingdale, New York 11735
(516)753-2200, (800)634-6340
fax: (516)753-2259

Kayman-San Francisco
1335 Lowrie Avenue
San Francisco, California 94080
(415)589-8900, (800)634-6340
fax: (415)589-8900

Kellsport
125 Sockanosset Crossroad
Cranston, Rhode Island 02920
(401)463-7922, (800)341-4600
fax: (401)463-6242

Kellsport/Canada
2177 Masson, Building #214
Montreal, P.Q. H2H 1B1 Canada
(514)525-6883, (800)363-8400
fax: (514)525-6960

Kellsport/New York
350 5th Avenue, #1024
New York, New York 10118
(212)465-8656, (800)341-4600
fax: (212)643-1641

Oklahoma Tees
5032 NW Waukomis
Northmoor, Maryland 64151
(816)587-3938, (800)233-5375

Oklahoma Tees
1012 NW 69th
Oklahoma City, Oklahoma 73116
(405)842-5316

Piedmont Mills
1214 Maple Avenue
Burlington, North Carolina 27215
(919)226-2223, (800)752-4009
fax: (919)229-6971

Platinum Sportswear
3208 Oakliff Ind. Street
Atlanta, Georgia 30340
(404)458-1479, (800)241-9483
fax: (404)458-0693

Platinum Sportswear of Baltimore
8350 Bristol Court, Suite 109
Jessup, Maryland 20794
(301)206-2044, (800)752-8688
fax: (301)497-9107

Platinum Sportswear of Tempe
902 South Edward Drive, Suite 4
Tempe, Arizona 85281
(602)254-9161, (800)845-1855
fax: (602)966-3720

Screen Gems
H.C. Miller & Son, Inc.
3801 East Roeser Road, Suite 16
Phoenix, Arizona 85040
(800)937-4478

Screen Gems
H.C. Miller & Son, Inc.
255 East Hellen Road, Suite A
Palatine, Illinois 60067
(800)233-5480

Screen Gems
H.C. Miller & Son, Inc.

530 S. Cavalier
Springfield, Missouri 65802
(800)247-2629

Screen Gems
H.C. Miller & Son, Inc.
P.O. Box 33
Orwigsburg, Pennsylvania 17961
(800)233-3103

TLC Distributors
4720 Hewes Avenue
Gulfport, Mississippi 39507
(601)863-2068, (800)852-8337

Toddler Tees/Pacific Playwear
18324-06 Oxnard Street
Tarzana, California 91356
(818)708-7911
(800)356-0900
fax: (818)772-6914

T-Shirt City, Inc.
Rotterdam Ind. Park
Route 7 Duanesburg Road Bldg. 3
Schenectady, New York 12306
(800)543-7230
fax: (513)542-5818

T-Shirt City, Inc.
4501 W. Mitchell Avenue
Cincinnati, Ohio 45232
(800)543-7230
fax: (513)542-5818

T-Shirt City, Inc.
808 Cowan Street Building D
Cowan Industrial Park
Nashville, Tennessee 37207
(800)543-7230
fax: (513)542-5818

T-Shirt City, Inc.
3630 HI-35 South
Waco, Texas 76706
(800)543-7230
fax: (513)542-5818

T-Shirt Supply
1301 1st Avenue North
Birmingham, Alabama 35203
(205)324-3775, (800)826-1225
fax: (609)451-2209

T-Shirt Supply
5909 St. Augustine Road, #6
Jacksonville, Florida 32207
(904)731-8422, (800)874-4875
fax: (609)451-2209

T-Shirt Supply
3915 W. Hacienda Avenue, #117
Las Vegas, Nevada 89118
(702)798-7668, (800)462-8438
fax: (609)451-2209

T-Shirt Supply
Highway 77
Seabrook, New Jersey 08302
(609)451-3521, (800)221-1527
fax: (609)451-2209

T-Shirt Supply
10029 Alfred Lane
Houston, Texas 77041
(713)690-5705, (800)462-8439
fax: (609)451-2209

Wholesale Blanks
4201 N.E. 12 Tr.
Fort Lauderdale, Florida 33334
(305)563-4433, (800)331-1067
fax: (305)565-5542

Wholesale Blanks Miami
4882 NW 167th Street
Miami, Florida 33014
(305)504-4435, (800)331-1067
fax: (305)565-5542

Wholesale T-Shirt Supply
1352 North Illinois Street
Indianapolis, Indiana 46202
(317)634-4423, (317)637-1345
(800)622-4788 (Indiana),
(800)428-4606 (US)
fax: (317)637-7670

Wholesale Textile Outlet
5901 NE 14th Avenue, Bay 48
Fort Lauderdale, Florida 33334
(305)491-2361

Wild Country Tee's-Alabama
Wild Country, Inc.

201 Glen Avenue SW
Fort Payne, Alabama 35967
(205)845-1671, (800)255-3699
fax: (205)845-5650

Wild Country Tee's-Dallas
Wild Country, Inc.
2910 Anode Lane
Dallas, Texas 75220
(214)350-9191, (800)447-1979
fax: (214)350-9238

The Wild Side
1543 Truman Street
San Fernando, California 91340
(818)365-6789, (800)421-3130
fax: (818)365-6667

Wild Side North, Inc.
P.O. Box 339
Slippery Rock, Pennsylvania 16057
(412)764-4100, (800)245-3810
fax: (412)794-1243

Wild Side North, Inc.
3439 Steen Drive
San Antonio, Texas 78219
(800)245-3810
fax: (412)794-1243

Sources for Miscellaneous Garments

Although you will make most of your income from
T-shirts, you may offer other items if they are ap-
propriate for your market. This section will give
you leads to finding some of the most popular items
such as sweatshirts, caps and denim garments.

American Mills
1698 South 2nd Street
Hopkins, Minnesota 55343
(612)933-6010, (800)876-4287
fax: (612)933-6232
(caps, visors, T-shirts)

Bay Rag
6000 N.W. 32nd Court
Miami, Florida 33142
(305)634-3366, (800)321-0139 (US)
(800)330-3244 (Florida)
fax: (305)634-2765
(denim jackets and apparel)

Classic Caps, Inc.
171 Parkhouse Street
Dallas, Texas 75207
(214)741-1555
fax: (214)748-3166
(caps)

Classic Impressions
5181 West Washington Boulevard
Los Angeles, California 90016
(213)836-1822
fax: (213)837-1900
(denim jackets)

Platinum Sportswear
3208 Oakliff Ind. Street
Atlanta, Georgia 30340
(404)458-1479, (800)241-9483
fax: (404)458-0693
(sweatshirts, tanktops, golf shirts, caps)

Platinum Sportswear of Baltimore
8350 Bristol Court, Suite 109
Jessup, Maryland 20794
(301)206-2044, (800)752-8688
fax: (301)497-9107
(sweatshirts, tanktops, golf shirts, caps)

Platinum Sportswear of Tempe
902 South Edward Drive, Suite 4
Tempe, Arizona 85281
(602)254-9161, (800)845-1855
fax: (602)966-3720
(sweatshirts, tanktops, golf shirts, caps)

Renaissance International
Headwear Division
12929-F Telegraph Road
Sante Fe Springs, California 90670
(213)946-7541, (800)233-0876
(213)946-8197
(caps)

Renaissance International
Headwear Division
7100 Broadway #1J
Denver, Colorado 80221
(800)233-0876, (213)946-8197
(caps)

Renaissance International
Headwear Division
203 Murray Drive
Chamblee, Georgia 30341

(800)233-0876, (213)946-8197
(caps)

Renaissance International
Headwear Division
757 Kawaiahao Street
Honolulu, Hawaii 96813
(800)233-0876, (213)948-8197
(caps)

Renaissance International
Headwear Division
8606 University Green
Middleton, Wisconsin 53562
(800)233-0876, (213)946-8197
(caps)

Torpedo International
(213)747-1212
(denim jackets, jeans, skirts, jumpsuits, vests)

T-Shirt City, Inc.
Rotterdam Ind. Park
Route 7 Duanesburg Road Bldg. 3
Schenectady, New York 12306
(800)543-7230
fax: (513)542-5818
(caps, tanktops, crop tops, shorts, kids' golf shirts, sport shirts, sweatshirts, jackets)

T-Shirt City, Inc.
4501 W. Mitchell Avenue
Cincinnati, Ohio 45232
(800)543-7230
fax: (513)542-5818
(caps, tanktops, crop tops, shorts, kids' golf shirts, sport shirts, sweatshirts, jackets)

T-Shirt City, Inc.
808 Cowan Street Building D
Cowan Industrial Park
Nashville, Tennessee 37207
(800) 543-7230
fax: (513)542-5818
(caps, tanktops, crop tops, shorts, kids' golf shirts, sport shirts, sweatshirts, jackets)

T-Shirt City, Inc.
3630 HI-35 South
Waco, Texas 76706
(800)543-7230
fax: (513)542-5818
(caps, tanktops, crop tops, shorts, kids' golf shirts, sport shirts, sweatshirts, jackets)

T-Shirt Supply
1301 1st Avenue North
Birmingham, Alabama 35203
(205)324-3775, (800)826-1225
fax: (609)451-2209

T-Shirt Supply
5909 St. Augustine Road, #6
Jacksonville, Florida 32207
(904)731-8422, (800)874-4875
fax: (609)451-2209
(caps, tanktops, crop tops, shorts, kids' golf shirts, sport shirts, sweatshirts, jackets)

T-Shirt Supply
3915 W. Hacienda Avenue, #117
Las Vegas, Nevada 89118
(702)798-7668, (800)462-8438
fax: (609)451-2209
(caps, tanktops, crop tops, shorts, kids' golf shirts, sport shirts, sweatshirts, jackets)

T-Shirt Supply
Highway 77
Seabrook, New Jersey 08302
(609)451-3521, (800)221-1527
fax: (609)451-2209
(caps, tanktops, crop tops, shorts, kids' golf shirts, sport shirts, sweatshirts, jackets)

T-Shirt Supply
10029 Alfred Lane
Houston, Texas 77041
(713) 690-5705, (800)462-8439
fax: (609)451-2209
(caps, tanktops, crop tops, shorts, kids' golf shirts, sport shirts, sweatshirts, jackets)

T-Shirts and More, Inc.
7667 National Turnpike
Louisville, Kentucky 40214
(502)368-2768, (800)633-1602 (Kentucky)
(800)833-8677 (US)
fax: (502)363-5855 (local)
(800)992-0135 (US)
(caps, tanktops, crop tops, shorts, kids' golf shirts, sport shirts, sweatshirts, jackets)

United Enterprises, Inc.
4177 L.B. Mcleod
Orlando, Florida 32811
(407)839-0336, (800)882-5410
fax: (407)839-3908
(neon apparel)

United Enterprises, Inc.
5410 West Roosevelt Road
Chicago, Illinois 60650-1235
(312)379-1300, (800)323-5410
fax: (312)379-5410
(neon apparel)

United Enterprises, Inc.
P.O. Box 7587
Charlotte, North Carolina 28241-7587
(704)588-0983, (800)438-4848
fax: (704)588-5410
(neon apparel)

Blank License Plates

Groff Industries, Inc.
(800)634-7633
(813)961-1427 (Tampa)
(617)545-9537 (New England)
(817)268-6815 (Dallas)
(216)933-6050 (Ohio, Indiana)

Hot Plates
5 Waushakum Avenue
Ashland, Massachusetts 01721
(800)225-4662

Pioneer Neon Supply
(800)722-7068

Tubelite Co., Inc.
4102 Adams Street
Phoenix, Arizona 85009
(602)484-0122, (800)423-0669
fax: (602)278-2341

Tubelite Co., Inc.
14074 Doolittle Drive
San Leandro, California 94577
(415)562-4285, (800)562-4285
fax: (415)483-8557

Tubelite Co., Inc.
9380 NW 100th Street
Medley, Florida 33178
(305)883-9070, (800)331-0321
fax: (305)883-9456

Tubelite Co., Inc.
1612 Sligh Boulevard
Orlando, Florida 32806
(407)425-4622, (800)432-8526
fax: (407)425-7493

Tubelite Co., Inc.
3875 Culligan, Unit H
Indianapolis, Indiana 46218
(317)352-9366, (800)634-5938
fax: (317)352-1637

Tubelite Co., Inc.
300 Park Street
Moonachie, New Jersey 07074
(201)641-1011, (800)631-0778
fax: (201)641-6413

Tubelite Co., Inc.
3315 Pelton Street
Charlotte, North Carolina 28217
(704)525-2262, (800)438-1044
fax: (704)522-1372

Tubelite Co., Inc.
1224 Refugee Lane
Columbus, Ohio 43207
(614)443-9734, (800)848-0576
fax: (614)443-0201

Tubelite Co., Inc.
3111 Bellbrook
Memphis, Tennessee 38116
(901)396-8320, (800)238-5280 (US)
(800)582-2412 (Tennessee)
fax: (901)396-4648

Zee Products
P.O. Box 774
Hernando, Florida 32642
(904)344-5940, (800)336-3905
(November - July)

Zee Products
875 South Raymond Road
Battle Creek, Michigan 49017
(616)962-4995
(July - October)

Sign Painting

F.M.S. Corporation
8635 Harriet Avenue
Bloomington, Minnesota 55420
(612)888-7976
fax: (612)888-7978

Midwest Sign & Screen Printing Supply Co.
790 Umatilla
Denver, Colorado 80204

(303)534-8133, (800)525-3014
fax: (303)534-2406

Midwest Sign & Screen Printing Supply Co.
2120 Myrtle Avenue
St. Paul, Minnesota 55114
(612)646-7971, (800)328-6592
fax: (612)646-8293

Midwest Sign & Screen Printing Supply Co.
4949 E. 59th Street
Kansas City, Missouri 64130
(816)333-5224, (800)233-3770
fax: (816)333-5446

Midwest Sign & Screen Printing Supply Co.
8936 J. Street
Omaha, Nebraska 68127
(402)592-7555, (800)228-3839
fax: (402)592-5267

Midwest Sign & Screen Printing Supply Co.
16200 West Rogers Drive
New Berlin, Wisconsin 53151
(414)784-6677, (800)558-5590
fax: (414)784-6994

Quill-Hair & Ferrule
P.O. Box 23927
Columbia, South Carolina 29224
(800)421-7961

Signcraft Magazine
P.O. Box 06031
Fort Myers, Florida 33901
(813)939-4644

Sign of the Times Magazine
407 Gilbert Avenue
Cincinnati, Ohio 45202
(513)421-2050
fax: (513)421-5114
(also offers Special Buyers' Guide - 300 pages
which list all the equipment, supplies and
services of the sign industry)

Fingernail Painting Supplies

Design Magic II
1849 Washington Avenue
San Leandro, California 94577
(415)483-1236

East Coast Airbrush
5476 Merrick Road
Massapequa, New York 11758
(516)799-6466

Jumpeer Nails
420 Pompton Avenue
Cedar Grove, New Jersey 07009
(201)857-1433

Premier Nail Products
P.O. Box 16961
Encino, California 91416
(800)852-6297

San Francisco Nails
1849 Washington Avenue
San Leandro, CA 94577
(800)777-1242

Equipment/Supplies for Airbrushing Cakes

Arrow Neumatics
500 N. Oakweed Road
Dept. T
Lake Zurich, Illinois 60047
(708)438-9100
fax: (708)438-7110
(arrow filters)

Stencil Air
800 Church Street
Ripon, Wisconsin 54971
(800)462-0553
(colors)

Periodicals, Books and Organizations

Periodicals

Airbrush Action
P.O. Box 73
Lakewood, New Jersey 08701

American Artist
1515 Broadway
New York, New York 10036

Art Calendar
Route 2
Box 273-C
Sterling, Virginia 22170

Art Gallery Magazine
Hollycroft Press
Hollycroft
Ivoryton, Connecticut 06442

Art in America
Brant Publications
980 Madison Avenue
New York, New York 10021

Art Now Gallery Guides
Art Now, Inc.
320 Bonnie Burn Road, Box 219
Scotch Plains, New Jersey 07076

Art Now USA
Art Now, Inc.
320 Bonnie Burn Road, Box 219
Scotch Plains, New Jersey 07076

Art Today
Web Publications
Box 12830
15100 West Kellogg
Wichita, Kansas 67235

The Artist's Magazine
F&W Publications
1507 Dana Avenue
Cincinnati, Ohio 45207

ARTnews
5 West 37th Street
New York, New York 10018

Decor Source Book
Commerce Publishing Company
408 Olive Street
St. Louis, Missouri 63102

Directory of Art Publishers, Book Publishers and Record Companies
Directors Guild Publishers
Renaissance, California

Impressions Magazine
A Gralla Publication
P.O. Box 801470
Dallas, Texas 75380

SCREENplay
Windsor Communications, Inc.
P.O. Box 740995
Dallas, Texas 75374

(214)361-2200
fax: (214)361-1904

Shirts Illustrated
Windsor Communications, Inc.
P.O. Box 740995
Dallas, Texas 75374
(214)361-2200
fax: (214)361-1904

WEAR
Windsor Communications, Inc.
P.O. Box 740995
Dallas, Texas 75374
(214)361-2200
fax: (214)361-1904

Books

American Art Directory
R.R. Bowker Co.
121 Chanlon Road
New Providence, New Jersey 07974

The Artist's Friendly Legal Guide
North Light Books
1507 Dana Avenue
Cincinnati, Ohio 45207

Artist's Guide to Philadelphia
Box 8755
Philadelphia, Pennsylvania 19101

Artist's Market
Writer's Digest Books
1507 Dana Avenue
Cincinnati, Ohio 45207

Business and Legal Forms for Fine Artists
Tad Crawford
Allworth Press
Distributed by North Light Books
1507 Dana Avenue
Cincinnati, Ohio 45207

Legal Guide for the Visual Artist
Tad Crawford
Allworth Press
Distributed by North Light Books
1507 Dana Avenue
Cincinnati, Ohio 45207

Making It Legal
Northland Publishing

P.O. Box N
Flagstaff, Arizona 86002

Thomas Register of American Manufacturers
Thomas Publishing Company
1 Penn Plaza
New York, New York 10017

Organizations

American Arbitration Association
140 West 51st Street

New York, New York 10020-1203
(212)484-4000

Letterheads
Meetings are announced in *Signcraft* and *Signs of the Times* magazines

Volunteer Lawyers for the Arts
Third Floor
1285 Avenue of the Americas
New York, New York 10019

Permissions

Page 11
© Bob Orsolini. *Used by permission.*

Page 18
© Bob Orsolini. *Used by permission.*

Pages 26-27
© Greg Terrell. *Used by permission.*

Page 42 (bottom left)
© Bob Orsolini. *Used by permission.*

Page 66
© 1990 Jurek. *Used by permission.*

Page 67
© Jurek. *Used by permission.*

Pages 76-78
© Andrew Cappuccio. *Used by permission.*

Pages 79-80
© Chris Cruz. *Used by permission.*

Pages 84-85
© Julian Bract. *Used by permission.*

Pages 91-93
© Kelley Swortfiguer. *Used by permission.*

Pages 96-97
© Gary Longordo. *Used by permission.*

Index

Improve your skills, learn a new technique, with these additional books from North Light

Graphics/Business of Art

Airbrush Artist's Library (4 books) $5.95/each

Airbrush Techniques Workbooks (6 books) $4.95 each

Airbrushing the Human Form, by Andy Charlesworth $9.95

Artist's Friendly Legal Guide, by Floyd Conner, Peter Karlan, Jean Perwin & David M. Spatt $18.95 (paper)

Artist's Market: Where & How to Sell Your Graphic Art (Annual Directory) $22.95

APA #2: Japanese Photography, $69.95

Basic Desktop Design & Layout, by Collier & Cotton $27.95

Basic Graphic Design & Paste-Up, by Jack Warren $14.95 (paper)

The Best of Neon, edited by Vilma Barr $59.95

Business & Legal Forms for Graphic Designers, by Tad Crawford $19.95 (paper)

Business and Legal Forms for Illustrators, by Tad Crawford $5.95 (paper)

Business Card Graphics, from the editors of PIE Books, $34.95 (paper)

CD Packaging Graphics, by Ken Pfeifer $39.95

CLICK: The Brightest in Computer-Generated Design and Illustration $39.95

Clip Art Series: Holidays, Animals, Food & Drink, People Doing Sports, Men, Women, $6.95/each (paper)

COLORWORKS: The Designer's Ultimate Guide to Working with Color, by Dale Russell (5 in series) $9.95 each

Color Harmony: A Guide to Creative Color Combinations, by Hideaki Chijiiwa $15.95 (paper)

Complete Airbrush & Photoretouching Manual, by Peter Owen & John Sutcliffe $24.95

The Complete Book of Caricature, by Bob Staake $18.95

The Complete Guide to Greeting Card Design & Illustration, by Eva Szela $29.95

Creating Dynamic Roughs, by Alan Swann $12.95

Creative Director's Sourcebook, by Nick Souter and Stuart Neuman $34.95

Creative Self-Promotion on a Limited Budget, by Sally Prince Davis $19.95 (paper)

The Creative Stroke, by Richard Emery $39.95

Creative Typography, by Marion March $9.95

Design Rendering Techniques, by Dick Powell $29.95

The Designer's Commonsense Business Book, by Barbara Ganim $22.95 (paper)

The Designer's Guide to Creating Corporate ID Systems, by Rose DeNeve $27.95

The Designer's Guide to Making Money with Your Desktop Computer, by Jack Neff $19.95 (paper)

Designing with Color, by Roy Osborne $26.95

Desktop Publisher's Easy Type Guide, by Don Dewsnap $19.95 (paper)

Dynamic Airbrush, by David Miller & James Effler $29.95

Fashion Illustration Workbooks (4 in series) $3.00 each

59 More Studio Secrets, by Susan Davis $12.95

47 Printing Headaches (and How To Avoid Them), by Linda S. Sanders $24.95 (paper)

Getting It Printed, by Beach, Shepro & Russon $29.50 (paper)

Getting Started as a Freelance Illustrator or Designer, by Michael Fleischman $16.95 (paper)

Getting the Max from Your Graphics Computer, by Lisa Walker & Steve Blount $27.95 (paper)

Graphically Speaking, by Mark Beach $29.50 (paper)

The Graphic Artist's Guide to Marketing & Self-Promotion, by Sally Prince Davis $19.95 (paper)

The Graphic Designer's Basic Guide to the Macintosh, by Meyerowitz and Sanchez $19.95 (paper)

Graphic Design: New York, by D.K. Holland, Steve Heller & Michael Beirut $49.95

Graphic Idea Notebook, by Jan V. White $19.95 (paper)

Great Package Design, edited by D.K. Holland $49.95

Great Type & Lettering Designs, by David Brier $34.95

Graphics Handbook, by Howard Munce $14.95 (paper)

Guild 7: The Architects Source, $27.95

Guild 7: The Designer's Reference Book of Artists $34.95

Handbook of Pricing & Ethical Guidelines, 7th edition, by The Graphic Artist's Guild $22.95 (paper)

HOT AIR: An Explosive Collection of Top Airbrush Illustration, $39.95

How'd They Design & Print That?, $26.95

How to Check and Correct Color Proofs, by David Bann $27.95

How to Design Trademarks & Logos, by Murphy & Row $19.95 (paper)

How to Draw & Sell Cartoons, by Ross Thomson & Bill Hewison $19.95

How to Draw & Sell Comic Strips, by Alan McKenzie $19.95

How to Draw Charts & Diagrams, by Bruce Robertson $12.50

How to Find and Work with an Illustrator, by Martin Colyer $8.95

How to Get Great Type Out of Your Computer, by James Felici $22.95 (paper)

How to Make Your Design Business Profitable, by Joyce Stewart $21.95 (paper)

How to Understand & Use Design & Layout, by Alan Swann $21.95 (paper)

How to Understand & Use Grids, by Alan Swann $12.95

How to Write and Illustrate Children's Books, edited by Treld Pelkey Bicknell and Felicity Trotman, $22.50

International Logotypes 2, edited by Yasaburo Kuwayama $24.95 (paper)

Labels & Tags Collection, $34.95 (paper)

Label Design 3, by the editors at Rockport Publishers $49.95

Legal Guide for the Visual Artist, Revised Edition by Tad Crawford $7.50 (paper)

Letterhead & Logo Designs 2: Creating the Corporate Image $49.95

Licensing Art & Design, by Caryn Leland $12.95 (paper)

Living by Your Brush Alone, by Edna Wagner Piersol $16.95 (paper)

Make It Legal, by Lee Wilson $18.95 (paper)

Making a Good Layout, by Lori Siebert & Lisa Ballard $24.95

Making Your Computer a Design & Business Partner, by Walker and Blount $10.95 (paper)

Marker Techniques Workbooks (8 in series) $4.95 each

North Light Dictionary of Art Terms, by Margy Lee Elspass $12.95 (paper)

Papers for Printing, by Mark Beach & Ken Russon $39.50 (paper)
Preparing Your Design for Print, by Lynn John $12.50
Presentation Techniques for the Graphic Artist, by Jenny Mulherin $9.95
Primo Angeli: Designs for Marketing, $7.95 (paper)
Print Production Handbook, by David Bann $16.95
Print's Best Corporate Publications $34.95
Print's Best Logos & Symbols 2 $34.95
Print's Best Letterheads & Business Cards, $34.95
The Professional Designer's Guide to Marketing Your Work, by Mary Yeung $10.50
Promo 2: The Ultimate in Graphic Designer's and Illustrator's Promotion, edited by Lauri Miller $39.95
3-D Illustration Awards Annual II, $59.95
Trademarks & Symbols of the World: Vol. IV, $24.95 (paper)
Type & Color: A Handbook of Creative Combinations, by Cook and Fleury $39.95
Type: Design, Color, Character & Use, by Michael Beaumont $19.95 (paper)
Type in Place, by Richard Emery $34.95
Type Recipes, by Gregory Wolfe $19.95 (paper)
Typewise, written & designed by Kit Hinrichs with Delphine Hirasuna $39.95
The Ultimate Portfolio, by Martha Metzdorf $32.95
Using Type Right, by Philip Brady $18.95 (paper)

Art & Activity Books For Kids

Draw!, by Kim Solga $11.95
Paint!, by Kim Solga $11.95
Make Cards!, by Kim Solga $11.95
Make Clothes Fun!, by Kim Solga $11.95
Make Costumes!, by Priscilla Hershberger $11.95
Make Prints!, by Kim Solga $11.95
Make Gifts!, by Kim Solga $11.95
Make Sculptures!, by Kim Solga $11.95

Watercolor

Basic Watercolor Techniques, edited by Greg Albert & Rachel Wolf $14.95 (paper)
Buildings in Watercolor, by Richard S. Taylor $24.95 (paper)
Chinese Watercolor Painting: The Four Seasons, by Leslie Tseng-Tseng Yu $24.95 (paper)
The Complete Watercolor Book, by Wendon Blake $29.95
Fill Your Watercolors with Light and Color, by Roland Roycraft $28.95
How to Make Watercolor Work for You, by Frank Nofer $27.95
Jan Kunz Watercolor Techniques Workbook 1: Painting the Still Life, by Jan Kunz $12.95 (paper)
Jan Kunz Watercolor Techniques Workbook 2: Painting Children's Portraits, by Jan Kunz $12.95 (paper)
The New Spirit of Watercolor, by Mike Ward $21.95 (paper)
Painting Nature's Details in Watercolor, by Cathy Johnson $22.95 (paper)
Painting Watercolor Portraits That Glow, by Jan Kunz $27.95
Splash I, edited by Greg Albert & Rachel Wolf $29.95
Starting with Watercolor, by Rowland Hilder $12.50
Tony Couch Watercolor Techniques, by Tony Couch $14.95 (paper)
The Watercolor Fix-It Book, by Tony van Hasselt and Judi Wagner $27.95
Watercolor Impressionists, edited by Ron Ranson $45.00
The Watercolorist's Complete Guide to Color, by Tom Hill $27.95
Watercolor Painter's Solution Book, by Angela Gair $19.95 (paper)
Watercolor Painter's Pocket Palette, edited by Moira Clinch $15.95
Watercolor: Painting Smart, by Al Stine $27.95
Watercolor Tricks & Techniques, by Cathy Johnson $21.95 (paper)
Watercolor Workbook: Zoltan Szabo Paints Landscapes, by Zoltan Szabo $13.95 (paper)
Watercolor Workbook: Zoltan Szabo Paints Nature, by Zoltan Szabo $13.95 (paper)
Watercolor Workbook, by Bud Biggs & Lois Marshall $22.95 (paper)
Watercolor: You Can Do It!, by Tony Couch $29.95
Webb on Watercolor, by Frank Webb $29.95
The Wilcox Guide to the Best Watercolor Paints, by Michael Wilcox $24.95 (paper)

Mixed Media

The Art of Scratchboard, by Cecile Curtis $10.95
The Artist's Complete Health & Safety Guide, by Monona Rossol $16.95 (paper)
The Artist's Guide to Using Color, by Wendon Blake $27.95
Basic Drawing Techniques, edited by Greg Albert & Rachel Wolf $14.95 (paper)
Being an Artist, by Lew Lehrman $29.95
Blue and Yellow Don't Make Green, by Michael Wilcox $24.95
Bodyworks: A Visual Guide to Drawing the Figure, by Marbury Hill Brown $10.95
Business & Legal Forms for Fine Artists, by Tad Crawford $4.95 (paper)
Calligraphy Workbooks (2-4) $3.95 each
Capturing Light & Color with Pastel, by Doug Dawson $27.95
Colored Pencil Drawing Techniques, by Iain Hutton-Jamieson $24.95
The Complete Acrylic Painting Book, by Wendon Blake $29.95
The Complete Book of Silk Painting, by Diane Tuckman & Jan Janas $24.95
The Complete Colored Pencil Book, by Benard Poulin $27.95
The Complete Guide to Screenprinting, by Brad Faine $24.95
Tony Couch's Keys to Successful Painting, by Tony Couch $27.95
Complete Guide to Fashion Illustration, by Colin Barnes $11.95
The Creative Artist, by Nita Leland $12.50
Creative Painting with Pastel, by Carole Katchen $27.95
Drawing & Painting Animals, by Cecile Curtis $26.95
Drawing: You Can Do It, by Greg Albert $24.95
Exploring Color, by Nita Leland $24.95 (paper)
The Figure, edited by Walt Reed $16.95 (paper)
Fine Artist's Guide to Showing & Selling Your Work, by Sally Price Davis $17.95 (paper)
Getting Started in Drawing, by Wendon Blake $24.95
The Half Hour Painter, by Alwyn Crawshaw $19.95 (paper)
Handtinting Photographs, by Martin and Colbeck $29.95
How to Paint Living Portraits, by Roberta Carter Clark $28.95
How to Succeed As An Artist In Your Hometown, by Stewart P. Biehl $24.95 (paper)
Keys to Drawing, by Bert Dodson $21.95 (paper)
Light: How to See It, How to Paint It, by Lucy Willis $19.95 (paper)
Make Your Woodworking Pay for Itself, by Jack Neff $16.95 (paper)
The North Light Handbook of Artist's Materials, by Ian Hebblewhite $4.95
The North Light Illustrated Book of Painting Techniques, by Elizabeth Tate $29.95
Oil Painting: Develop Your Natural Ability, by Charles Sovek $29.95
Oil Painting: A Direct Approach, by Joyce Pike $22.95 (paper)
Oil Painting Step by Step, by Ted Smuskiewicz $29.95
Painting Floral Still Ltfes, by Joyce Pike $19.95 (paper)
Painting Flowers with Joyce Pike, by Joyce Pike $27.95
Painting Landscapes in Oils, by Mary Anna Goetz $27.95
Painting More Than the Eye Can See, by Robert Wade $29.95
Painting Seascapes in Sharp Focus, by Lin Seslar $10.50 (paper)
Painting the Beauty of Flowers with Oils, by Pat Moran $27.95
Painting the Effects of Weather, by Patricia Seligman $27.95
Painting Towns & Cities, by Michael B. Edwards $24.95
Painting with Acrylics, by Jenny Rodwell $19.95 (paper)
Pastel Painter's Pocket Palette, by Rosalind Cuthbert $16.95
Pastel Painting Techniques, by Guy Roddon $19.95 (paper)
The Pencil, by Paul Calle $19.95 (paper)

Perspective Without Pain, by Phil Metzger $19.95

Photographing Your Artwork, by Russell Hart $18.95 (paper)

Putting People in Your Paintings, by J. Everett Draper $19.95 (paper)

Realistic Figure Drawing, by Joseph Sheppard $19.95 (paper)

Tonal Values: How to See Them, How to Paint Them, by Angela Gair $19.95 (paper)

Crafts & Home Decorating

The Complete Flower Arranging Book, by Susan Conder, Sue Phillips & Pamela Westland $24.95

Contemporary Crafts for the Home, by Bill Kraus $10.50

Creative Basketmaking, by Lois Walpole $12.95

Creative Paint Finishes for the Home, by Phillip C. Myer $27.95

Decorative Painting for Children's Rooms, by Rosie Fisher $10.50

The Dough Book, by Toni Bergli Joner $15.95

Festive Folding, by Paul Jackson $17.95

Great Gifts You Can Make in Minutes, by Beth Franks $15.95 (paper)

Make Your Own Picture Frames, by Jenny Rodwell $12.95 (paper)

Make Your Woodworking Pay for Itself, by Jack Neff $16.95 (paper)

Master Strokes, by Jennifer Bennell $27.95

Painting Murals, by Patricia Seligman $26.95